AMERICA
ON
DISPLAY

AMERICA ON DISPLAY

Joyce Jurnovoy and David Jenness

Facts On File Publications
New York, New York • Oxford, England

AMERICA ON DISPLAY

Copyright © 1987 by Joyce Jurnovoy and David Jenness

First published in the United States of America by Facts On File, Inc.
460 Park Avenue South, New York, New York 10016.

Library of Congress Cataloging-in-Publication Data

Jurnovoy, Joyce.
 America on display.

 Includes index.
 1. Museums—United States—Guides. 2. United
States—Description and travel—1981- —Guide-books.
I. Jenness, David. II. Title.
AM11.J87 069'.0973 86-24394
ISBN 0-8160-1361-6

Interior design by Oksana Kushnir

Printed in United States of America
10 9 8 7 6 5 4 3 2 1

To intrepid collectors
and hobbyists—may you always
find extra room in your attic.

ACKNOWLEDGMENTS

Working on this book was a joy thanks to the one and only Kate Kelly and her "private world"; special thanks to agent Meg Ruley, who made it all possible; gratitude to our dear friends—Bobsy Draper, Dr. Eduard G. Friedrich, Jr., Millicent Jenness, Andre Poulin, Suzanne Reid, and Maurice Wiener—for their kindness and generosity.

Hats off to Steven Daniels, Bob McLaughlin, and Arlene Pignataro at Expertech, Inc., for their patience and loyalty; our appreciation to Auto Driveaway and Philip Rubell for wheels and to Ann Ficklen for her networking skills. Others who made the work easier are Carmine Capone, Lou Carbonetti, Walter Connelly, Sam Salzarulo, and Irene Sharpiro. Thanks to Joe Reilly for his sharp eyes, and to Suzanne DeVito, Pam Golden, and the crew at FOF for their enthusiastic support.

We owe a special debt to all the unique museums that participated.We recommend calling ahead to check admission prices, and hours, which are subject to change, and accessibility features; special rates for group tours can usually be arranged in advance.

CONTENTS

INTRODUCTION

The unique museums scattered across America weave a cultural tapestry of our popular tastes, passions, and pastimes—collecting, sports, politics, celebrity watching, technology, and industry. Collectively they display our popular culture, from soup to nuts. If you don't believe it, visit the Campbell Museum's collection of soup tureens in Camden, New Jersey, and the Nut Museum in Old Lyme, Connecticut.

The objects hobbyists and fans of Americana treasure need not be beautiful, rare, or even expensive, although many are. In our research we were amazed to discover entire museums devoted exclusively to such diverse memorabilia as cookie jars, dollhouses, beer cans, toy trains, vacuum cleaners, slot machines, and barbed wire. Some of these offbeat museums will strike you as funny or strange—the excesses of an obsessed hobbyist" and indeed their founders share an intense vision. For it takes an extraordinary commitment to assemble a collection dedicated solely to esoterica.

We mused at the relevance of a collection comprised of roller skates (National Museum of Roller Skating in Lincoln, Nebraska), and potatoes (The Potato Museum in Washington, D.C.). But after all, collecting is entertainment, and we are a nation of incurable collectors. Our cellars, attics, and curio cabinets are filled with collectibles. And we're just as curious about what others collect—as Ripley discovered, the stranger the better. So why not a museum that reflects our personal interests, whether it be coins, board games, baseball cards, bricks, door locks, or tattoos? (Yes, there is a Tattoo Museum in San Francisco.)

Other specialized museums that celebrate what we value as a society are presidential, military, and science museums, which salute our heroes, and advances in technology. We're also a nation of celebrity watchers, often down to the juicy details of the stars' personal lives. A group of unusual museums documents

this fascination with stars. Among them are the one and only Liberace Museum in Las Vegas, Elvis' Graceland in Memphis, and country-and-western singer Barbara Mandrell's museum in Nashville. And sports fans will find individual museums featuring their favorite sport, whether it be bowling, softball, swimming, tennis, golf, or weightlifting.

The one-of-a-kind museums sponsored by individual philanthropists are an important part of *America on Display*. Notable examples include the fascinating Henry Ford Museum in Dearborn, Michigan, the unique Forbes Magazine Galleries in New York City, created by publisher Malcolm Forbes, and industrialist George F. Getz's historic fire engines on display at the Hall of Flame in Phoenix, Arizona.

Corporate America is putting its dollars into museums that not only serve as vehicles for public relations and image building but, in their way, present a slice of American life. Included are industry-sponsored museums, such as the Goodyear World of Rubber in Akron, Ohio, the Rubber Capital of the World, and the Tupperware Museum in Kissimmee, Florida.

Each region of our country encompasses wildly diverse interests. A case in point: the Chicago area is home to the McDonald's Museum, the Time Museum, the International Surgical Hall of Fame Museum, the American Police Museum, the Cookie Jar Museum, and the Bradford Museum of Collector's Plates, to name just a few. To highlight this amazing amalgam, as well as present a convenient guide for travelers, we've organized *America on Display* by region.

Some collections are located in historic homes; others are housed in multimillion dollar complexes, complete with restaurants, theaters, concert halls, and busy gift shops. Generally, they are "user friendly," offering exciting multimedia exhibits and viewer participation.

Most of these unique repositories have evolved since 1970, as more cities and towns began to strive for cultural identity and to focus on the preservation of their grass roots traditions. Many owe their existence to community pride in a hometown hero. For example, it's thanks to the citizens of Lemont, Texas, birthplace of the great athlete Babe Didrikson Zaharias, for creating the Babe Didrikson Zaharias Memorial and Museum, and to the residents of Claremore, Oklahoma, who honor one of their own, humorist Will Rogers, with a memorial and museum.

INTRODUCTION

No art or history background is needed to enjoy the rich and varied culture presented in unique museums, and many of them will spark nostalgic memories. For example, in Los Angeles, the Museum of Neon Art's collection of flashing marquees and saloon signs once lit up Main Streets across the country; the McDonald's Museum (the very first one in Des Plaines, Illinois) recalls life in the 1950s; the bleachers from Brooklyn's long-gone Ebbet's Field at the Baseball Hall of Fame and Museum in Cooperstown, New York, where baseball was reportedly invented, evokes past World Series fever.

From the thousands of specialized museums, we have attempted to select the most original for *America on Display*. We couldn't include them all. Together they form a patchwork quilt, displaying so much of what's popular in America. We're extending an invitation to anyone interested in the American vernacular. Whether you're a collector, hobbyist, armchair sociologist, or simply planning to travel on vacation or business, the unusual museums of America are ready to welcome you.

THE
EAST

CONNECTICUT

An eight-foot nut cracker marks the entrance, a nut hangs from the door knocker, and you must bring a nut to gain entrance. Miss Elizabeth Tashjian, a woman nutty about nuts, has transformed the parlor and living room of her 19th century mansion into a showplace for nuts. The Nut Museum, founded in 1972, is sequestered behind a thicket of black walnut, hazelnut, and chestnut trees in Old Lyme, Connecticut, the Nutmeg State.

As creator, curator, and sole tour guide, Miss Tashjian often greets visitors in an Armenian robe, an eye-catching belt of black walnuts hanging from her waist. The robe, which once belonged to her grandmother, honors the fact that most popular nuts come from Asia Minor. This whimsical lady reports that her love affair with nuts began in childhood, when she was overwhelmed by the beauty of a nut she had opened and felt compelled to sketch it rather than eat it. She's been collecting, painting, and sculpting nuts ever since. For her, nuts are a powerful metaphor for social comment and one of her large paintings, depicting a dwarf and a face hidden in the textures of a nut, is entitled *Quote Me, Never Dwarf the Little Man*.

The main room of the museum, decorated with acorn cornices, contains a variety of nuts from many countries, nut masks, and more paintings of nuts by Miss Tashjian. There is an extensive display of nutcrackers and a 35-pound specimen of the world's largest nut, a double coconut (*Lodicea maldivica*) from the Seychelles islands, which Miss Tashjian points out resembles human buttocks. Known for her wit, she is apt to crack, "We all came from the same shell." And she can be philosophical: "Nuts can bring peace and open up the narrow confines of selfdom. We learn gentleness and respect from the nut, which is hard on the outside and soft and sweet on the inside."

The Nut Museum

303 Ferry Road
Old Lyme, Connecticut 06371
(203) 434-7636
Open: call for an appointment
Admission: one nut (any variety)
and $2

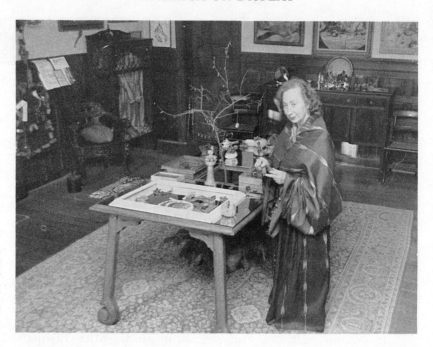

Elizabeth Tashjian inside The Nut Museum, surrounded by her collection of nut art and artifacts.

Photograph by the *Hartford Current*

Miss Tashjian delights in sharing juicy tidbits about nuts and nut lore, and claims that Eve gave Adam a nut—not an apple. Visitors to her nutty abode may discover that there are 40 ways to chew a betel nut, that a male nut sinks and a female nut floats, that the Queen of Sheba preferred pistachios, or that filberts thrown into a fire on Halloween can predict whether a love match will be smooth or stormy. She has been known to break into an *a cappella* version of the song she has written, "The March of the Nut," or a nut anthem called "Nuts Are Beautiful," whose theme is echoed in the sculpture garden in her yard. Miss Tashjian has even heralded the nut as a guest on "The Tonight Show" and "Late Night with David Letterman." "I'm really doing a lot for humanity," she states matter-of-factly. "What I'm offering is originality. And I've taken the demerit mark off nuts."

An intense passion for nuts is further evident in her display of jewelry made from beechnuts, spoons made from walnuts, carved nuts from South America, and tiny scenes constructed inside hickory shells from Mexico. Children will surely be charmed with the toy furniture made from nuts. More treasures in her collection include a horn chestnut from China, a heart nut from Japan, and a walnut shell containing a miniature wedding scene.

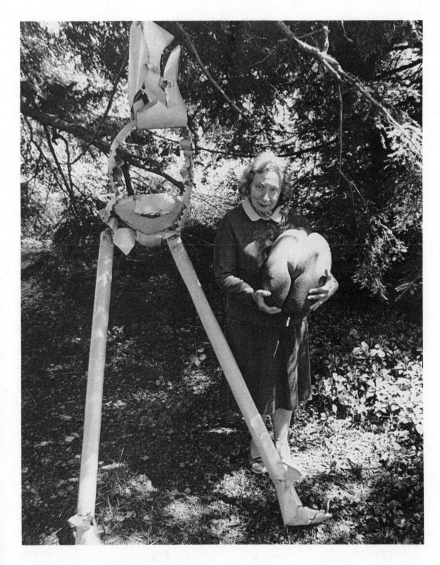

Miss Tashjian holding one of the largest nuts in the world, known as a double coconut (*Lodicea maldivica*), beside her sculptural impression of a nutcracker.

Courtesy of The Nut Museum

Surrounded by the nuts she loves, life at the Nut Museum can be quite serene, except when an occasional squirrel or chipmunk pops in to raid the collection. But Miss Tashjian continues to hope they'll be distracted by the bountiful filberts and pecan trees in her yard. Because visitors must donate a nut to be admitted, there have been some unusual contributions indeed. One is a prized *zapate* nut, donated by a man from the Dominican Republic, who claims to have owned it for 50 years. Another man attempted to donate his wife.

The Lock Museum of America

130 Main Street
Terryville, Connecticut 06786
(203) 589-6359
Open: May through October,
Tuesday through Sunday,
1:30 P.M. to 4:30 P.M.,
or by appointment
(203) 582-9497
Admission: $1 for adults, free for
children under 12
Wheelchair accessible

T he quiet little town of Terryville, Connecticut, was once a thriving center of cabinet and trunk lock manufacturing. A century and a half later, it is home to The Lock Museum of America. If you're lured by locks, this two-story brick museum offers the largest display of locks, keys, and ornate hardware in the country. Here you can find a 4,000-year-old wooden pin tumbler lock that was discovered in the ruins of an Egyptian palace. It is the oldest artifact in the collection of more than 22,000 items.

Thomas Hennessy, curator and president of the museum and a leading authority on American locks, is responsible for the displays and occasionally acts as tour guide. His arrangement highlights the history of lockmaking in America, particularly the lock manufacturers who flourished in Connecticut during the latter half of the 19th century.

There is also a fascinating display of Colonial locks, door locks, and padlocks by early American lock companies. In the Sargeant and Greenleaf Room are bank locks, vault locks, safe locks, and time locks from board member Harry C. Miller's personal collection. An important item on view is an eight-lever key lock that was installed at the White House during Abraham Lincoln's administration.

More than 1,000 locks and keys, manufactured from 1854 to 1954, can be found in the Eagle Lock Company Room. If you're a stickler for detail, you'll appreciate the Terryville-based company's records from 1889, which list its 285 employees and their salaries. Of special interest in the Yale Room is the original patent model of Linus Yale, Jr.'s, mortise cylinder pin tumbler lock, which revolutionized the lock industry; it was the first high-security lock that could be mass produced and sold at affordable prices.

It's amazing to review the array of devices cautious folks have used to safeguard themselves and their possessions: imagine the frugal owner of an icebox lock, or the overly protective master who installs a dog collar lock on his pooch. A billiard cue lock enabled a careful pool player to lock his prized cue on a rack; an example from 1883 is on display.

While most of the locks in this museum were meant to keep trespassers out, law breakers have not been forgotten. Installed on the second floor is a rather serious-looking inventory of restraining devices, including handcuffs, leg irons, and prison locks. Another exhibit case displays a selection of shiny brass

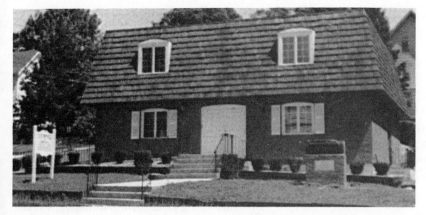

The unassuming Lock Museum of America is located in Terryville, Connecticut, the birthplace of the cabinet and trunk lock industry.

Courtesy of The Lock Museum of America

doorknobs carved with the logos of various organizations, including the New York Railroad, the state of Georgia, and the Elks Club.

After the tour, enjoy a cup of cider and a donut served in the Klimas Dillon Room in the basement. At the gift shop are Lock Museum souvenirs and related books—*The Lure of the Lock*, and Mr. Hennessy's definitive book, *Early Locks and Lockmakers of America*.

P.T. BARNUM MUSEUM

820 Main Street
Bridgeport, Connecticut 06604
(203) 576-7320

See displays on the Prince of Humbug and his leading protégé, Tom Thumb, as well as an unwrapped Egyptian mummy, a five-ring circus model, and Victorian-era exhibits. Visitors learn that Barnum served one year as mayor of Bridgeport.

AMERICAN CLOCK AND WATCH MUSEUM

100 Maple Street
Bristol, Connecticut 06010
(203) 583-6070

Located in a historic post-Revolutionary War house, this museum presents American clocks and watches. Classic grandfather clocks, wall clocks, desk top clocks, and pocket watches are displayed against handsome wood paneling and stenciled plaster walls.

THE SHORE LINE TROLLEY MUSEUM

17 River Street
East Haven, Connecticut 06512
(203) 467-6927

Ride turn-of-the-century trolleys on a three-mile scenic tour and see other historic clangers in open carbarns. Watch a parade of streetcars or step into the Restoration Shop to see craftsmen at work.

BIRDCRAFT MUSEUM

314 Unquowa Road
Fairfield, Connecticut 06430
(203) 259-6305

This museum is for the birds, more than 2,000 birds in fact, presented in dioramas that document Connecticut's natural history. Included is the Charles E. Wheeler collection of duck decoys.

THE EDWARD CLARK STREETER COLLECTION OF WEIGHTS AND MEASURES

Medical Historical Library
Yale University
333 Cedar Street
New Haven, Connecticut
Call for an appointment (203) 785-4259 or 785-4354

Dr. Streeter was a physician and medical historian who believed that the study of weights and measures is the foundation of all sciences. The international collection of weights, scales, cups, rulers, and clocks on view is his legacy. The collection includes Babylonian, Assyrian, Egyptian, Greek and Roman weights and European standards of measurement. Call for an appointment.

WINCHESTER CENTER KEROSENE LAMP MUSEUM

100 Old Waterbury Turnpike
Winchester Center, Connecticut 06094
(203) 379-2612

Kerosene was king between 1852 and 1880 and this museum presents a private collection of 500 metal, glass, and ceramic hanging and standing lamps. Take a close look at the kerosene slide projectors.

DELAWARE

ZWAANENDAEL MUSEUM

Kings Highway and Savannah Road
Lewes, Delaware 19958
(302) 645-9418

In 1631, the Dutch settled Delaware and this museum commemorates the pioneers with a replica of a typical Dutch town hall. Exhibits explore early life among the settlers.

MAINE

WENDELL GILLEY MUSEUM

Route 102, Box 254
Southwest Harbor, Maine 04679
(207) 244-7555

Wendell Gilley, an oil burner repair man and taxidermist, carved more than 6,000 birds in his spare time and many of his inch-high miniatures are on view as well as life-size models of chickadees, terns, ducks, hawks, wild turkeys, and bald eagles. A short video shows the late Mr. Gilley at work.

BRYANT STOVE MUSEUM

P.O. Box 2048, Rich Road
Thorndike, Maine 04986
(207) 568-3665

It's the age of microwaves and central heating, but many remember the cast iron cookstoves and heaters that once warmed households in the 19th and early 20th century. See more than 100 different models as well as the miniature stoves carried by traveling stove salesmen.

MARYLAND

U.S. NAVAL ACADEMY MUSEUM

U.S. Naval Academy
Annapolis, Maryland 21402
(301) 267-2108

This orderly museum displays a fleet of detailed ship models, Navy memorabilia, and artifacts from naval encounters throughout history.

BABE RUTH BIRTHPLACE-MARYLAND BASEBALL HALL OF FAME

216 Emory Street
Baltimore, Maryland 21230
(301) 727-1539

Baseball hero George Herman "Babe" Ruth's major contributions to the game are documented along with a display of his personal memorabilia. There are audiovisual displays, and the history of the Baltimore Orioles is chronicled.

LACROSSE HALL OF FAME

Newton White Athletic Center
Homewood, Baltimore, Maryland 21218
(301) 235-6882

Lacrosse, considered the oldest game in North America, was developed by American Indians in the 1400s to condition braves for combat and to settle tribal disputes. Today it's played by colleges and clubs in the United States and Canada. This small repository displays Indian lacrosse sticks, artifacts, and modern uniforms. See the trophies, photographs, and plaques of each inductee.

WILDFOWL ART MUSEUM

Salisbury State College
655 South Salisbury Boulevard
P.O. Box 703
Salisbury, Maryland 21801
(301) 742-4988

This museum presents a first-rate collection of exquisitely carved duck decoys and tells the history of duck decoy and wildfowl carving in the United States. See prize winners from the World Championship Carving Contests and a diorama of ducks in the wild as seen from a rush-covered duck blind.

MASSACHUSETTS

Boston Tea Party Ship and Museum

Congress Street Bridge
Boston, Massachusetts 02210
(617) 338-1773
Open: daily, 9:00 A.M. to dusk
Admission: $3.25 for adults, $2.25 for children ages five to 12, free for children under five

Hail to the Colonists who, dressed as Indians, boarded three British merchant ships docked at Griffin's Wharf on a chilly December night in 1773 and dumped 340 chests of tea into Boston harbor to protest unfair British taxation. Some said they were nothing but a bunch of ruffians paid by local merchants. Nonetheless, the Boston Tea Party, as the action was christened, helped sow the seeds of discontent that led to the American Revolution.

With a ticket to the Boston Tea Party Ship and Museum and a good imagination, visitors can reenact the scene when they step aboard the *Beaver II*, a 110-foot Norwegian coastal schooner tied to Griffin's Wharf that was reconstructed in 1973 to resemble the original *Beaver*. Below deck is the spacious cargo hold where the tea was stored and from which "Indians" hauled large lacquered wooden chests to the deck, smashed them open with hatchets, and emptied the burlap bags they contained over the rail.

A small building on the wharf houses exhibits that tell the story. While sitting on wooden tea chests, watch a short slide show about the main issue of the day: "Taxation without representation." King George III and a highly indebted British government were squeezing the economy of the struggling American Colonies to finance the unpopular French and Indian War. Tea was as popular then as coffee is today, and the high tariff on tea steamed the Colonists until they felt they had to take a stand.

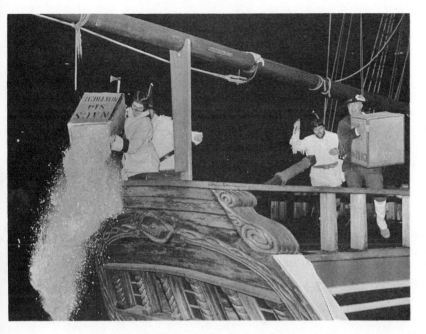

The reenactment of the Boston Tea Party from the stern of the *Beaver II*, a copy of the original *Beaver*, one of the ill-fated cargo ships laden with tea that was beset by "Indians" one December night in 1773.

Jim Davis, *Boston Herald*

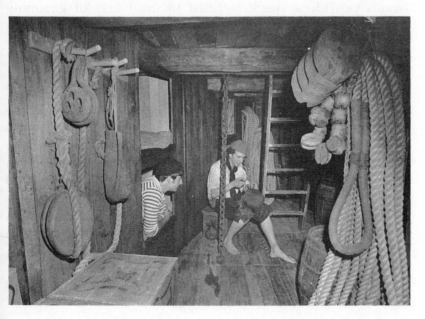

Museum guides dressed as seamen below deck on the *Beaver II*.

Ulrike Welsch, Boston Tea Party Ship and Museum

A scale model of Colonial Boston helps trace the route of the "Indians" from the Old South Meeting House to the original Griffin's Wharf, which is buried under landfill some 100 yards away. A lacquered tea chest believed to have been salvaged from the Tea Party is on view, and modern-day Colonists are invited to enjoy a cup of "tax-free tea" from a large urn, courtesy of the original tea shippers, Dawson Newman and Company.

Bring a camera and play patriot by heaving overboard a tea chest, stenciled with the words "East Indian Bohea"—a type of black tea popular with the Colonists. It's tightly secured with a length of rope so the whole family can take turns.

Exit through the gift shop, where Indian headdresses, tomahawks, and books are among the many souvenirs. Ironically, the most popular item is a tiny wooden crate of English Breakfast Tea, stamped with the words "Boston Tea Party Ship and Museum."

Computer Museum

300 Congress Street
Boston, Massachusetts 02210
(617) 426-2800
Open: Tuesday through Sunday, 10:00 A.M. to 6:00 P.M.
Admission: $4 for adults, $2 for students and seniors, half price from 6:00 P.M. to 9:00 P.M. on Fridays
Wheelchair accessible

The complex world of megabytes, fractals, and cellular automata comes to life at the Computer Museum, which covers two floors in a 19th century brick warehouse on Boston's historic waterfront. Brick walls and exposed wooden beams provide a rustic contrast to the banks of gleaming hardware, which comprise the most extensive collection of historic computers ever assembled. All the major computer manufacturers—IBM, MITRE, Osborne, Apple, Honeywell, Digital, Data General—are represented.

Director Gwen Bell and curator Oliver Strimpel present exhibitions that appeal to the experienced hacker as well as the computer illiterate. Visitors first encounter mammoth early computers, whose memory banks require huge aisles of vacuum tubes; the same amount of information is now stored on a silicon chip the size of a credit card. Computer buffs are sure to appreciate the $20 million Whirlwind, the first major computer ever built; it was developed for the U.S. Navy in 1945 by a team from the Massachusetts Institute of Technology. Nearby, a video monitor shows Edward R. Murrow interviewing MIT researchers as they use it to perform an elaborate calculation.

The link to today's Fifth Generation supercomputers is illustrated by several vacuum tube "dinosaurs" like the UNIVAC

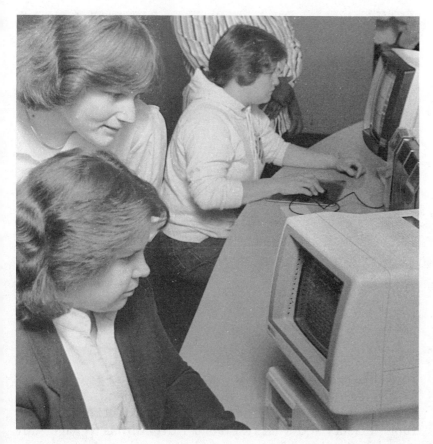

Visitors experiment with one of the many interactive exhibits in the personal computer gallery at the Computer Museum.

Martha Everson, Computer Museum

I and the ILLIAC IV. Also on display is a segment of the largest computer ever built, the AN/FSQ-7, which weighed 175 tons and had more than 30,000 square feet of vacuum tubes. It was built by IBM and served the U.S. Air Defense system from 1958 to 1983.

This "user friendly" museum offers plenty of opportunities to "interface" with computers. A common sight is a young whiz kid helping Mom or Dad operate a machine. Visitors can make their own keypunch cards at an exhibit that traces the growth of computers in the work place, or examine a memory chip under a microscope to understand the significance of the integrated circuit. Another popular section is The Computer and The Image Gallery, which demonstrates the computer's many contributions in different fields, from weather forecasting to medicine. If

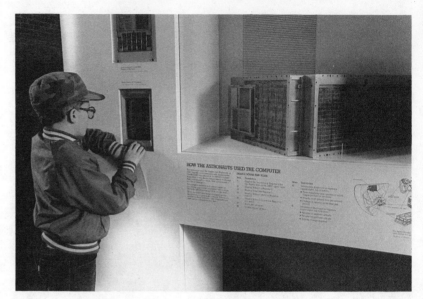

This young visitor learns how computers helped the Apollo astronauts maintain orbit around the moon.

Courtesy of Computer Museum

you'd like to select an architectural plan for a house or design a car, you can give it a try using state-of-the-art CAD/CAM software, and for that car design your efforts will be graded for fuel efficiency and wind resistance. Adventurous teenagers are especially fond of the Flight Simulator, in which they can pretend to be Chuck Yeager and pilot an aircraft. Also fun is the Image Processor, which allows users to create colorful computer-enhanced self-portraits.

If you're more than just a soft touch for software, there is an extensive library and study center, with books, photographs, films, and videotapes. In the See It Then theater, vintage films from 1920 to 1981 show how programming and operating machines have changed. At the Computer Animation theater, the history of animation is presented through the work of such film producers as Lucasfilms, Ltd., creators of *Star Wars*.

Since its opening in 1984, the Computer Museum has been demystifying the technology and making computers more accessible, even fun. Are you interested in microcircuit jewelry, designer computer paper, a computer cookbook, or Chocolate Chips (chocolates shaped like computer chips)? Find these and more at the Computer Museum Store on the ground floor.

I t's all here—the days of the "Camelot" White House, the witty press conferences, the memorable speeches, the glamorous First Lady, the tragic day in November. For those who lived through the chaotic Kennedy era, this well-endowed museum, designed by the celebrated architect I.M. Pei, captures the Kennedy mystique in a way that's both informational and emotional. The stark monumental John F. Kennedy Library and Museum, which was completed in 1979, was funded by donations of $18 million from public and private sources; even schoolchildren sent in their pennies.

When first entering the museum, visitors are treated to a half-hour film on Kennedy's life, with particular emphasis on the 1960 campaign and his 1,037 days in office. He was an image-conscious president, letting filmmakers follow him on the campaign, into meetings in the Oval Office, and with his family. A clear and seemingly intimate picture of his dynamic personality unfolds.

Displays cover the Kennedy clan's emigration from Ireland in the mid-1800s and proceed chronologically through 1968,

The Museum At the John F. Kennedy Library

Columbia Point
Dorchester, Massachusetts 02125
(617) 929-4523
Open: daily, 9:00 A.M. to
5:00 P.M.; closed
Thanksgiving, Christmas, and
New Year's Day
Admission: $2.50 for adults, $1.50
for seniors, free for children
under 16
Wheelchair accessible

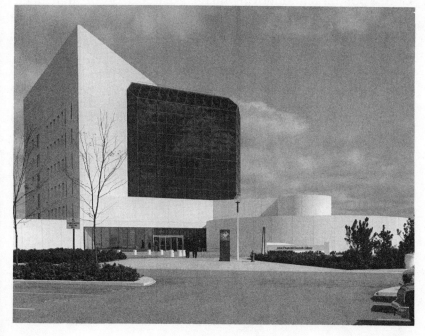

The imposing John F. Kennedy Library, designed by architect I.M. Pei.

Courtesy of The Museum at the John F. Kennedy Library

when brother Robert was assassinated during his presidential campaign. Above the displays a time line highlights world events during the stages of Kennedy's life. Organized into themes, such as The Formative Years and Day in the Life of the President, glass-encased exhibits of photography, writings, doodles (JFK was an avid doodler), and memorabilia present his childhood, Harvard years, World War II naval experiences in the Pacific, and stints as a representative and senator until 1960, when Kennedy's time line intersects with the world's. Captions quote memorable lines from his many speeches; additional information has been written by the noted historian Arthur M. Schlesinger, Jr.

Occupying center stage in the middle of the main exhibition hall is the 35th president's desk and the cushioned rocking chair he used in the Oval Office for his bad back. There is a plethora of audiovisual installations, including a film of Kennedy's press conferences showing his charming, off-the-cuff style and a documentary on Robert Kennedy's life, *RFK Remembered*, that recreate the spirit of optimism that both Kennedys have come to symbolize.

The tour ends with a wall-size photograph of a reflective John Kennedy walking alone on the beach in Hyannis on Cape Cod, a poignant and moving image. Visitors exit through an enormous, nine-story tinted-glass pavilion that overlooks Massachusetts Bay. Kennedy's sailboat, the *Victura*, is set on the shore.

The library houses Kennedy's presidential papers and declassified documents as well as 115,000 photographs, six million feet of film, and 1,000 audio tapes, which are part of the Oral History of JFK amassed from hundreds of friends and acquaintances in the 1960s. In addition to more than 20,000 books on U.S. government and politics during Kennedy's time, there are substantial collections of papers relating to Robert Kennedy, Theodore White, and Ernest Hemingway.

The Whaling Museum

Listen and you can almost hear the cry "Thar she blows" from the crow's nest as the hardy whalers readied themselves. Herman Melville's novel, *Moby Dick*, immortalized the seafaring men of the 1850s who sailed the world from New Bedford, Massachusetts, in search of the oil-laden sperm whale. When the demand for whale oil declined in the late 1800s, the fashionable city of Melville's time, with its wealthy captains and ship owners, fell from grace. But the Whaling Museum, sponsored by the Old Dartmouth Historical Society, retains the flavor of the city's golden age through its artifacts. Built in 1907, the big brick museum stands on cobblestoned Johnny Cake Hill, overlooking the waterfront and across from the Seamen's Bethel, where Melville once worshipped.

Out to sea for months, even years, whalers wiled away the hours carving and engraving whale bones and teeth. They rubbed oil and lampblack on the surfaces to bring out the design, and these labors of love were presented to mother or sweetheart back home. The museum displays a beautiful collection of this folk art, known as scrimshaw, including an ornate watch holder and assorted pie crimpers. Gracing the walls of the

18 Johnny Cake Hill
New Bedford, Massachusetts 02740
(617) 997-0046
Open: Monday through Sunday,
9:00 A.M. to 5:00 P.M.; Sundays,
1:00 P.M. to 5:00 P.M.
Admission: $2.50 for adults, $1.50
for children six to 14
Wheelchair accessible

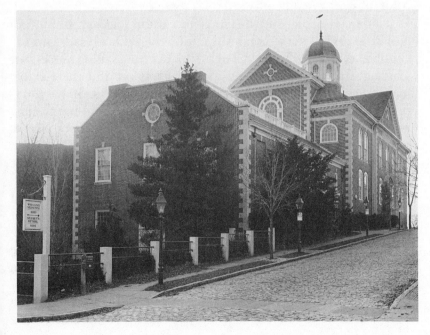

Built in 1907, the New Bedford Whaling Museum stands on Johnny Cake Hill, overlooking the historic waterfront.

Courtesy of The Whaling Museum

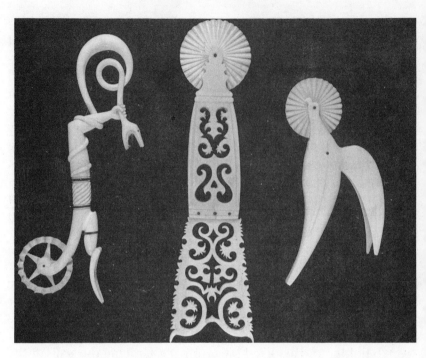

Pie-jagging wheels from the scrimshaw collection.

Courtesy of The Whaling Museum

museum are many fine examples of the shipcarver's art: colorful figureheads and stern boards.

The centerpiece of the museum is the *Lagoda*, an 89-foot half-size model of a whaling ship, fully rigged, with sails run up. Climb aboard to get the feel of a 19th century sailing vessel; see whalecraft, such as the long barbed harpoon and the flexible manila rope used to pull in whales. Nearby are the 30-foot oar-powered skiffs used to chase whales; see where the harpoonist braced himself at the bow to heave a spear at a surfacing whale. Smell the musky oil casks still pungent after 100 years. Overhead, the skeleton of a sperm whale gives an idea of the size of the prey.

Local New Bedford history is represented by the artwork of the New Bedford School of painters, featuring portraits of proud captains in full dress or epic scenes depicting whaling battles on the high seas. Wealthy whaling families, not unlike modern oil magnates, lived extravagantly, as you'll observe in their extensive collections of china, crystal, and dolls. Commissioned in 1848, the grand mural, 8 1/2 feet high and over a quarter mile long, offers a panoramic view of a whaling

voyage from New Bedford "around the Horn" to the Pacific, the Orient, the Indian Ocean, and back home.

More than 800 logbooks kept by the whaling masters provide a fascinating account of long whaling voyages, complete with colorful sketches of whales, ships, and communities encountered along the way. There are no accounts by Captain Ahab of a large white whale, but in every other detail, this museum evokes the adventures of *Moby Dick*.

America's native berry, the cranberry, is celebrated at the Cranberry World Visitors Center, sponsored by the Fortune 500 company Ocean Spray, a cooperative of cranberry and citrus growers. Located at their corporate headquarters in Plymouth, Massachusetts, the museum thoroughly traces the cranberry's social and commercial history from Colonial times to the present in colorful exhibits and audiovisual presentations. The Indians introduced the berry to the Pilgrims, who thought its blossom looked like a Sandhill crane, hence they called it a "craneberry," later shortened to cranberry.

Cranberry World

Ocean Spray Cranberries, Inc.
225 Water Street
Plymouth, Massachusetts 02360
(617) 747-1000
Open: April 1 to November 30, daily, 9:30 A.M. to 5:00 P.M.
Admission: free
Wheelchair accessible

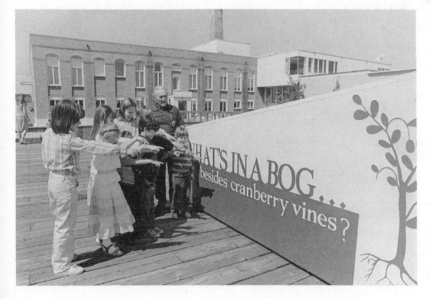

These visitors to Cranberry World learn about cranberry bogs and can look forward to sampling some of the delicious cranberry products made by Ocean Spray.

Courtesy of Cranberry World

You can browse at your own pace, or take a tour with any of the knowledgeable guides dressed in cranberry garb and pick up interesting facts about the cranberry: a cranberry vine grows for 800 years; only five states—Massachusetts, New Jersey, Oregon, Washington, and Wisconsin—have the right mixture of climate, freshwater, and sandy soil to grow cranberries; berries have air pockets and are graded by how high they bounce. "You have to bounce if you want to be an Ocean Spray cranberry," explains Willie, a retired grower and guide who enthuses visitors with his own bounce and dry Cape Cod humor.

Cranberry World welcomes an average of 2,000 visitors a day, who get a chance to operate antique tools used to harvest cranberries, see a short film of a bog owner talking about life as a grower, watch a machine that bounces berries to separate them, see a "thresher" (a cranberry picker that resembles a complex lawnmower), and learn about Ocean Spray's bottling techniques.

This museum is clearly a three-dimensional advertisement for Ocean Spray that touches all five senses. At the end of the tour, visitors receive free samples from the Demo Kitchen, where Ocean Spray prepares such treats as cranberry coffeecake, cranberry mousse, cranberry chutney cheese spread, and a broad sampling of juices—not only the classic

Willie explains how cranberries are sorted: "You have to bounce if you want to be an Ocean Spray cranberry."

Courtesy of Cranberry World

cranberry but also cranapricot, cranraspberry, and crantastic, a fruity cranberry punch. While enjoying your refreshments, a video display shows Ocean Spray television commercials from the past.

Take home free recipe booklets. How about cranberry sanghria, cranberry-strawberry shortcake, or berry chili barbecue? There's even a free recipe poster for each visitor, suitable for framing. The gift shop sells cranberry-scented soap and candles, cranberry cookbooks, cranberry Christmas ornaments, cranberry refrigerator magnets, and, of course, plenty of Ocean Spray products.

Naismith Memorial Basketball Hall of Fame

1150 West Columbus Avenue
Springfield, Massachusetts 01101
(413) 781-6500
Open: September through June 30, daily, 9:00 A.M. to 5:00 P.M.; July 1 through Labor Day, daily, 9:00 A.M. to 6:00 P.M.
Admission: $5 for adults, $3 for students (under 15) and seniors, free for children (under eight)
Wheelchair accessible

During one cold December in 1891, Dr. James Naismith, football coach at Springfield College in Springfield, Massachusetts, devised a game to occupy his student-athletes between football season and baseball season. He hung a peach basket at each end of the gym, made up 13 rules, and called the game "Basketball." Today, not far away in downtown Springfield, the $11.5 million Naismith Memorial Basketball Hall of Fame honors Dr. Naismith and the American game.

The basketball experience begins outside the museum as visitors approaching on the highway see a 43-foot high mural that creates the illusion of basketball players in motion. Inside the entrance of the three-story glass and steel building is an unusual 40-foot "waterfall" of more than 100 basketballs that appear to tumble continually into a well.

The tour begins on the third floor, which is devoted to the evolution and the story of the game. Uniforms and trophies from high school, college, and professional competitions are displayed, and film clips of historic games will impress hoop fanatics. Here, too, is the basketball used to set the world nonstop dribbling record (347.2 miles) in 1981. The Honors Court pays tribute to hall of fame inductees, who are enshrined with medallions and brief histories of their careers. You'll find Wilt "the Stilt" Chamberlain, Bill Russell, "Dollar" (now Senator) Bill Bradley, and five-foot-tall Senda Berenson Abbott, who organized the first women's basketball games in 1893.

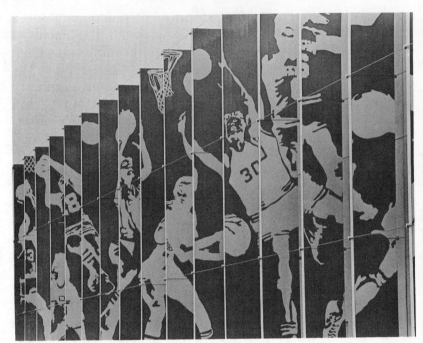

This exterior mural—10 panels, each 43 feet high—creates the illusion of players in motion as you drive by the Basketball Hall of Fame.

Courtesy of Naismith Memorial Basketball Hall of Fame

Screened on the second floor, films catch the drama of a basketball game. *Hoopla*, a 22-minute film covering basketball's basics—passing, setting a pick, executing a fast break—is a warm-up for *Play 52*, a multidimensional action film. Surrounded by four movie screens and quadraphonic sound, viewers are run through standard basketball plays as if they were on the court with a team.

If you want to show what you can do, try the Shoot Out on the first floor, where you have to shoot at baskets of varying heights from a moving sidewalk. After you've given it your best shot, head for the NBA locker room, where the uniforms and sneakers of such stars as Kareem Abdul-Jabbar, Earvin "Magic" Johnson, and Larry Bird are encased in glass-fronted lockers. On the way out, the well-stocked gift shop sells just about everything related to the game, from basketball jewelry to a regulation NBA ball and hoop.

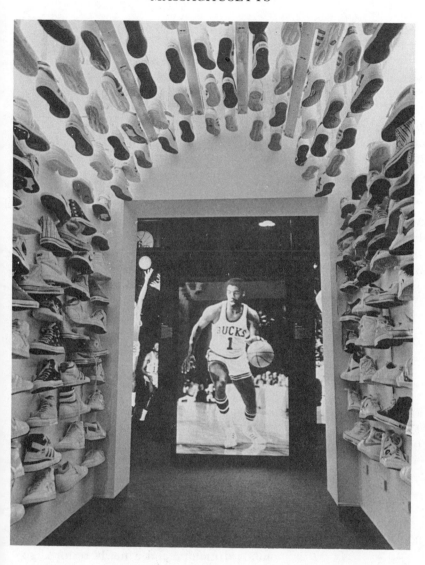

Hall of famer Oscar Robertson appears to be dribbling into a tunnel of basketball shoes.

Courtesy of Naismith Memorial Basketball Hall of Fame

CRANE MUSEUM

Off Route 9
Dalton, Massachusetts 01226
(413) 648-2600

The history of papermaking is presented at this museum, sponsored by the Crane Paper Company, a privately owned concern that has been making paper here since 1801. See a model of the vat house of the first Crane paper mill and displays of Crane paper products from the 19th century.

A & D RAILWAY MUSEUM

49 Plymouth Street
Middleborough, Massachusetts 02346
(617) 947-5303

Twenty-five years ago, Adolf "Able" Arnold's doctor recommended he find a hobby to relax. Arnold chose toy trains, amassed one of the world's largest private collections, and opened the A & D Railway Museum in a former supermarket. Visitors pay their "fare" at a railroad ticket booth to see an elaborate layout featuring 25 operating trains and display cases filled with antique and rare toy trains. A workshop gallery shows wooden trains in various stages of repair.

PAPER HOUSE

Pigeon Hill Street
Pigeon Cove, Massachusetts 01966
(617) 546-2629

This fully furnished New England house has been built entirely from 100,000 newspapers that have been layered or rolled, then glued and laquered. It is truly a one-of-a-kind project.

SALEM WITCH MUSEUM

19 1/2 Washington Square North
Salem, Massachusetts 01970
(617) 744-1692

This eerie museum tells the story of the Salem witchcraft trials of 1692 through tableaus and audiovisual material.

SANDWICH GLASS MUSEUM

Sandwich Historical Society
Route 130, P.O. Box 103
Sandwich, Massachusetts 02563
(617) 888-0251

The Boston and Sandwich Glass Company, whose heyday ran from 1825 through 1888, specialized in making delicate multicolored paperweights, lamp bases, cologne bottles, and goblets. Specimens are chronologically arranged.

INDIAN MOTORCYCLE MUSEUM

33 Hendee Street
Springfield, Massachusetts 01139
(413) 737-2624

Oscar Hedstrom invented the Indian motorcycle in 1901 and opened the Indian Motorcycle Company in Springfield the same year. It closed a half century later, in 1953, as a result of poor business decisions. But in this one-of-a-kind museum, motorcycle fans and collectors Charles and Ester Manthos have assembled a variety of Indian motorcycles and motor-driven vehicles, including one of Hedstrom's first motorcycles, the "granddaddy" of all snowmobiles, antique outboard motors, and a newly restored six-cylinder 1928 Indian Roadster. In addition to a range of American-made motorcycles by other manufacturers, the museum owns a replica of the first motorcycle ever made (one of two), invented in 1885 by Gottlieb Daimler in Germany, who would later form Mercedes-Benz.

NEW HAMPSHIRE

A nyone who's earned his tenderfoot badge will remember struggling with knots, pitching a tent in the rain, and eating a meal cooked over an open fire. The Boy Scout experience, in all its rustic glory, is captured at the Lawrence L. Lee Boy Scout Museum located at Camp Carpenter in Manchester, New Hampshire, headquarters of the Daniel Webster Council.

"I will be friendly, courteous, kind, obedient, cheerful, thrifty, brave, clean and reverent." Boer War hero Major General Robert Stephenson Smyth Baden-Powell, who created the Boy Scouts in England at the turn of the century, would be pleased to know that the good old-fashioned virtues stated in the Boy Scout pledge still thrive. His goal was to give lower-class English boys a chance to learn the principles of teamwork and discipline available to upper-class youth in boarding schools. The idea quickly caught on in the United States and around the world. By the 1930s, the Boy Scouts of America had become a national institution, prompting President Herbert Hoover to

Lawrence L. Lee Boy Scout Museum

Bodwell Road
P.O. Box 1121
Manchester, New Hampshire
03105
(603) 627-1492
Open: July and August, daily, 10:00
A.M. to 4:00 P.M.; September
through June, Saturday only,
10:00 A.M. to 4:00 P.M.
Admission: free
Wheelchair accessible

The Lawrence L. Lee Boy Scout Museum is packed with glass cases of memorabilia documenting the proud history of scouting.

Ron Covey, Lawrence L. Lee Boy Scout Museum

25

The Max I. Silber Library and Research Center has the most extensive collection of scouting publications in the United States.

Ron Covey, Lawrence L. Lee Boy Scout Museum

comment, "I know of no other form of Americanization that so produces real Americans."

The museum is packed with glass cases of memorabilia and exhibits documenting the proud history of scouting. They include uniforms, patrol medallions, and awards for Cub Scouts, Boy Scouts, and Explorer Troops from around the world. Of particular interest are several original paintings commissioned for the cover of *Boy's Life*, the official Scout magazine, the flag and patch carried to the moon by astronaut and former Scout Alan Shepard, and a flag and ceremonial dagger given to Baden-Powell by the Scouts of Hungary during the 1933 World Jamboree.

The lakeside museum, conceived by Daniel Webster, Council Commissioner Max I. Silber and Executive Lawrence L. Lee, was built entirely by Scouts. Completed in 1969, the long, rough-boarded, knotty pine lodge, nestled among tall pines, is situated near nature trails, campgrounds, and picnic areas, making it an ideal family adventure. Camping arrangements and tours can be set up by calling the Daniel Webster Council in advance.

The Max I. Silber Library and Research Center contains the most extensive collection of scouting publications in the United States. Displayed at a cozy hearthside setting are scout-

ing periodicals, Braille versions of the Scout and Cub handbooks, and copies of every hardbound Scout fiction and nonfiction book ever published. Boy Scout Museum watches, Christmas ornaments, coins, stamps, and neckerchiefs are among the souvenirs that can be purchased. However, the Eagle and Woodbadge belt buckles can be bought only by Scouts who have earned them.

I f you're a game player but don't care for Pac Man, Space Invaders, or other electronic games, then visit Mrs. Dennis' cozy red house at the foot of Mount Monadnock in Peterborough, New Hampshire, where you'll find old-fashioned games like skittles and Minoru. In 1977 Lee Dennis turned her private collection of more than 1,000 antique board games and card games, dating from 1812 to 1930, into a museum called The Game Preserve. All the handsome, colorful lithographed game covers in her remarkable collection line the walls of her study, hallway, and living room. The rare and most delicate are preserved in specially sealed frames.

The Game Preserve

110 Spring Road
Peterborough, New Hampshire
93458
(603) 924-6710
Open: by appointment or by chance
Admission: $1.50 for adults, $1 for children

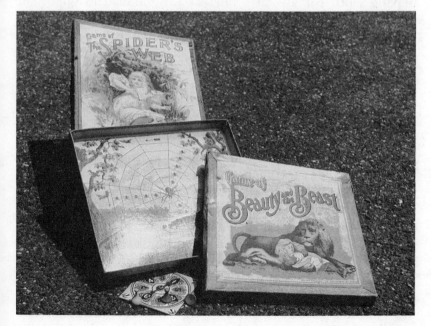

Just a few of Lee Dennis' beautiful antique board games that are part of her private collection of more than 1,000.

Courtesy of The Game Preserve

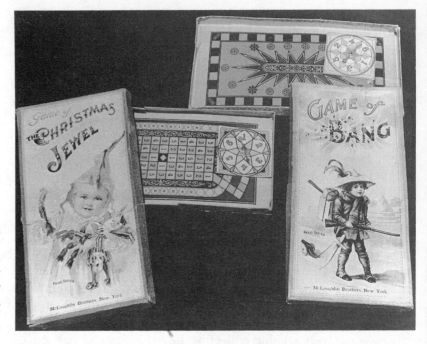

Games created by the McLoughlin Brothers at the turn of the century are considered by many collectors to be the most attractive games ever made because of their beautifully designed covers.

Courtesy of The Game Preserve

Mrs. Dennis began collecting in the 1950s rather by accident. One rainy day she found herself at an auction and bid $10 for a large gaming table. In it she found the directions and playing cloth for an early horseracing game. Intrigued, she began looking for games in junk shops and at flea markets and garage sales. In those days, games were considered white elephants and sold for an average of 50 cents.

Today the oldest title in her gallery of games, The Mansion of Happiness, is worth at least $200. It was created by a minister's daughter in 1843 and colored in by hand. The object for each player is to be the first to arrive at the Mansion while avoiding such pitfalls as Passion and Idleness. According to Mrs. Dennis, in strict pre-Civil War households, this game served as a lesson in morality as much as a form of entertainment.

Contemplating the games of the past with Mrs. Dennis provides an interesting history lesson. Visitors learn that during the Civil War, Milton Bradley, a young artist, designed a fold-up game kit for soldiers, which included dominoes, checkers, and his own invention, The Checkered Game of Life, before establishing the company that has produced hundreds of successful board games.

Another industry leader, George S. Parker, began inventing games when he was in high school, and soon he formed a

successful company. However, Parker Brothers blundered when they initially rejected a game by a young inventor named Charles Darrow because it took too long to play. Fortunately for those of us who have bought Boardwalk and Park Place, they reconsidered and Monopoly became the biggest selling board game in history. Themes in other Parker Brothers games, titled Pikes Peak or Bust, Lindy Hop-Off, or Siege of Havana, which was inspired by the Spanish-American War, capitalized on news events of the past.

The games we choose to play have always mirrored our society and values. Games such as Telegraph Boy or District Messenger Boy, circa 1888, display the American work ethic. Players begin as entry-level employees and attempt to advance steadily around a board symbolizing the corporate ladder. These products, created by the McLoughlin Brothers, are among Mrs. Dennis' favorites and, because of their beautifully designed covers, are considered by many collectors to be the most attractive games ever made.

This museum is fun for history buffs and game players of all ages. Children will particularly enjoy a colorful game carpet that is woven with game boards: chess, cribbage, Parcheesi (based on pachisin, the national game of India), and even hopscotch. In addition to serving as tour guide, Mrs. Dennis sells board games and other childhood collectibles on her enclosed porch, which she calls The Pastime Porch.

NEW JERSEY

Campbell Museum

Soup's on at the Campbell Museum. For serious students of the decorative arts and those interested in food and the history of food service, the museum, which opened in 1970 at Campbell's corporate headquarters in Camden, New Jersey, presents beautiful symbols of affluent dining. Luxuriously decorated tureens, ladles, trays, spoons, and soup dishes made of porcelain, china, earthenware, silver, and pewter by European and American craftsmen are displayed in hanging modules in an elegant gallery setting, complete with red velvet wall coverings.

Campbell Place
Camden, New Jersey 08101
(609) 342-6440
Open: Monday through Friday,
9:00 A.M. to 4:30 P.M.
Admission: free
Wheelchair accessible

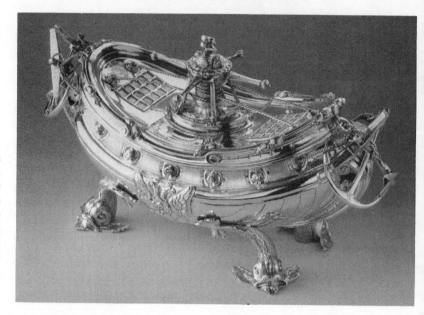

The detail on this silver tureen from Russia (circa 1766) is extraordinary, from the winged dolphin feet to the four-barred capstan handle. The applied shape plaque on each side of the bowl is embossed with Russia's double-headed eagle and the monogram of Catherine the Great.

Courtesy of Campbell Museum

Since the beginning of recorded history, people have spooned food from communal containers, and the museum has bowls dating back to 500 B.C. Refined table arts, developed in the Middle Ages by the nobility of Europe, reached heights of creativity during the 18th century in the elegant courts of Louis XIV and Louis XV. Musicians played soothing music, flowers and spices scented the air, and servants lavished attention on table service. The best potters and silversmiths of Europe, from such houses as Meissen, Rouen, Limoges, Wedgewood, and Worcester, were commissioned to create elaborate soup and stew containers.

The French called them *les pièces dormant* and in England they were known as VIPs—very important pieces. But in America, they were simply called holloware, and no well-set table or sideboard was complete without one. Serving as the centerpeice was a deep, covered tureen (round for stew, oval-shaped for soup) with stand and ladle. These handcrafted objects of status were often in the shape of game fowl or other animals associated with the table, and the museum has a small menagerie, including a large goose of Meissen porcelain (circa 1745), an English porcelain hen guarding a nest of chicks under her wing, a boar's head, a turkey with tail feathers flared, and two rabbits (you lift the covers off by the ears)—all painted in

This cock tureen, made of tin-enameled earthenware (*faience*), was created in France by Jacques Chapelle (circa 1760).

Courtesy of Campbell Museum

exquisite detail. One Portuguese tureen is fashioned as a bucket of fish. Others are in the shape of vegetables or fruit; exceptional is a rare Wedgewood cauliflower (circa 1765).

Many of the ceramic bowls are colorfully decorated with pastoral landscapes, seascapes, or elegant floral prints; some contain exotic scenes from the Orient. The silver and pewter tureens have intricately designed rims, legs, and cover handles. Some are embellished with sculptural images of lions heads, dogs feet, fig leaves, and mythical figurines. Unique table services were often given as gifts of state and decorated with a coat of arms or government symbol. Outstanding among the historical ceramics on view is a soup plate from a set ordered for the White House by Abraham Lincoln that features a large bald eagle and the national motto, E Pluribus Unum. A film, *Artistry in Tureens*, is shown by appointment.

ATLANTIC CITY HISTORICAL MUSEUM ON GARDEN PIER

New Jersey Avenue and The Boardwalk
Atlantic City, New Jersey 08404
(609) 347-5844

A nostalgic tour of Atlantic City history through collected artifacts, photographs, and souvenirs. There are purses made out of clamshells, lobster claw salt shakers, Miss America trophies, bathing beauty figurines, and more.

UNITED STATES GOLF ASSOCIATION MUSEUM

Golf House
Far Hills, New Jersey 07931
(201) 234-2300

Golf fans will appreciate exhibits of old-time clubs and balls, golf art, and trophies. Of special note is the fold-up golf club that astronaut Alan B. Shepard, Jr. used when he teed off on the moon.

THE EDISON TOWER

Menlo Park, New Jersey
(201) 549-3299

After Henry Ford moved Thomas Edison's entire laboratory to his Greenfield Village museum in Dearborn, Michigan, a tower was erected at the exact spot where Edison invented more than 500 patented items, including the phonograph and the incandescent light bulb. A small museum tells the story of Edison's work and displays Edison memorabilia.

NEW YORK

National Bottle Museum

Verbeck House
20 Church Avenue
P.O. Box 621
Ballston Spa, New York 12020
(518) 885-7589
Open: June 1 through Labor Day, daily, 10:00 A.M. to 4:00 P.M.
Admission: $1 for adults, free for children under 11

The healthful mineral waters of Ballston Spa in Saratoga County, New York, were once shipped across the country and around the world in attractive hand-blown green, aqua, and amber "Saratoga bottles," which were distinguished by a short neck, broad shoulders, and a double lip. Fittingly, Ballston Spa is the home of the National Bottle Museum and its international collection of bottles and related glassware.

Supported by the Federation of Historical Bottle Clubs (FOHBC), the museum was uncorked in 1979 in a rambling Victorian mansion called Verbeck House. With its authentic Queene Anne furnishings and decor, the genteel 25-room structure is a perfect setting for ornate glass flasks and bottles from the 1800s.

According to the FOHBC, antique bottles are the third most popular collectible, after stamps and coins. "Bottle collecting is like treasure hunting," said Bernard Puckhaber, the museum's founder and charter president. "Through bottles, people find out facts about the area they live in."

At one time, glass factories across the country created unique bottles for local wineries, breweries, and medicinal companies. The museum acknowledges these regional containers with an exhibit of antique bottles relating to all 50 states.

The National Bottle Museum is located in a charming 25-room Victorian house.

Courtesy of National Bottle Museum

A display of early-American milk bottles.

Courtesy of National Bottle Museum

Emphasizing the relationship of bottles to their era, one room of Verbeck House has been transformed into an 1890s pharmacy, with an array of bottles and jars in all shapes and colors, from amber flasks of bitters to cobalt blue poison bottles. A turn-of-the-century doctor's office provides another historic setting, as

does a glassblowing exhibit, which features a model of a glass-making factory and the tools of the trade.

Bottles on loan from collectors and clubs across the country comprise the temporary exhibits. Not every display features bottles; popular nonbottle displays have been antique glass target balls, which were used by skeet shooters and trick marks-. men in vaudeville acts in the mid-1800s, and witch balls—long pieces of blown glass with a round bulb on one end—that were filled with salt and hung near the fireplace to ward off evil spirits.

The museum reference library indexes materials on bottle identification, classification, and manufacturing history. Seminars and special events are held throughout the year and the museum sponsors a bottle convention each May that draws hundreds of collectors together for an auction, show, and sale.

Anonymous Arts Museum

Charlotteville, New York 12036
(No telephone)
Open: July through September, Saturdays and Sundays, 12:00 P.M. to 3:00 P.M.
Admission: free
Wheelchair accessible

As director of the O.K. Harris Gallery in New York City, Ivan Karp is a prominent figure in contemporary art circles. He and his wife, Marilyn, also share a passion for their personal and eclectic collections of unusual objects. Among the prizes are cigar labels, animal face can openers, and Naughty Nellies (19th century bootjacks in feminine shapes). Karp also boasts a large collection of antique food choppers—he owns 350—and has the world's largest collection of the word "OK" incorporated into an amazing assortment of memorabilia, everything from license plates and postcards to key chains and signs.

Another collection of Americana, that has taken him 30 years to amass, consists of more than 2,000 ornamental sculptures that once adorned Victorian-era buildings built between 1880 and 1910 in New York City. He has managed to salvage a surreal assortment of gargoyles, gods, royalty, and mythical creatures, carved out of granite, marble, sandstone, and terra cotta, some rendered in tin and copper and a few even constructed from molded concrete.

To attract the burgeoning immigrant population to their apartment buildings and tenements, landlords competed with each other by adorning their buildings with eye-catching decorations in the European tradition. According to Karp, land-

This late 19th century terra cotta head from a building on the Upper West Side of New York City is part of the collection of the Anonymous Arts Museum.

D. James Dee, Courtesy of The Anonymous Arts Recovery Society

lords chose figures from a model book, but craftsmen frequently sculpted each other's likenesses on building facades. Since the sculptural ornaments were created by unknown European artisans, mostly German and Scandinavian, Karp calls his museum the Anonymous Arts Museum. It is located in a

This late 19th century cast iron head was designed for the Brooklyn Academy of Music in Brooklyn, New York.

D. James Dee, Courtesy of The Anonymous Arts Recovery Society

refurbished general store in Charlotteville, New York, near his family's summer residence.

Located on the main floor of the two-story wooden structure, the artifacts are mounted on the wall at eye level, with a small plaque that notes the former building site of each piece and when it was created. "These objects have been neglected by art and architectural historians," says the effervescent Karp, who rescued his first piece in the 1950s, when he was a struggling young entrepreneur on New York's Lower East Side. "There are fascinating clues to our past in this remarkable lost art form." Karp also maintains an extensive slide archive that documents buildings in New York that have ornamentation. For more information, write to: The Anonymous Arts Recovery Society, 380 West Broadway, New York, NY 10012.

National Baseball Hall of Fame and Museum

P.O. Box 590, Main Street
Cooperstown, New York 13326
(607) 547-9988
Open: May to October, daily, 9:00
A.M. to 9:00 P.M.; November to
April, daily, 9:00 A.M. to 5:00 P.M.;
closed Thanksgiving, Christmas,
and New Year's Day
Admission: $5 for adults, $2 for
children ages seven to 15
Wheelchair accessible

Did baseball evolve from the English game of rounders or did it originate in 1846 in Hoboken, New Jersey? To quell the debate, a prominent commission of baseball players and businessmen met in 1905 and, after three years of tireless investigation, determined that the game was invented by Abner Doubleday in Cooperstown, New York, in 1839. Indeed, an old baseball from that period was found in Cooperstown among the belongings of a man who claimed to have been present when Doubleday scratched a diamond in the dirt and assigned positions for the first game. That identical ball is on display at the National Baseball Hall of Fame and Museum in Cooperstown, which opened to celebrate baseball's centennial in 1939.

Housed in a large Federal-style brick building, this museum is a nostalgic tribute to the boys of summer and holds an expansive collection of historic artifacts, accumulated over a century and a half. See the bat Babe Ruth used to hit his record-breaking 60th home run in 1927, a cup of earth from Ebbet's Field in Brooklyn, Lou Gehrig's New York license plate, and Dwight Gooden's hat.

Throughout the three-story building, the collection is distributed in theme rooms. The Great Moments Room presents relics and life-size photographs from record-setting events: Roger Maris' 61st home run in 1961, Rickey Henderson's 130 stolen bases in 1982, Pete Rose's 4,192nd hit in 1985, and Roger Clemens' 19th strikeout in 1986. Find a complete collection of World Series rings, programs, press pins, and tickets along with the much coveted World Series trophy in the World Series Room. Sit in the dugout theater for an audiovisual presentation that highlights famous World Series action.

Gum and tobacco cards have always been a favorite of collectors and this unique collection has some cards that date as far back as 1887. One gallery traces the evolution of uniforms from heavy woolen flannels to today's lightweight, durable, stretch polyester. Included are uniforms from great teams of the past—the Washington Senators, the Brooklyn Dodgers, the Boston Braves. Another showcase traces the development in equipment—bats, balls, gloves and catcher's gear—over the years.

In the Ballparks Room, see turnstiles, lockers, dugout benches, and grandstand seats that capture the special charm and personality of old-time ball parks—such as Ebbet's Field,

Close to 200 baseball immortals are enshrined in a separate wing of the museum. Each hall of famer is represented by a bronze plaque occupying a niche in one of the alcoves.

Courtesy of National Baseball Hall of Fame and Museum

Shibe Park, and Forbes Field—as well as today's stadiums with their computerized scoreboards and artificial turf.

"It ain't braggin' if you really done it," said St. Louis Cardinals' pitcher Dizzy Dean, and the greatest hitters, pitchers, and fielders to play the game, such as Hank Aaron, Ted Williams, Jackie Robinson, Joe DiMaggio, and Sandy Koufax, are duly honored with bronze plaques in the grandiose Hall of Fame Room. Special exhibitions on Babe Ruth and Casey Stengel present memorabilia, quotes, and photographs that dramatize their lasting contributions to the game.

Behind the museum, the National Baseball Library shows baseball films throughout the day. At the gift shop, you can purchase a complete line of uniforms and helmets sporting the logos and colors of the pro teams as well as commemorative pins, posters, and baseball cards. Down the street is Doubleday Field, the cow pasture where young Doubleday devised the rules of the game. In August the annual Baseball Hall of Fame game between two pro teams takes place there.

The history of glass, both cultural and esthetic, becomes crystal clear at the Corning Glass Center, a three-part museum complex in Corning, New York, which attracts a half million visitors annually. Every aspect of glass is explored and its practical and scientific applications are presented in imaginative ways.

The Museum of Glass houses one of the largest collections in the world; more than 24,000 glass objects are on view, including prehistoric tools and weapons chipped from volcanic obsidian (a natural form of glass), elegant creations by European and Arabic craftsmen, and the works of contemporary artists. Even the museum building, designed by Gunnar Birkirts, is an architectural kaleidoscope of glass and mirrors that must be a window washer's nightmare. Completed in 1980, the serpentine structure is entirely clad with textured glass panels and titled mirrors that shut out solar rays but reflect the surrounding landscape within the museum. Inside the museum's lobby, abstract glass sculptures illuminate the versatility of glass as an artistic medium. The Masterpiece Gallery displays more than a hundred works of delicate beauty.

Corning Glass Center

Route 17
Corning, New York 14831
(607) 974-8271
Open: daily, 9:00 A.M. to 5:00 P.M.; closed Thanksgiving, December 24, 25, and New Year's Day
Admission: $2.50 for adults, $2 for seniors, $1.25 for children ages six to 17; a family rate of $6 is available to two adults and their children
Wheelchair accessible

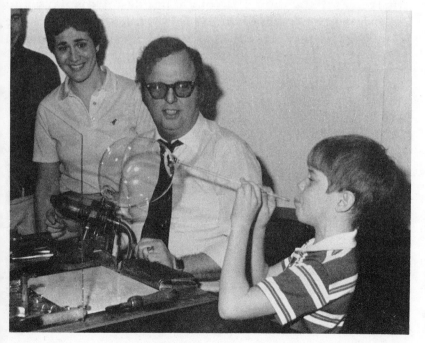

A young visitor at the Corning Glass Center tries his skill at blowing a glass bubble with the help of a resident lamp worker.

Courtesy of Corning Museum of Glass

Featured are a hooded cobra adorning the forehead of a 1 1/2-inch-high pharoah made 3,500 years ago in Egypt from cast and retouched glass and a 1,000-year-old water pitcher from Persia, arguably the most important example of Islamic carved glass in existence. Six wings leading off the Masterpiece Gallery each display over 1,200 pieces of antique glass in specially designed backlit "study cases" with plaques that inform viewers about each work's function, technique, and historical development. Brief slide shows provide fascinating facts on international glassmaking traditions.

An outstanding feature of the glass museum is the Jerome Strauss Collection of Drinking Vessels. Containing more than 2,400 pieces, it's one of the most comprehensive surveys of man's use of glass for drinking ever assembled. Beginning with Egyptian core-formed drinking flasks dating to 1400 B.C., the collection spans the history of civilization up to goblets produced in Afghanistan in the early 1970s.

After seeing the glass museum, visitors can tour the Hall of Science, an adjacent building, to see one of the largest pieces of glass ever made—the first casting of the 200-inch-diameter mirror disk for the telescope on Mount Palomar in California. Here, one learns how glass is made and used for science, industry, and the home through hands-on displays and audiovisual presentations. You'll see windows from the Space Shuttle, laboratory beakers, light bulbs, lenses, mirrors, myriad glass toys, cookware, spectacles, and tools. In one area, a crafts-

The Corning Museum of Glass building, designed by architect Gunnar Birkerts, has been described as "the most innovative museum structure in the United States." Mirrors mounted below the exterior glass wall panels give visitors a continuous panoramic view of the surrounding landscape.

Courtesy of Corning Museum of Glass

man demonstrates the ancient art of blowing glass and creates a glass menagerie of tiny animals by bending and shaping heated rods of glass tubing. Visitors are treated to an 11-minute show about glass technology's impact on the quality of life.

The third stop on the tour is a visit to the Steuben Glass Factory. A glass-covered bridge leads to a viewing gallery overlooking the factory floor, where delicate works of art are hand-formed as you watch. Unlike most factories, Steuben workers are not specialized; each worker tries to master all aspects of his craft—cutting, engraving, designing, and glassblowing. You'll see teams of workers laboring at reheating ovens, called "glory holes," where the gaffer (master blower) shapes the molten glass into the form stipulated by the designer. After slowly cooling in a special annealing oven, the piece is removed for grinding, polishing, and engraving.

There is an extensive library devoted to the art and history of glassmaking, which is open to the public on weekdays. Corning glass and Corningware can be bought in different locations at close-out prices, but the Steuben Glass Shop offers its artworks at no discounts, and there are no seconds, because if a work isn't perfect, it is melted down and started again.

E ver wanted to fly like a bird? Since the beginning of time, men have sought the adventure of motorless flight by strapping themselves to strange winged contraptions. The fascinating history of soaring in sailplanes and hang gliders is presented at the National Soaring Museum in Elmira, New York.

Housed in a building that resembles a sailplane hangar, the museum is located on historic Harris Hill, overlooking the Chemung Valley, which has ideal terrain for creating the thermal updrafts necessary for soaring. The 16,000-square-foot facility, established in 1969, presents classic and contemporary sailplanes, informative exhibits on meteorology and aerodynamics, and films on soaring. Sit at the controls of a sailplane in a cockpit simulator and you can almost hear the whoosh of the wind as you glide through the air.

At the Soaring Hall of Fame, it's hats off to those who dared—like William Hawley Bowlus, who leaped from a hill at

National Soaring Museum

Rd #3
Harris Hill Road
Elmira, New York 14903
(607) 734-3128
Open: daily, 10:00 A.M. to 5:00 P.M.; closed Christmas and New Year's Day
Admission: $2 for adults, $1 for students and seniors, free for children under 12
Wheelchair accessible

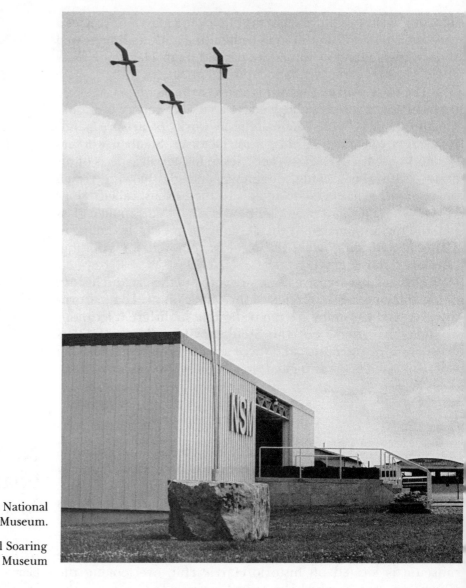

The entrance to the National Soaring Museum.

Dan Driscoll, National Soaring Museum

the age of 14 with a homemade glider that had rocking chair rungs for landing gear. He designed innovative sailplanes in the 1920s and 1930s, taught Charles and Anne Lindbergh how to soar, and helped build *The Spirit of St. Louis* for Lindbergh's 1927 transatlantic flight.

After touring the museum, why not go for a ride in a sailplane with a licensed pilot and experience the thrill of motorless

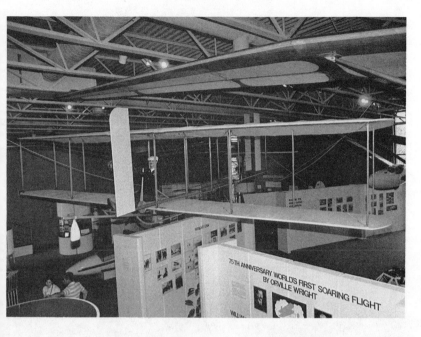

This early glider is part of an exhibit on the Wright Brothers' first attempts at flight.

Jeff Richards, National Soaring Museum

flight for yourself? Using just the energy of the wind and sun, soaring aficionados describe a magnificent interlude of peace as they glide. The museum's entrance observation deck offers a beautiful view of gliders dipping and sailing over the valley. Nearby Harris Hill Park is a great spot for picnics.

Our culture is intact: Fred Flintstone has been preserved for future generations at the Museum of Broadcasting in New York City. It is a thriving international institution, filling nine floors with screening rooms, a theater, private listening and viewing consoles, and a collection of more than 25,000 radio and television programs.

"It's really a history of our times," said CBS founder William Paley, who endowed the museum with a foundation in 1975. The museum's collection includes coverage of President John Kennedy's assassination, the first moon landing, the Vietnam War, and the Watergate scandal, among other important historical events. It also encompasses the diversity of pop culture. The museum's most requested television program for private viewing is the Beatles' first appearance on the "Ed

Museum of Broadcasting

1 East 53rd Street
New York, New York 10022
(212) 752-7684
Open: Tuesday, 12:00 noon to 8:00 P.M.; Wednesday through Saturday, 12:00 noon to 5:00 P.M.
Admission: $3 for adults, $2 for students, $1.50 for seniors and children under 13
Wheelchair accessible

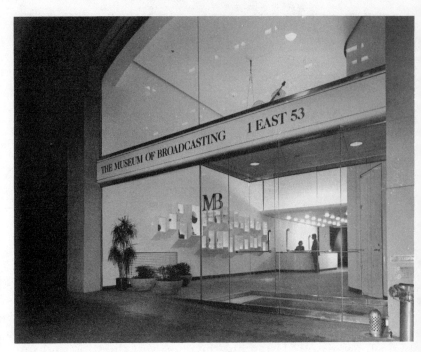

The entrance to the Museum of Broadcasting

Courtesy of Museum of Broadcasting

Sullivan Show," and for radio Orson Welles' spooky production of "Invasion from Mars." When curators discovered several "lost" episodes of "The Honeymooners," people lined up around the block to see them.

The museum has preserved many vintage radio broadcasts from the 1930s and 1940s, such as the emotional account of the *Hindenberg* disaster of 1937, Edward R. Murrow's World War II broadcasts from London, as well as classic comedy routines from Jack Benny, Fred Allen, Amos and Andy, and the Marx Brothers. These delightful radio relics have been transferred to cassette tape and can be enjoyed through a pair of headphones at one of the museum's 23 individual consoles.

The classic stars of television's Golden Age in the 1950s and early 1960s, Sid Caesar, Milton Berle, and Rod Serling, among many others, can be seen. Shows such as "All in the Family," "The Mary Tyler Moore Show," "Upstairs/Downstairs," and

Visitors view classic television programs or listen to vintage radio shows at these state-of-the-art consoles.

Courtesy of Museum of Broadcasting

"M*A*S*H" have been added to the museum's notable video collection.

Museum staff members continually search the archives of networks, production companies, and individual collectors for important footage that may have been lost or overlooked; many "Tonight Show" programs from the 1950s and 1960s have been lost. When videotape replaced filmed kinescopes, which were used to record live shows, many were erased and reused or corroded because of improper storage.

The museum frequently mounts special exhibitions that revolve around a theme or creative force, such as Bob Hope, the teleplays of Paddy Chayefsky, or the Muppets. Weeklong seminars, open to the public, have included Lucille Ball, Walter Cronkite, and Norman Lear. Whether your interests are historical, cultural, or nostalgic entertainment, this unique museum documents the best of the airwaves.

Forbes Magazine Galleries

62 Fifth Avenue
New York, New York 10011
(212) 206-5548
Open: Tuesday through Saturday,
10:00 A.M. to 4:00 P.M. (tour
groups Thursday only)
Admission: free
Wheelchair accessible

Whether it's hot air balloons or state-of-the-art motor-
cycles, publisher Malcolm Forbes is a collector ex-
traordinaire. You'll see why he's in a class by himself at
the exquisitely appointed Forbes Magazine Galleries in New
York City, which displays just a portion of his diverse collections,
and exudes his enthusiasm for tapping into the joys of child-
hood.

Forbes has spared no expense in presenting a delightful
world of make-believe. At the Ships Ahoy Gallery, there's a
flotilla of more than 500 intricately detailed toy boats—ocean
liners, riverboats, warships, submarines, speedboats, rowboats
—and with the aid of transparent bases, each ship is suspended
as if afloat; a soundtrack of lapping waves and nautical whistles
and horns adds atmosphere. Imaginative dioramas in the On

A unique selection of historic
treasures, including a rare inscribed
photograph of Abraham Lincoln
and his young son, Tad, and a 1787
bottle of Chateau Lafite bottled for
Thomas Jefferson, is on exhibit at
the Forbes Magazine Galleries.
Other highlights include the key to
the White House, the original
logbook kept by the *Enola Gay*
copilot during the bombing of
Hiroshima, and a copy of the
Emancipation Proclamation signed
by President Lincoln as well as his
famous stovepipe hat and the
opera glasses he used the night
he was assassinated.

Larry Stein, Forbes Magazine
Galleries

Peter Carl Fabergé's *Coronation Egg* (1897) and the *Lilies of the Valley Egg* (1898) were surprise Easter presents to the Russian Czarinas Alexandra Feodorovna and Maria Feodorovna respectively. The five-inch-long golden transluscent enamel *Coronation Egg* opens to reveal a gold and raspberry red enamel replica of the czarina's coronation coach. The pink transluscent enamel egg, to which the jeweled lilies cling, has as its surprise miniatures of Czar Nicholas II and his two eldest daughters, Olga and Tatiana. A geared mechanism enables the miniatures to rise out of the egg, which, when open, stands nearly eight inches high.

Courtesy of Forbes Magazine Galleries

Parade Gallery show off more than 12,000 lead soldiers: cowboys and Indians are locked in epic battle on the high plains, French gendarmes parade smartly through a small European town, a castle courtyard bustles with activity as palace guards escort the royal stage coach. "Happy memories of countless childhood hours spent playing with both toy ships and soldiers were the stimulus for these two collections," reports Forbes. "None of our own survived those years of growing up."

Forbes began collecting as a boy, snipping autograph signatures from the letters of dignitaries corresponding with his father, and he has continued amassing historical documents and memorabilia. Among the fascinating items in the classical Autograph Galleries are such rarities as the opera glasses President Abraham Lincoln used the night he was assassinated in Ford's Theater, the logbook from the B-29 bomber *Enola Gay*, which dropped the first atomic bomb on Hiroshima, and General Dwight Eisenhower's top-secret communique announcing to the Allied Chiefs of Staff that Germany had surrendered during World War II.

The preeminent collector of Fabergé eggs, Forbes has acquired 12 of the 54 jeweled "surprise" Easter eggs originally created by the House of Fabergé for the last two czars of Russia. Alexander III began the tradition by presenting one to his wife each year, and son Nicholas gave one to his wife and his mother until the revolution ended his reign in 1918. Forbes' most recent acquisition, *The Rosebud Egg*, for which he paid $1,905,200 was created in 1895. Measuring only 2 5/8 inches high, it is a master work of fine detail. The engraved gold shell has a fine layer of strawberry red enamel and is set with diamonds in a delicate wreath-and-bow pattern. Inside, the surprise is a life-size yellow enamel rosebud of beaten gold resting on a cream-colored velvet lining.

The pink and mauve Fabergé Gallery exposes other beautiful objects created by Peter Carl Fabergé, jeweler by appointment to the czar for 31 years. Among the many gems of note is a tiny harp with a miniature of Alexander II and the diamond-studded, red enamel Heart Surprise frame with miniatures of Czar Nicholas, Czarina Alexandra and their second daughter, Tatiana, whose birth in 1897 this piece commemorates. The Picture Gallery holds changing displays of paintings, photographs, and sculpture installations.

The *New York* (circa 1900), made by Marklin and Co. of Nuremberg, Germany, exemplifies the finest of the toymaker's art, with its charming exaggerations emphasizing the "toyness" of the boat while still maintaining a standard of excellence in the hand-painted details.

Courtesy of Forbes Magazine Galleries

This visual fun house of a museum has been promoting the high-tech, three-dimensional, laser-created images of holography as a new art form since its inception in 1976. Located on two dimly lit floors of a loft building in Manhattan's Soho art district, the Museum of Holography's changing exhibits by international artists provide fascinating optical paradoxes that challenge the viewer's perceptions.

This unique marriage of art and technology is explained in a continuously running film on the museum's lower level. Invented by Dennis Gabor in 1947 (for which he won the Nobel Prize for physics in 1971), the complex process of holography involves reflecting high-intensity laser beams off an object onto a piece of film or glass coated with photograph emulsion. When you shine a light on or through the flat hologram, a three-dimensional image appears to float within it. Move up, down, left, right and you can see the object's top, bottom, and sides; sometimes the image moves, changes color, and even transforms into an entirely different object.

A historical display chronologically details the development of holographic technology. In addition to current industrial and commercial applications and future possibilities, such as three-dimensional holographic television and films, the medium offers creative artists myriad possibilities.

Among the artworks in the museum's permanent collection are hologram still lifes and holograms combined with other artistic media—sculpture, video, painting, film—such as a wax candle with a holographic flame that flickers as you move. Since many of the displayed works are lit with one pin spotlight, you'll find that if you pass your hand over the beam, the hologram disappears.

The permanent collection includes works by Setsuko Ishii, Japan's foremost holographic artist, who incorporates holograms into her Japanese gardenlike environmental pieces, Germany's leading painter and holographer, Dieter Jung, whose abstract color field holograms are highly acclaimed, and Harriet Casdin-Silver, a fellow at M.I.T.'s Center for Advanced Visual Studies and holographic art pioneer, who began creating holograms in 1968 and continues to broaden the art form by combining holograms with video, robotics, and holophonics (three-dimensional sound).

Monthly seminars present leading artists who discuss holograms as art medium. The museum's Dennis Gabor Holo-

Museum of Holography

11 Mercer Street
New York, New York 10013
(212) 925-0581 or 925-0526
(prerecorded message)
Open: Tuesday through Sunday,
12:00 noon to 6:00 P.M.
Admission: $3 for adults, $2.75 for students, and $1.75 for seniors and children under 12

The first time a hologram, created with the use of lasers, ever appeared on the cover of a major magazine.

Charles O'Rear, National Geographic Society

graphic Laboratory is one of the few facilities open to artists who wish to create holograms. The Museum Store Gallery sells holographic fine art, books, catalogs, and unique holographic jewelry and greeting cards.

A tiny eagle sculpture, produced by Eidetic Images, Inc., of Elmsford, New York, eventually became the subject of a hologram on the cover of *National Geographic*.

Charles O'Rear, National Geographic Society

The Strong Museum

One Manhattan Square
Rochester, New York 14607
(716) 263-2700
Open: Monday through Saturday,
10:00 A.M. to 5:00 P.M.; Sunday,
1:00 P.M. to 5:00 P.M.
Admission: $2 for adults, $1.50 for
seniors, $.75 for children ages four
to 16
Wheelchair accessible

Margaret Woodbury Strong was a voracious collector, who was raised to enjoy life's fineries in the Victorian tradition. She was the daughter of an affluent buggy whip manufacturer and early investor in Eastman Kodak, and her parents encouraged her to collect. During her lifetime, and especially after her husband's death in 1958, she amassed a potpourri of more than 300,000 objects, including candlesticks, bathtubs, bells, bicycles, ship models, thimbles, doorstops, and dolls—27,000 dolls, possibly the largest collection in the world.

Her dream was to open a Museum of Fascination, and when she died in 1969, her 30-room Rochester, New York mansion was filled, floor to ceiling, with acquisitions. In her will she left her entire collection to the public, endowing it with $60 million worth of Kodak stock. It took nearly a decade to organize a museum, and since Strong's mansion was not large enough, The Strong Museum opened in a sprawling $12 million contemporary building on 13 1/2 acres in downtown Rochester in 1982.

Under the direction of H.J. Swinney, the museum has become a major educational institution with more than 50,000 square feet of exhibition space, a 290-seat auditorium, classroom space, and a library. Mrs. Strong's enormous collection focuses on the life-styles of the middle class during the Victorian era and extends from 1820 to 1930.

The main exhibition area on the first floor is divided into four parts: childhood, changing styles, American technology, and the Victorian woman. Using photographs, furniture, informative plaques, and a plethora of artifacts, exhibits examine many aspects of American life. The Great Transformation documents the growth of society from the rural farm life of the early 1800s to the urban industrialism of the turn of the century. Changing Patterns: Household Furnishings 1820-1929 interprets the course of furniture styles, from Greek Revival through Colonial Revival. Light of the Home: Middle Class American Women 1870-1910 explores the lives and preoccupations of Victorian women, and other exhibits encompass the popular blue and white ceramicware of the period, toys, and miscellaneous collections.

The well-organized Study Collections, located on the second floor, are housed in a unique system of "visible storage" areas. Lighted glass-fronted cases display more than half the famous doll collection, and there is every type of doll imaginable:

kewpie dolls, mechanical dolls, wax dolls, Barbie dolls, a Princess Grace doll, Teddy Roosevelt dolls, and many more made of wood, cloth, paper, bisque, and porcelain. Each has a registration number, and the serious doll collector can refer to computer-generated file cards in the third floor library for background information on any doll in the collection.

Other exhibit cases present a range of artifacts, from Oriental art (the rage of Victorian collectors) and elaborate dollhouses filled with miniature furniture to toys, textiles, and household utensils. The library also has many 19th century publications and a special collection of miniature books (under three inches high). Dollhouse kits, toys, and antique doll reproductions are available in the gift shop; there is even a limited-edition doll of Margaret Woodbury Strong on her wedding day.

The Museum of Cartoon Art

Ward Castle
Comly Avenue
Rye Brook, New York 10573
(914) 939-0234
Open: Tuesday through Friday, 10:00 A.M. to 4:00 P.M.; Sunday, 1:00 P.M. to 5:00 P.M.
Admission: $1.50 for adults, $.75 for seniors and children under 12

Biff! Boom! Kapow! Leapin' lizards—it's The Museum of Cartoon Art. This delightful museum in Rye Brook, New York, just a 40-minute drive in the Batmobile from Gotham, pays tribute to the art of comic books and strips and political and animated cartoons with its large collection of original artwork, films, and videotapes.

A group of cartoonists, led by Beetle Bailey's creator, Mort Walker, opened the museum in 1974 to preserve and display an art form that hasn't always received its just accolades. Housed in a large Victorian mansion known as Ward's Castle, it is subsidized with a grant from the Hearst Foundation, a fitting benefactor since William Randolph Hearst was the first to print Sunday funnies in his newspapers at the turn of the century.

A papier-mâché likeness of the first widely successful comic strip character, R.F. Outcault's Yellow Kid, greets visitors at the door. Other papier-mâché statues bring cartoon characters to life: Dennis the Menace slides down the banister, Beetle Bailey snoozes in the corner, Dagwood scrubs his back in a tub in the Hall of Fame room. Familiar cartoon characters even appear in the wall-to-wall carpeting.

The cartoon castle is bursting with the original artwork of such great cartoonists as Walt Kelly, whose "Pogo" lampooned everything from McCarthyism to toxic waste dumps; Milton

Cartoonist Milton Caniff, creator of "Terry and The Pirates," lecturing at The Museum of Cartoon Art.

Morgan Walker, The Museum of Cartoon Art

Caniff, creator of "Terry and The Pirates," the wartime melodrama that brought an artistic sophistication to the funnies; George Herriman's strip "Krazy Kat," which, with its cryptic love triangle between Krazy, Ignatz Mouse, and Iffisa Pupp, has been compared with the works of James Joyce in its use of language and Samuel Beckett in its bleak, existential philosophy.

Visitors can flip through racks of original cartoons by contemporary artists, including Charles Schulz ("Peanuts"), Garry Trudeau ("Doonesbury"), and Chic Young ("Blondie"); wade through a stack of Sunday funnies, or witness great feats of heroism against universe-threatening villains in the collection of DC and Marvel comic books. A Marvel comics display illustrates the step-by-step collaborative process of creating a comic book, from script page to pencil drawing, inked board to color overlay, proof sheet to printed book on the stands.

The Cartooning Hall of Fame pays tribute to the cartooning masters, among them Walt Disney, Rube Goldberg, and Charles Dana Gibson, whose illustrations of Gibson Girls set the fashion for an era. See classic animated cartoons on a videotape monitor in the TV Room. How about Bugs Bunny, Woody Woodpecker, or Porky Pig? Th-th-that's not all, folks. See Betty Boop and Popeye on film in the screening room. This has got to be the only museum in the country where the graffiti in the bathroom was done by professionals.

This Sunday panel from 1897, called "Hogan's Alley," by Richard F. Outcault appeared weekly in the *New York World* and is generally credited with defining the field of modern newspaper comics. The night-shirted character holding the tankard is Mickey Dugan, also known as the Yellow Kid.

Chuck Green, The Museum of Cartoon Art

National Women's Hall of Fame

American women owe a debt of gratitude to Seneca Falls, a small town in upstate New York, home of the first women's conference. In 1848, 300 men and women met in Wesleyan Chapel and put forth a series of resolutions, called the Declaration of Sentiments, which included women's right to vote. Seventy-two years later, after passage of the 19th Amendment, Seneca Falls was the scene for another meeting—to draft the Equal Rights Amendment.

The National Women's Hall of Fame (NWHF) in downtown Seneca Falls was opened in 1979 by a group active in the women's movement. A plaque on the front of the converted bank building states the hall's purpose: "To honor in perpetuity those women, citizens of the United States of America, whose contributions to the arts, athletics, business, education, government, the humanities, philanthropy and science, have been the greatest value for the development of their country."

Inside the two-story building, visitors browse exhibits that feature 35 of the most influential women in America, past and present. Inductees include Susan B. Anthony, Helen Keller, Mary Cassatt, Bessie Smith, Amelia Earhart, Margaret Mead, Eleanor Roosevelt, and Pearl Buck, among others. Brief

76 Fall Street
Seneca Falls, New York 13148
(315) 568-2936
Open: year-round, Monday through Saturday, 10:00 A.M. to 4:00 P.M.; May through October, Sunday, 12:00 P.M. to 4:00 P.M.
Admission: Suggested donation $3 for adults, $2 for students, seniors, and members of AAA
Wheelchair accessible

biographies, portraits, photographs, artifacts, and audiovisuals elaborate their accomplishments.

The museum is a popular stop for school and community groups, which receive a previsit kit with slides and discussion material. Researchers will find the 2,000-volume library and archives an excellent resource on women's history. The gift shop features a variety of NWHF trinkets and souvenirs, including banners and patches with quotes by prominent women; favorites include: "No one can make you feel inferior without your consent"—Eleanor Roosevelt; "Pray for the dead, fight like hell for the living"—Mother Jones.

After touring the hall of fame, visit Seneca Falls' historic district, including Wesleyan Chapel and the restored home of Elizabeth Cady Stanton, one of the original women's rights organizers. The drive to raise the funds to purchase the house was substantially aided by an $11,000 donation from actor/director/writer and feminist supporter Alan Alda. Elizabeth Cady Stanton Park, constructed under the sponsorship of the National Women's Hall of Fame, is adjacent to the house.

Goebel Collectors' Club Gallery and Museum

105 White Plains Road
Tarrytown, New York 10591
(914) 332-0300
Open: Monday through Friday, 10:00 A.M. to 4:30 P.M.; Saturdays, 11:00 A.M. to 4:00 P.M.; closed holidays
Admission: free
Wheelchair accessible

Sister Maria Innocentia Hummel was a frail Franciscan nun at the Convent of Siessen in Germany who drew and painted idyllic scenes of apple-cheeked children that reflect an innocence many people have found appealing. In 1935, porcelain manufacturer Franz Goebel acquired the rights to create porcelain figurines and bas-relief plates from her drawings. Although Sister Maria died in 1946 at the age of 37, adaptations of her drawings are still issued under the supervision of the sisters at the convent.

Responding to interest in the cherubic figurines by American collectors, the Goebel Group of West Germany opened the Goebel Collectors' Club Gallery and Museum in Tarrytown, New York, in 1977. The centerpiece of the landscaped grounds is an eight-foot-high replica of one of the most popular figures in the Hummel series, *The Merry Wanderer*, a wide-eyed, clean-scrubbed urchin strolling along with umbrella and satchel. Made of weatherproof ceramic and opaque-colored glazes, it weights a ton and a half.

At the museum, headquartered in a Georgian-style brick mansion overlooking the Hudson River, guests will see a half-hour film on the complicated process of creating the delicate collectibles. Two floors of well lighted exhibits display over 2,000 pieces, including rare, antique, and discontinued works by Hummel and other artists. A display of backstamps shows how collectors determine the age of a figurine. Also on view are bas-relief plates and bells depicting the Hummel tots in a variety of poses, and there is a selection of Sister Maria's original pastels and charcoal sketches. But Hummels are not the only chubby-cheeked minors in Goebel's catalog; other figurines include a series of Charlot Byi Redheads and Dolly Dingle Children. A list of dealers and gift shops carrying Goebel products is available upon request.

THE NEW YORK CITY TRANSIT EXHIBIT

Boerum Place and Schermerhorn Street
Brooklyn, New York 11201
(718) 330-3060

Located in an abandoned subway station; visitors follow the development of New York's mass transit from horse-drawn carriages and trolleys to modern trains. See vintage subway cars and tile mosaics salvaged from assorted New York stations.

THE MUSICAL MUSEUM

P.O. Box 901
Deansboro, New York 13328
(315) 841-8774

If you've ever had the urge to crank a chrodophone, pump a melodeon, or tinkle on an antique coinola, stop in. An amazing menagerie of mechanical instruments and music boxes, many restored to working condition, can be viewed and even played. Listen to antique phonographs and jukeboxes as you admire the mechanical wizardry that went into some of these fantastic melody makers.

HALL OF FAME OF THE TROTTER

240 Main Street
Goshen, New York 10924
(914) 294-6330

The only museum dedicated to harness racing is located in the former Good Time Stables, a Tudor-style building that once housed one of the finest private stables in the country. It's on the edge of Historic Track, where horses can be seen "working out." Exhibits include an extensive Currier and Ives print collection, the history of the Standardbred horse, sulkies, and carriages. The hall of fame has lifelike full-color statuettes of all inductees.

THE GREYTON H. TAYLOR WINE MUSEUM

Greyton H. Taylor Memorial Drive
Hammondsport, New York 14840
(607) 868-4814

Surrounded by vineyards, this museum features artifacts from the Finger Lakes wine industry, where grapes have been cultivated since 1828. The rugged museum building once housed the original Taylor Wine Company. Vineyard cultivating and winemaking equipment is on display, along with bottles, labels, and historical documents relating to wine. The nearby Winemaker's Shop sells winemaking paraphernalia and fresh grape juice for winemaking at home.

AMERICAN MUSEUM OF FIREFIGHTING

Volunteer Fireman's Home
Harry Howard Avenue
Hudson, New York 12534
(518) 828-7695

In the 19th century, most fire departments were strictly volunteer, and this unique museum celebrates those brave firefighters through its priceless collection of antique fire engines, memorabilia, and artworks associated with firefighting.

REMINGTON FIREARMS MUSEUM

Catherine Street off Route 5S
Ilion, New York 13357
(315) 894-9961

In 1816 Eliphalet Remington made a better gun barrel and the world beat a path to his door. This museum displays the flintlocks, rifles, handguns, and other products manufactured by "America's oldest gunmaker." Learn how modern firearms are made; see the gun used by Annie Oakley and a copy of the first rifle made on Remington's forge.

AMERICAN NUMISMATIC SOCIETY MUSEUM

Broadway and 155th Street
New York, New York 10032
(212) 234-3130

From man's first coins, 3,000-year-old lumps of metal from Asia Minor, to a melange of modern international money, this museum presents one of the world's finest collections of coins and paper money.

FRANKLIN FURNACE

112 Franklin Street
New York, New York 10013
(212) 925-4671

Founded by artist Martha Wilson in 1976, Franklin Furnace is an offbeat museum that presents international avant-garde art and serves as a performance and exhibition space. Situated in a loft in the arty area of Tribeca in downtown New York, its archives contain the largest collection of published artworks by contemporary artists, including books, periodicals, posters, records, and tapes.

INFOQUEST CENTER

AT & T Building Arcade
550 Madison Avenue
New York, New York 10022
(212) 605-5555

More than 40 interactive exhibits explore the wonders of communications technology, including fiber optics, microelectronics, and computer software. Among the unique exhibits is one that offers an opportunity to direct a music video; another lets you tour New York in a video taxi. In the auditorium, a dazzling 10-minute show utilizes 32 laser disks.

MUSEUM OF THE AMERICAN INDIAN

Broadway and 155th Street
New York, New York 10032
(212) 283-2420

Founded in 1916 to collect, study, and exhibit the cultures of the aboriginal peoples of North, Central and South America, this museum holds a vast collection of native American artifacts that is the largest in the world.

THE MUSEUM OF THE AMERICAN PIANO

211 West 58th Street
New York, New York 10019
(212) 246-4646

Dedicated to preserving the craft of American piano makers, this museum presents beautifully carved grand and upright pianos; you can even sit down and tinkle the ivories on many of them. Recitals by leading artists on antique instruments and lectures on piano history are frequently held.

THE POLICE MUSEUM

235 East 20th Street
New York, New York 10003
(212) 477-9753

The New York Police Department has been exhibiting confiscated goods and weapons at the Police Museum since 1920. On a tour you can see such relics of crime as a machine gun used by Al Capone's gang for a rub-out and exotic homemade weapons fashioned by street gangs. There's also a display of old police uniforms, posters, and paraphernalia from the turn of the century.

PENNSYLVANIA

Phillips Mushroom Place

909 East Baltimore Pike
Route 1
Kennet Square, Pennsylvania
19348
(215) 388-6082
Open: daily, 10:00 A.M. to
6:00 P.M.
Admission: $1.25 for adults, $.75
for seniors, free for students
Wheelchair accessible

It is said that more mushrooms are grown in the area around Kennet Square, Pennsylvania, than anywhere else in the world, which is why this small berg, just north of Wilmington, Delaware, has proclaimed itself The Mushroom Capital of the World. If you're in the dark about cultivation and marketing of the mystical fungus and want to learn their history, stop by Phillips Mushroom Place and Museum for a brief tour; a three-foot-high plaster mushroom marks the entrance.

While there are 38,000 varieties of mushrooms, only one, *Agaricus-Bisporus*, is grown commercially, although recently the Japanese *Shitake* is finding a market. According to the American Mushroom Institute, located nearby, the plant's popularity is mushrooming; America's consumption of mushrooms has more than doubled in the past decade. This success is due to good mushroom public relations and modern growing techniques that make year-round cultivation and harvesting possible.

The mushroom's illustrious history began in ancient Egypt, where only pharaohs were permitted to eat the sacred sprout; hieroglyphics reveal that the mushroom was believed to impart immortality and ancient Greek and Roman civilizations called it "the food of the Gods." The word mushroom comes from the French *mousseron*, meaning "moss," which is presumably where most wild mushrooms were found, and it was the French who began commercial cultivation in the 18th century.

Today, cultivation begins in the laboratory, where tiny spores, or seeds, are attached to cereal grains. The grains, or "spawn," are sown into sterilized organic compost in large windowless houses or underground caverns. After a month, the first mushrooms are ready for harvest. At the museum, exhibits, dioramas, films, and slide presentations describe the cultivation process and show mushrooms in various stages of growth. Since they grow in total darkness, pickers wear lighted helmets. An old-fashioned helmet with a kerosene lamp is displayed.

American mushroom growing began in Kennett Square around the turn of the century, and in the 1930s, William Phillips cooled his growing houses with ice for year-round cultivation. His sons, Marshall and Donald, carry on the tradition, turning out 2 1/2 million pounds of mushrooms a year. The Phillips brothers opened the mushroom museum in 1972, which is attached to the Cap and Stem Gift Shop, selling fresh and pickled mushrooms, mushroom prints, jewelry, ceramics, notepads, mobiles, placemats, and even mushroom bread.

Fin, Fur and Feather Wildlife Museum and The National Taxidermy Association Hall of Fame

I f you don't mind staring down a grizzly or a two-ton walrus, you'll appreciate this museum dedicated to our hunting heritage. Located in the game-rich forest country on the Clinton-Lycoming county border in central Pennsylvania, the Fin, Fur and Feather Wildlife Museum and National Taxidermy Association Hall of Fame is a veritable who's who in big game.

Carole and Paul Asper, avid hunters and conservationists, created the museum out of a warehouse behind Asper's sporting goods emporium in 1978. The couple displayed trophies they had gathered locally and from wild places around the world. The National Taxidermy Association joined them to establish a hall of fame.

Taxidermy, a century-old artform developed in the United States, combines the talents of woodsman, artist, sculptor, and anatomist. On view in a room devoted to the association is the work of the country's best known taxidermists, including Carl Akeley, Louis Paul Jonas, and even Theodore Roosevelt.

With the help of trained guides, more than 15,000 visitors a year learn about hundreds of mounted specimens, ranging from ducks and Dall sheep to beavers and bull elephants. Most of the mounts along the wood-paneled walls are from Paul and Carole's hunts; of the 27 species of North American big game recognized by Boone and Crockett, the official scorers of trophies, Paul has collected 26. His most treasured prize is a Marco Polo sheep, with elegantly coiled horns, that he bagged in Afghanistan on an expedition in 1978.

Photographs and memorabilia from various hunts are displayed in glass cases in front of the animals that were stalked and brought down. Life-size mounts stand in authentic positions on

HCR 75, Box 59
Lock Haven, Pennsylvania 17745
(717) 769-6620
Open: daily, April 15 to December 24, 9:00 A.M. to 5:00 P.M.; December 26 to April 14, Friday, Saturday, Sunday, 9:00 A.M. to 5:00 P.M.
Admission: $4 for adults, $2 for children under 12
Wheelchair accessible

small platforms that suggest the animal's natural habitat; a moose stops to sniff the air; a gazelle bounds across a plain; a mountain goat scales a rocky ridge.

The Aspers' share a concern for the world's wildlife and the rapidly diminishing environment necessary to support it. While the antihunting movement may be displeased with the museum, Asper promotes hunting as a valid and beneficial sport, believing that hunters, fishermen, and trappers are the only consistent supporters of wildlife programs. "It may seem like a contradiction to nonhunters, but the man who cares most about deer is the skillful deer hunter," he maintains. The adjacent Fin, Fur and Feather Trading Post carries everything for the outdoorsman from books, clothing, and camping supplies to guns and ammunition.

The Mummers' Museum

Two Street and Washington Avenue
Philadelphia, Pennsylvania 19147
(215) 336-3050
Open: Tuesday through Saturday,
9:30 A.M. to 5:00 P.M.; Sundays,
12:00 noon to 5:00 P.M.
Admission: $1.50 for adults, $.75
for seniors and children
under 12

If you've wondered how the tradition of parading in outrageous outfits and dancing outdoors to string bands on one of the coldest days of the year began, drop by the Mummers' Museum in Philadelphia for the scoop.

All over the world, New Year's Day is celebrated in myriad colorful and extravagant ways, but nothing rivals Philadelphia's annual Mummers Day Parade down Broad Street, where a prancing melting pot of heritages—Northern European, British, and black American—strut their stuff. Interwoven in the celebration are the Finnish and Swedish rituals of shooting guns and visiting neighbors on New Year's Day, British and Welsh costumed Christmas Mumming Plays, and the German penchant for disguising themselves as clowns and raucously riding down country roads. Into this cacophony came Southern blacks, who contributed the famous Mummers' Strut and some of the stock comic characters, such as the wench and the dude.

The first Mummers' clubs appeared in Philadelphia in the mid-19th century, each representing different ethnic groups, and each New Year's Day they tried to outdo each other with elaborate costumes, floats, and string bands. Many celebrations were held around the city until the turn of the century, when theatrical producer and publicity agent H. Bart McHugh proposed a city-sponsored New Year's Day Parade with prizes for the best costumes and string bands.

The time honored event is fully captured at the Mummers' Museum, whose colorfully tiled exterior might be mistaken for a parade float. The tour starts on the top floor with the sounds and sights of parading Mummers. Giant photo murals in the exhibit room create the illusion of walking down Broad Street and you can imagine yourself strolling along among dozens of costumed mannequins that revolve on small platforms. Origins of Mummery features old-time movies of vintage parades and you can pick up a telephone receiver to hear senior Mummers reminiscing about past events. Picture yourself in full Mummer regalia by putting your head in a porthole; better bring your camera for this one.

The Hall of Music presents the instruments and lively tunes of the traditional Mummers' string bands. Special honor is paid to the parade's theme song, "Oh Dem Golden Slippers," written by James Bland in 1879. Visitors also learn how to strut properly, study the parade route on a map, see how it's changed over the years, and learn how the judges make their selections. The main lobby exhibits the winning New Year's suits from the most recent Mummers Parade, augmented by large colorful photographs of the parade.

Streitwieser Trumpet Museum

Fairway Farm
Vaughan Road
Pottstown, Pennsylvania 19464
(215) 327-1351
Open: by appointment only
Admission: $2.50 suggested donation
Wheelchair accessible

Franz Streitwieser has good reason to blow his own horn. He is not only an accomplished professional trumpeter and brass instrument instructor, he is the proud founder of the Trumpet Museum, which he opened in 1980. Located in a renovated 19th century barn on 17 rolling acres just outside Pottstown, Pennsylvania, the museum boasts a collection of more than 300 trumpets and a hundred other brass instruments of every size and shape as well as various drums, which line the rustic walls in handsome wooden showcases.

Streitwieser, a transplanted Austrian who has played in concert halls throughout Europe, is determined to change the status of brass wind instruments. "When somebody finds an old violin in the attic, they think it's valuable," he notes, "but when somebody finds an old brass instrument, they just throw it out." Yet his favorite instrument has a distinguished past. Historically trumpets were used to ward off evil spirits in Tibet nearly 2,000

Franz Streitwieser, founder of the Streitwieser Trumpet Museum, holding his own invention, the clarin horn.

Courtesy of Streitwieser Trumpet Museum

years ago and to herald royalty during medieval times. They were also used in war, hunting, and religion. They added a spirited upper register to the jazz bands of this century. On view are the larger trumpets and trombones made famous by bandleader John Philip Sousa during the American brass marching band era at the turn of the century.

Franz proudly displays special horns used by soldiers in the Civil War, 18th century German steer horns, and copies of long-curved bronze trumpets used by the Vikings. None of the horns are labeled, but Streitwieser provides an enthusiastic commentary, often demonstrating the tone of a horn as he conducts a tour. One of his favorites is a gold-plated tenor horn made in 1880 that was used in a Russian czar's chamber orchestra.

Franz acquired his collection from antique stores and private sources throughout the world, and he and his wife, Katherine, a member of the Du Pont family, make annual trips

Franz toots on a Scandinavian Luur Viking horn, one of the many unique horns on display.

Courtesy of Streitwieser Trumpet Museum

The stage of the Streitwieser Trumpet Museum, where many recitals are held, using rare instruments.

Courtesy of Streitwieser Trumpet Museum

to Europe in search of new finds. Also on view is sheet music, prints, recordings, and books. The Streitwiesers sponsor eight chamber concerts a year, and antique instruments in the collection are often used. At these concerts, Franz often shows off his own musical invention, a clarin horn, which enables a musician to easily play the higher notes of Baroque music.

The Little League Baseball Museum

Little League Complex
U.S. Route 15
P.O. Box 3485
Williamsport, Pennsylvania 17701
(717) 326-3607
Open: daily, Memorial Day through Labor Day, 10:00 A.M. to 8:00 P.M.; remainder of year, Monday through Saturday, 10:00 A.M. to 5:00 P.M.; Sundays, 1:00 P.M. to 5:00 P.M.
Admission: $3 for adults, $1.50 for seniors, $1 for children ages five to 13
Wheelchair accessible

Little League baseball has reached major league proportions. There are 7,000 leagues worldwide, with more than 2.5 million players participating. Every August the Little League World Series pits the best teams from the United States, Canada, Latin America, Europe, and the Far East against each other in a tournament that culminates in a nationally televised championship game. The 42-acre World Series Complex in Williamsport, Pennsylvania, consists of a 10,000-seat stadium, practice diamonds, an Olympic-size swimming pool, living quarters for visiting teams, and a newly constructed Little League Baseball Museum.

Since the game was invented in the mid-1800s, boys have played baseball, but organized Little Leagues, using good equipment and playing on a standardized field, began in Williamsport in 1939. Three local men, Carl Stotz and George and Bert Bebble, formed a three-team league and their idea quickly caught on; the first Little League World Series was held in 1947.

Located in a brick building overlooking the stadium, the museum presents the entire Little League story through a variety of hands-on exhibits and films. The lobby is a large astroturfed hall with a small baseball diamond and a giant color mural of Lamade Stadium packed with cheering fans that was taken during the 1982 World Series. Visitors can be photographed with bat and ball against the backdrop to capture the image of playing in a world series for fans back home. Flags of the 27 countries that play Little League baseball hang from the ceiling and a scoreboard shows the score and statistics of the previous year's championship game.

In the museum's 100-seat Diamond Theater, *Summer Fever*, a documentary narrated by Dick Van Dyke projects the excitement of the sport. The Play It Safe Room emphasizes safety

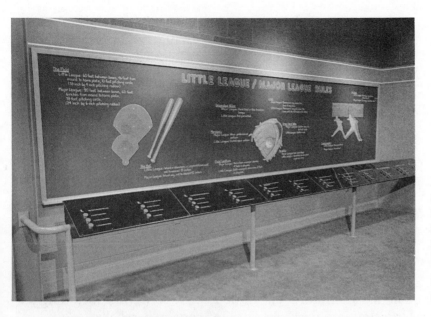

One of the computerized displays at the Little League Hall of Fame is this quiz board featuring multiple-choice questions about Little League and Major League rules.

Courtesy of The Little League Hall of Fame

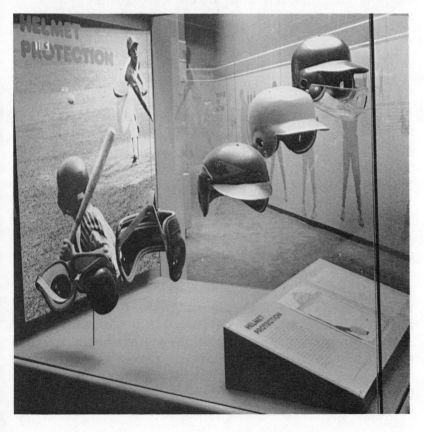

Another display case shows the evolution of the Little League batting helmet.

Courtesy of The Little League Hall of Fame

and traces the evolution of protective equipment; e.g., there is a display of batting helmets from 1939 to the present. Various self-activated displays in the Basics Room show how bats, balls, and gloves are manufactured; one multiple-choice console tests visitors' knowledge of Little League rules and regulations.

The World Series Room showcases the history of the international tournament, and a video monitor screens highlights of past games. The most popular exhibit is the Play Ball Room on the lower level, where a series of batting and pitching cages offer 90 seconds of hitting and pitching practice, and a video camera provides an "instant replay."

The Little League organization estimates that three-quarters of all major league players once played Little League. As a case in point, you can see a Little League trophy won by New York Mets star Keith Hernandez and a Little League hat worn by Mike Schmidt, the Philadelphia Phillies' slugging ace. The museum store sells Little League souvenirs, including jewelry, clothing, desk sets, and, of course, baseballs.

The Bob Hoffman Weightlifting Hall of Fame

Board Road
P.O. Box 1707
York, Pennsylvania 17405
(717) 767-6481
Open: Monday through Saturday, 10:00 A.M. to 4:00 P.M.; closed holidays
Admission: free
Wheelchair accessible

Are your biceps lacking? Do your pectorals need pumping up? A trip to the Bob Hoffman Weightlifting Hall of Fame should be inspirational. Here are displays on the history of the Iron Game and the mighty men who pumped their way to glory in the Olympics. Sponsored by the York Barbell Company of York, Pennsylvania, sometimes referred to as Muscletown since the first national powerlifting competitions were held there in 1964, the Weightlifting Hall of Fame offers a colorful look at all aspects of bodybuilding and human strength.

As you enter the unique Y-shaped building ("Y" for York), the spacious lobby features a huge medallion emblazoned with the museum's name and colorful international pennants, as well as a large oil painting of sports entrepreneur Bob Hoffman, known as the Father of Weightlifting, who founded the York Barbell Company in 1932. Over the years, his company has expanded to sell everything from fitness equipment and vitamins to high-protein foods and clothing.

Passing life-size photographs of such athletic stars as basketball player Julius "Dr. J" Erving and golfer Nancy Lopez, visitors are ushered into the exhibit areas, which include an

The grand entrance to the Y-shaped Bob Hoffman Weightlifting Hall of Fame.

Commercial/Industrial Photographers

Olympic Weightlifting display with medals, trophies, photographs, and information about star performers from international competitions since 1923. The Golden Age area contains renderings of great strongmen of the past century accompanied by many of the weights and exercise devices they used. The birth of bodybuilding is recounted, beginning with the exploits of legendary Eugen Sandow. The fine points of physique competition and posing are explained in an exhibit featuring photographs of winners of the prestigious Mr. America bodybuilder award, along with a tribute to the women who have made a lasting impression on the sport.

Bob Hoffman, a former weightlifting champion, has inspired and trained weightlifters for international competition for more than 50 years. You can see a pictoral retrospective, *The Bob Hoffman Story*, and a full-size bronze statue of a muscular Bob Hoffman atop a pedestal near his collection.

If you're determined to build up your physique, stop by the equipment display room, which features York's line of fitness and exercise equipment. High-protein snacks at the canteen will give you that extra oomph to move onto the Bob Hoffman Softball Hall of Fame area of the building, which celebrates the history of America's popular summertime sport.

CANDY AMERICANA MUSEUM

46 N. Broad Street
Lititz, Pennsylvania 17543
(717) 626-1131

At the headquarters of the Wilbur Chocolate Company, deep in the heart of Amish Country, find the old-time equipment and artifacts of the candy industry from the "sweet old days." View antique chocolate pots, candy molds, and cooking utensils, and finish your visit at Wilbur's Chocolate Factory Candy Outlet.

MARTIN GUITAR MUSEUM

The Martin Guitar Company
510 Sycamore Street
Nazareth, Pennsylvania 18064
(215) 759-2837

The Martin Guitar Company has been building high quality guitars and other stringed instruments since the late 1880s, living up to its motto Not Many but Much. Strum a recently made Martin or view classic Martin zithers, mandolins, banjos, and harps.

TOY TRAIN MUSEUM

Paradise Lane
Box 248
Strasburg, Pennsylvania 17579
(717) 687-8976

All aboard for the Train Collector's Association's assemblage of toy trains located in a building that looks like a toy train depot. See three operating layouts in standard, O, and S gauge, as well as classic trains from the early 20th century. A short film, *Joe McDoakes, So You Want a Model Railroad*, made in the 1950s, captures the sentiment of toy train collecting.

RHODE ISLAND

International Tennis Hall of Fame and Tennis Museum

S ince tennis is called the Sport of Kings, and the International Tennis Hall of Fame and Tennis Museum, ensconced at stately Newport Casino in Newport, Rhode Island, has fittingly enshrined King Gustav V of Sweden, among many other elite players, such as Don Budge, Helen Wills Moody, Bill Tilden, and Althea Gibson. Established in 1954, the museum presents the story of tennis' phenomenal growth during the past century into a sport played by an estimated 65 million enthusiasts worldwide.

While there is evidence of games involving a racket and a ball in ancient Arab, Greek and Roman cultures, the modern game of tennis evolved from indoor court tennis, popular among French clerics and royalty 800 years ago. The invention of the rubber ball lead to lawn tennis, which was patented in England in 1874 and imported to the United States soon after by trend-conscious Americans. The early tennis greats—Richard Sears, William Larned, Suzanne Lenglen, who are honored in photo displays—played for glory and trophies, since no prize money was offered until 1968.

Built in 1880, Newport Casino was one of the grandest clubs of the exclusive summer enclave of high society's "400." Designed by architect Stanford White, it is a sprawling Colonial brick and shingled structure with handsome gables and latticed porches. Newport Casino served as the American counterpart to Wimbledon, hosting the first U.S. Tennis Championships in 1881; Newport remained the home of the Nationals until 1915, when overcrowding forced a move to Forest Hills, New York. In addition to a thriving casino, it sported a dozen lawn tennis courts, an indoor court tennis room, and a 450-seat Victorian theater, all of which have been meticulously restored to their original splendor. The casino rooms now house the museum's extensive collection of tennis memorabilia and minutiae.

A display of tennis racquets includes one used by Richard Sears, who won the first seven National Championships at Newport (1881-1887), and a much-battered Wilson 2000 that Jimmy Conners used to win the U.S. Open in 1983. Of note in the trophy collection is the Sears Bowl, a sterling silver punch bowl

The Newport Casino
194 Bellevue Avenue
Newport, Rhode Island 02840
(401) 849-3990
Open: daily, May through October, 10:00 A.M. to 5:00 P.M.; November through April, 11:00 A.M. to 4:00 P.M.
Admission: $4 for adults, $2.50 for seniors, $2 for children under 16

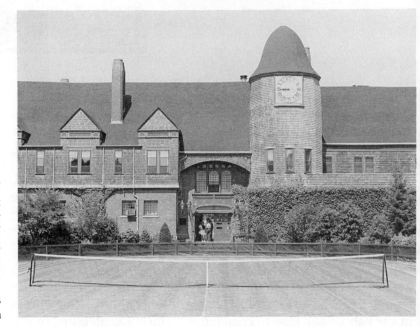

The International Tennis Hall of Fame, located in the historic Newport Casino, designed by Stanford White, was the site of the first U.S. Open Tennis Championships from 1881 through 1915.

Michael Baz, International Tennis Hall of Fame and Tennis Museum

that was the first Nationals tennis trophy. Mannequins show 100 years of ladies' tennis fashions, from cumbersome Victorian-era floor-length dresses to a petite outfit once worn in competition by Billie Jean King. The Davis Cup Room contains photographs of the great international players who've won the prized cup. Each inductee in the Tennis Hall of Fame is honored with a small plaque, incorporating a photograph and a biography. The Film Room shows tennis movies and slides of great matches over the years.

VERMONT

THE AMERICAN MUSEUM OF FLY FISHING

Box 42
Manchester, Vermont 05254
(802) 362-3300

Ardent anglers will enjoy this tribute to the art of fly fishing. View more than 1,000 antique rods; 400 reels, some dating back as far as 1826; and thousands of hand-tied flies, including masterpieces of such expert flytiers as Ray Bergman, Joe Brooks, and Mary Marbury. See fly-fishing tackle used by such famous Americans as Ernest Hemingway, Presidents Dwight Eisenhower and Herbert Hoover, Daniel Webster, and Bing Crosby. The Rod Shop shows late 19th century rod-making equipment from a shop in Maine.

MAPLE MUSEUM

Routes 14 and 107
Royalton, Vermont 05068
(802) 763-8809

Stop by this delicious museum in the springtime and you'll find a sticky situation as sap, gathered from maple trees all over the state, is boiled down to make premium maple syrup and maple candy. Exhibits explain the age-old process of syrup making and displays feature antique utensils and equipment.

THE FAIRBANKS MUSEUM AND PLANETARIUM

Main and Prospect Streets
St. Johnsbury, Vermont 05819
(802) 748-2372

This Victorian-era natural history museum presents unique artifacts of nature and man. Imagine a series of portraits of the American flag, Abraham Lincoln, and George Washington made entirely of insects glued to canvas.

THE
SOUTH

William Christopher Handy, descendant of a line of Methodist ministers, grew up in Florence, Alabama, in the 1870s singing and playing sacred music in his father's church. In spite of Reverend Handy's disapproval, his son was more interested in the black folk music of the South, especially the haunting melodies of longing and mourning, known as the "blues."

Handy left home and began teaching music and playing trumpet in small ragtime bands from Chicago to Memphis. Times were hard, and for inspiration, he turned to the music of his youth, adapting it into the popular song style of the day. His tunes were different enough to attract a large audience, and Handy turned out a string of hits—"Memphis Blues," "St. Louis Blues," and "Beale Street Blues," among them—that brought the blues into mainstream music and earned him the moniker Father of the Blues.

In 1971, the citizens of Florence restored the humble log cabin where Handy was born, and the Handy family donated many of his personal belongings to create the W.C. Handy Home and Museum. Here you can see his upright piano, his golden trumpet, and the original scores of "St. Louis Blues" and other songs, with Handy's pencil marks in the margins. Photographs on view highlight his successes—playing at Carnegie Hall, conducting the World's Fair Orchestra in 1940—and show him with celebrities in posh New York nightclubs.

Handy was ill in his later years; he was blind and then had a stroke. His Braille library, including a Braille bible, can be viewed. He established the W.C. Handy Foundation for the Blind to aid students, and citations and awards grace the walls, including a blow-up of the Handy Commemorative Stamp issued by the U.S. Post Office. Great recordings of his songs by

W.C. Handy Home and Museum

620 West College Street
Florence, Alabama 35630
(205) 766-7410
Open: Tuesday through Saturday, 9:00 A.M. to 12:00 noon, 1:00 P.M. to 4:00 P.M.
Admission: $1 for adults, $.25 for students
Wheelchair accessible

such stars as Tommy Dorsey, Louis Armstrong, and Fletcher Henderson are part of the music collection.

According to Handy, who died in 1958 at the age of 84, the blues is a musical form, consisting of a unique pattern of "blue harmonies" and three-line verses, in which the first two lines are the same and the third is the "pay off." His style of the blues inspired such composers as George Gershwin (whose "Rhapsody in Blue" used characteristics of the blues), Eubie Blake, and Cole Porter, to mention just a few, and of course its influence is still felt in rock music, which evolved out of rhythm and blues in the 1950s.

The Women's Army Corp Museum

P.O. Box 5339
Fort McClellan, Alabama 36205
(205) 238-3512
Open: Monday through Friday,
8:00 A.M. to 4:00 P.M.; closed
holidays
Admission: free
Wheelchair accessible

The former training center for the Women's Army Corps at Fort McClellan, near Anniston, Alabama, is not the place you would expect to find a Lillian Russell parasol, a woman's one-piece bathing suit made from a mattress cover, or a U.S. flag made from 2,400 canceled postage stamps. But enter the WAC Museum, just inside Galloway Gate, and you'll find these items and much more.

The WAC Museum was first established in 1955, but the present bunkerlike building, with a proud gold and green WAC flag fluttering out front, was constructed in 1977 with funds raised by the WAC Foundation. On the lawn behind the museum is a pool and full-size statue of the Greek goddess Minerva, whose helmeted head appears in profile on the special WAC insignia. Some still call it the Edith Nourse Rogers Museum, its original name, in honor of the congresswoman from Massachusetts who introduced the bill that established the WACs in 1942.

Part public relations tool and part recruiter's aid, the museum presents the gallant history of the corps; films and audiovisual displays show the training required and occupations available to women who serve in today's Army. To bring the

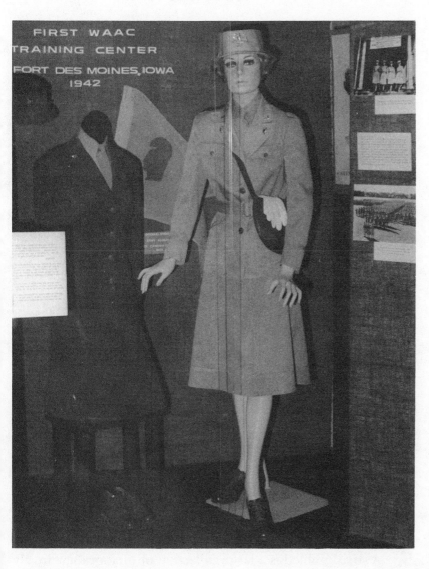

An early WAC uniform with photographs of the first WACs in training at Fort Des Moines in Iowa.

U.S. Army photograph

message home, videotapes reveal former WACs discussing their service life. Here's a chance to glimpse life in the barracks during basic training. One exhibit reviews the changes that occurred in the late 1970s, when the WACs merged with the Army, women first entered the United States Military Academy at West Point, and the number of enlisted women on active duty grew from 10,000 to more than 70,000.

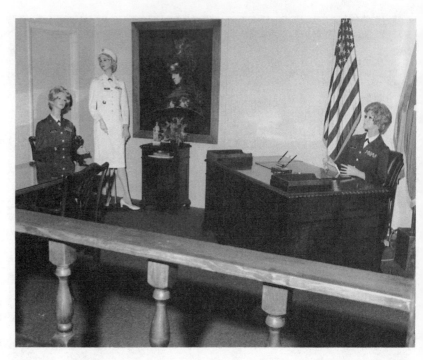

A tableau displaying WACs in uniform

U.S. Army photograph

Neatly attired mannequins in functional settings demonstrate the sartorial evolution of WAC uniforms, from World War II "Ike" jackets and pink skirts to present-day pants suits. Tropical, off-duty, and dress uniforms are also displayed. You can "Try on a Hat for History" at a special mirrored display of different WAC hats.

Also assembled is a large collection of memorabilia involving World War II and the Korean and Vietnam War; flags from WAC posts all over the world are exhibited. Other exhibits are composed of personal items donated by veteran WACs, mementos from the 14th Army WAC Band, and service medals and decorations that have been awarded to WACs.

Every few years, the WAC Foundation sponsors a WAC Museum reunion in May, featuring a parade, dinner party, tour of the museum, bus tour of Fort McClellan, and other events that are open to non-WACs who have supported the foundation.

Alabama Space and Rocket Center

6 ...5...4...3...2...1... Lift off. If you've dreamed of venturing into space, then chart a course to the Alabama Space and Rocket Center in Huntsville, Alabama. In 1970, Wernher von Braun, the German rocket pioneer who contributed so much to the American space program, helped to create this NASA and state-funded museum, which chronicles the glorious history of space exploration.

More than merely a collection of NASA hardware, this is an interactive, exciting museum that attracts 700,000 visitors annually. On the 50-acre complex, there are more than 60 hands-on exhibits that convey the experience of space travel. Feel the sensation of weightlessness, guide a spacecraft by computer, and fire a real rocket engine. Climb aboard the 30-seat Space Shuttle simulator for a make-believe flight, complete with vibrating takeoff, and dock with an orbiting space center. Up to 46 passengers can ride the *Spaceship Lunar Odyssey*, a simulated lift-off and flight to the moon and back, experiencing the feeling of centrifugal force on takeoff and fantastic scenery in the overhead space dome. Films on space technology and travel are shown hourly in the Spacedome Theater.

Prominently displayed are artifacts that have been to space and back, including the rust-covered *Apollo 16* that took three

Tranquility Base
Huntsville, Alabama 35807
(800) 572-7234 (in Alabama)
(800) 633-7280 (outside Alabama)
Open: June through August, daily, 8:00 A.M. to 7:00 P.M.; September through May, daily, 9:00 A.M. to 5:00 P.M.; closed Christmas Day
Admission: $4 for adults, $2.25 for children ages three to 12, seniors, and military employees, free for children under three
Wheelchair accessible

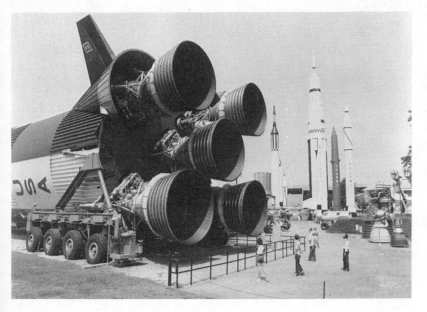

The *Saturn V* rocket, developed and tested in Huntsville for the Apollo missions to the moon, dwarfs visitors at the Alabama Space and Rocket Center. The Rocket City, as its inhabitants call it, continues to be the propulsion center for NASA and the Army's missile command.

Courtesy of Alabama Space and Rocket Center

A young visitor tries on a space suit in front of the Lunar Lander.

Courtesy of Alabama Space and Rocket Center

astronauts to the moon in 1972, and a section of Skylab, NASA's first space station that crashed back to earth in 1979. Even Miss Baker, a squirrel monkey that in 1958 was NASA's first space traveler, makes her home here.

Outside the complex, wooded Rocket Park showcases a collection of rockets; the mammoth *Saturn V* moonshot rocket, lying on its side like a huge beached whale, is longer than a football field. Buckle yourself into the seesawlike Zero Gravity

Machine for a brief space walk; counterbalanced by weights, you can push off and drift through the air like an astronaut floating outside the shuttle.

Take a 90-minute tour of NASA's Marshall Space Flight Center, where the actual Space Shuttle program and development of the U.S. Space Station progress. You can sign up for Space Camp, a weeklong program that caters to the fantasies of would-be astronauts. Campers learn the principles of rocketry and train on sophisticated space simulation equipment.

The Governor Lurleen B. Wallace Memorial Museum

725 Monroe Street
Montgomery, Alabama 36130
(205) 261-3183
Open: Monday through Friday, 8:00 A.M. to 5:00 P.M.; weekends and holidays, 9:00 A.M. to 5:00 P.M.
Admission: free
Wheelchair accessible

Born Lurleen Burns in Tuscaloosa County in 1926, she was married to George Wallace at 16, a mother at 18, first lady of Alabama at 36, and governor of Alabama at 40. Although she served less than two years as governor before she died at the age of 41, Lurleen B. Wallace deeply captured the hearts of her constituency. As a result, the Governor Lurleen B. Wallace Memorial Museum was opened in downtown Montgomery, not far from the state capitol.

Located on the main floor of a historic Old South residence, the Rice-Semple-Haardt House, the memorial presents the highlights of Mrs. Wallace's eventful life. Glass trophy cases are filled with photographs showing her performing duties as titular head of Alabama and with her husband, George. Here, too, are her college diplomas, graduation cap and gown, and a mannequin resembling young Lurleen dressed in a school uniform. Visitors can also see the small study desk she used as a child.

Another room displays the cushioned executive chair she sat in at her Capitol office, which was specially designed for the diminutive governor, along with the flags that flanked it. See also the bust she kept of Queen Nefertiti, the Egyptian ruler who was a source of inspiration for Lurleen. Many of her needlepoint and knitting creations are also on display, such as detailed needlepoint-covered dining chairs and an elaborate tablecloth and napkin set.

As the second woman ever to be elected governor in United States history, Mrs. Wallace's inauguration garnered national coverage, as demonstrated by the many newspaper and maga-

Among the artifacts at The Governor Lurleen B. Wallace Memorial Museum are her college diplomas, graduation cap and gown, and a lookalike mannequin garbed in young Lurleen's school uniform.

Courtesy of The Governor Lurleen B. Wallace Memorial Museum

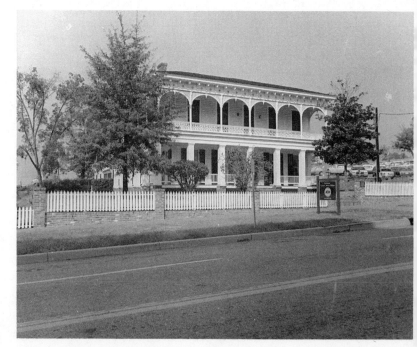

The historic Rice-Semple-Haardt House is the site of The Governor Lurleen B. Wallace Memorial Museum.

Courtesy of The Governor Lurleen B. Wallace Memorial Museum

zine articles on display. See the modest black dress and pillbox that she wore at the inaugural parade and the evening gown designed for the inaugural ball, which she canceled as a way of registering concern for American servicemen fighting in Vietnam.

Mrs. Wallace loved the outdoors and often went on hunting or fishing trips at the crack of dawn after a long night of official banqueting. A photograph of her dressed in hunting garb, with a rifle in one hand and a 15-pound turkey she bagged in the other, shows her zestful spirit.

ALABAMA SPORTS HALL OF FAME AND MUSEUM

Civic Center Plaza
Birmingham, Alabama 35202
(205) 323-6665

Exhibits and memorabilia focus on Alabama's best known native sons in the sports world, including Joe Louis, Paul "Bear" Bryant, Willie Mays, Jesse Owens, and Hank Aaron.

MILITARY POLICE CORPS MUSEUM

Fort McClellan
Alabama 36205
(205) 238-3522

Uniforms, documents, and memorabilia of U.S. Military Police at home and abroad. See a press used to counterfeit money.

U.S. ARMY AVIATION MUSEUM

Building 6007
Fort Rucker, Alabama 36362
(205) 255-4584

Aircraft is displayed in hangars and on airfields, tracing the history of army flight from Piper Cub planes used for surveillance in 1942 to the imposing helicopter gunships used in the 1960s and 1970s in Vietnam. See also experimental helicopters, a Hall of Fame and memorial dedicated to the 1,400 Army aviation men who lost their lives in Southeast Asia, and President Dwight Eisenhower's *Army One* helicopter.

INTERNATIONAL MOTOR SPORTS HALL OF FAME

Speedway Boulevard
Talladega, Alabama 35160
(205) 362-2261

Located next to the Alabama International Motor Speedway, this museum houses pace cars, drag racers, motorcycles, and all sorts of racing automobiles, including Malcolm Campbell's world record-setting *Bluebird* and "Big Daddy" Don Garlits' world champion dragster.

ARKANSAS

Patent Model Museum

400 North 8th Street
Fort Smith, Arkansas 72901
(501) 782-9014
Open: Monday through Friday,
9:00 A.M. to 4:30 P.M.; weekends
by appointment
Admission: free

I nventor Joel See's washing and wringing machine shows how women got out "ring around the collar" back in 1863. There are many one-of-a-kind oddities to be found at the Patent Model Museum in Fort Smith, Arkansas. Inventions such as a transparent window shade, conceived by E.R. Kernan in 1856 and a unique round refrigerator, designed by H.B. Wallbridge, circa 1876, intrigued museum founder and Arkansas state Representative Carolyn Pollan.

Mrs. Pollan became interested when she spotted an advertisement for a patent model auction in *Smithsonian* magazine in 1970. Collector O. Gilbert Rundell of Peekskill, New York, was unloading part of his large collection. She went to New York and purchased 82 models, including rotary steam engines, paddles for boats, brick fireplaces, and even artificial legs.

A combination ironing table and clothes rack (circa 1874), invented by W.C. Arnold, on display at the Patent Model Museum.

Larry Obsitnik, Patent Model Museum

86

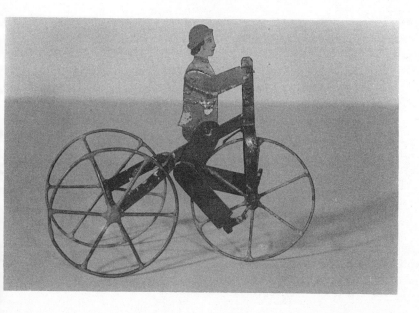

This is not a model but an actual toy that was registered with the patent office in 1869.

Courtesy of Patent Model Museum

Most of the models have movable parts, including an eight-by-eight-inch printing press, crafted in 1873, that prints when equipped with ink and miniature paper. Many of the inventions, such as cattle chutes, egg incubators, and grain scales, made their way into everyday life; a spring roller shade, patented in 1880, is still is use today.

The museum is ensconced in two rooms of the Rogers-Tilles House, one of the oldest houses in Fort Smith's historic Belle Grove district. Built in 1840 by Captain John Rogers, the city's founder, it had fallen into disrepair when Mrs. Pollan bought it in 1973. After three years of painstaking work, she opened the historic house and museum to the public as her Bicentennial gift to the city.

The models, tagged with inventor's name and patent number are displayed in handsome lighted curio cabinets that reflect the Victorian feel of the restored house. On the walls hang 17 framed prints of early patent models that were destroyed in the Patent Office fire of 1836. She has a few models that escaped the flames, including a brick-making machine and a cast iron stove. In 1876, J. Foster invented a floating bed with attached oars that he, no doubt, hoped would become standard on all oceangoing vessels. Although it didn't, visitors to the Patent Model Museum certainly have enjoyed it.

MILES MUSICAL MUSEUM

P.O. Box 488
Eureka Springs, Arkansas 72632
(501) 253-8961

This spacious museum is home to one of the most comprehensive and unusual musical instruments in the world. You'll see and hear the Hurdy Gurdy and Tournaphone and view a room full of antique organs and player pianos. Floyd and Martha Miles began collecting instruments in 1955 and have since been joined by their daughters, Joan and Marlene. It's not just exotic instruments on display, however; don't miss the clocks and fluorescent rocks.

THE MUSEUM OF AUTOMOBILES

Route 3
Petit Jean Mountain
Morrilton, Arkansas 72110
(501) 727-5427

Founded by the late Arkansas Governor Winthrop Rockefeller, this sleek museum displays many of his classic cars and motorcycles, including a 1913 Metz Roadster, a 1914 Model T Ford Speedster, and a 1929 Rolls Royce.

FLORIDA

International Swimming Hall of Fame

One Hall of Fame Drive
Fort Lauderdale, Florida 33316
(305) 462-6536
Open: Monday through Saturday, 10:00 A.M. to 5:00 P.M.; Sunday, 11:00 A.M. to 4:00 P.M.
Pool hours: summer, 10:00 A.M. to 4:00 P.M.; winter, 11:00 A.M. to 4:00 P.M.
Admission: $1.25 for adults, $1 for students, $3 for families
Wheelchair accessible

Did you know that Julius Caesar, Lord Byron, and Winston Churchill loved to swim, or that Ben Franklin practiced synchronized swimming? These and other little-known facts await visitors to the International Swimming Hall of Fame in Fort Lauderdale, Florida. The museum actually begins in the parking lot, where spaces are named after swim stars Johnny Weissmuller, Buster Crabbe, and Art Linkletter. At the main entrance, greeted by a huge mounted marlin and lifelike wax statues of swimming greats Johnny Weissmuller and Duke Kahanamoku, visitors plunge into the world of water.

Founded in 1965, the Swimming Hall of Fame exists due to the efforts of former swim coach William "Buck" Dawson, an energetic and imaginative promoter with an infectious smile and a buccaneer's eyepatch, who served as its executive director until his retirement in 1985. Buck's imprint is felt throughout the collection. Over the years, he installed swimming trivia and memorabilia, collected from around the world, in every nook

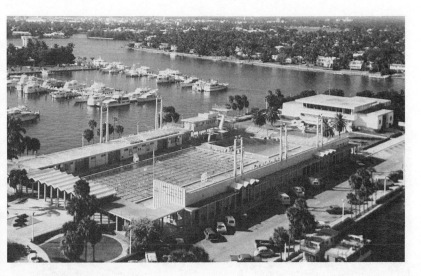

The International Swimming Hall of Fame overlooks an Olympic-size pool and diving complex, which hosts many international swimming and diving meets.

Courtesy of International Swimming Hall of Fame

and cranny of the two-story building. The result is a totally uninhibited love of all things aquatic, presented in exhibits, photographs, films, dioramas, and assorted works of art celebrating swimming, diving, water polo, and synchronized swimming.

Everywhere you turn in this crowded museum, the glories of former swim stars are heralded. There is a giant photograph of Gertrude Ederle, the first woman to swim the English Channel, who, by setting a new world record by two hours, proved that men and women are equal in long-distance swimming. The goggles and bathing suit worn by John Erikson on his exhaustive triple crossing of the English Channel (August 11-13, 1981) are also on display.

In an exhibit dedicated to great Olympians see John Weissmuller's gold medal from the 1924 Paris summer games, and a life-size photograph of John Naber, King of the Backstroke, at the 1976 games. Mark Spitz fans will appreciate the wax statue of him in his Olympic uniform and replicas of the seven gold medals he won at the 1972 Munich games. Nearby, the Hail to the Chiefs display presents photographs and medals of famous swimming presidents: Franklin Roosevelt, John Kennedy, Richard Nixon, Gerald Ford (who visited the museum as a guest of Dawson's in 1977), and Ronald Reagan (who enjoys swimming when he's not clearing brush).

The museum's second floor gallery pays tribute to the accomplishments of the hall's 300 honorees, such as Donna

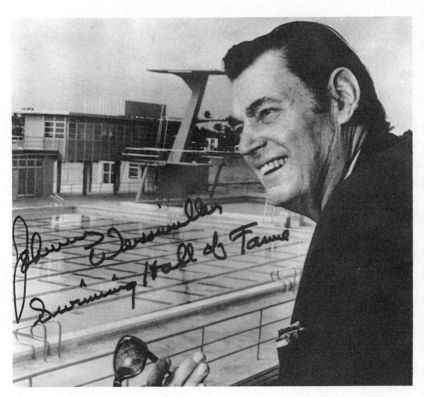

Swimming great Johnny Weissmuller is one of the many outstanding athletes honored at the International Swimming Hall of Fame.

Courtesy of International Swimming Hall of Fame

deVarona, Eleanor Holm, and Don Schollander. Clippings, photographs, good luck charms, and other memorabilia are exhibited on freestanding aquamarine panels. You also may want to wade through the extensive library stocked with books on the world's oldest and most popular sport.

More than just a repository, the hall has a chartered objective—to teach every child in the United States how to swim—and it provides thousands of Kiwanis Key Clubs throughout the country with programs to advance that goal through agencies, schools, and public pools. A main attraction at the hall is the Olympic-size pool and diving complex, open to the public, which has a 4,000-seat stadium, and hosts international swimming and diving meets, water circuses, and water polo tournaments. If you forgot to bring your suit, the Gift and Souvenir Shop sells Swimming Hall of Fame suits, caps, and towels, in addition to books on all phases of water sports. Also available are Swimming Hall of Fame patches, pins, rings, key chains, luggage tags, shoelaces, and bumper stickers that read "Different Strokes for Different Folks" and "Breast Stroking Is Fun."

The Tupperware Museum

Tupperware, that ubiquitous line of plastic food containers and kitchen gadgets marketed through a unique home party system, seems to symbolize the American suburban idealism of the 1950s and 1960s. While as yet there is no museum of plastic wrap or Princess telephones, tribute is paid to Tupperware. Today, 100,000 visitors a year pass through the world headquarters of Tupperware, Inc., in Kissimmee, Florida, a gleaming white modern complex consisting of offices, a convention center, and tourist facilities, which include the Tupperware Museum.

Free tours leave from the sleek lobby every 20 minutes, led by well-groomed guides in mauve uniforms. After passing a wall-long photo montage of the Tupperware design and manufacturing process, visitors enter Tupperware's ideal vision of the house. In the well-appointed kitchen, the freezer, refrigerator, and cupboards are jam-packed with food. In the pursuit of freshness, each morsel is neatly sealed in its own air-tight plastic container. The countertop is ablaze with brightly colored canisters, cookie jars, serving bowls, and a Pick-a-Dell pickle keeper. Why bother to chase a pickle in a round jar? What's more, a guide points out the convenient Ultra 21 line of freezer-to-microwave oven casserole dishes and containers, and explains Tupperware's Custom Kitchen Planning Service, which sends a Tupperware representative to your home to give you storage tips. All this is enough to make even the neatest homemaker swoon!

In addition, potential neatniks can view a multicolored array of plastic plates and bowls in the dining room, and a battery of Tupper toys in the kiddies' room. A campsite scene demonstrates products for nature lovers, including trays, condiment keepers, and a handy Pour N' Store pitcher.

For more inspiration, move on to the Museum of Historic Food Containers, housed in a long gallery. Four large glass exhibition cases contain more than 200 vessels from all over the world, some dating back 6,000 years. A delicate Wedgewood bowl, a rhino horn bowl from Africa, an Egyptian earthenware jar, and ancient Chinese bowls all tell the story of mankind's eternal quest for the perfect food storage container.

The last tantalizing display features a full line of the newest Tupperware products. You'll also receive a free seven-ounce Modular Mate dish for storing leftovers at home. Catalogs are available, but you have to be invited to a party by your local Tupperware dealer if you want to buy.

Tupperware World Headquarters
P.O. Box 2353
Orlando, Florida 32802
(305) 847-3111
Open: Monday through Friday,
9:00 A.M. to 4:00 P.M.
Admission: free
Wheelchair accessible

The Cypress Knee Museum

Highway 27
Palmdale, Florida 33944
(813) 675-2951
Open: daily, 8:00 A.M. to sundown
Admission: $2 for adults, $1 for seniors and children under 12, free for anyone over 80

Driving through swampy Palmdale, Florida, west of Lake Okeechobee, you pass a series of mysterious road signs: "Cypress Knee Museum" . . . "Beauty, Humor, Nature" . . . And if you aren't paying attention, the last sign will wake you up: "Lady, if he won't stop hit him on head with shoe!"

It's well worth a lump on the head to spend a while at Tom Gaskin's Cypress Knee Museum. Gaskin, in his late 70s, proudly explains that the museum is his own creation, established in 1951: "I did it without the help of the NRA, the WPA, the ERA, the Great Society, the New Deal, the Big Deal, the Bad Deal . . . and the damned Highway Department."

It was the Highway Department that laid down Highway 27, cutting a path right through Gaskin's beloved swamp, where he practices his unique and patented artform, creating cypress knee "sculptures." Many cypress trees, which grow slowly and can live for 6,000 years, have short conical shoots, or "knees," growing from the roots that form gnarled shapes resembling faces, animals, or objects.

Gaskins' passion for knees began in 1934, when he accidentally stripped off the bark of one and saw the possibilities. He's been stripping, hollowing, and creating vases, lamps, and "objet de swamp" ever since. The white museum, built around a large Cypress tree, displays the more unusual specimens Gaskins has collected from 23 states over the past 50 years, and a video details how cypress knees grow and his methods of preserving them.

Cypress knee "faces" include Franklin Roosevelt and Adolf Hitler as well as E.T. and Donald Duck, but interpretation is in the eyes of the beholder, for one person's Statue of Liberty can be another's Quasimodo. There's an atomic mushroom cloud, a brain, a bedpan, and a series of pirouetting feet, one of which Gaskins has adorned with a pair of glasses and a cigar. Each piece is titled and reflects Gaskins' colorful imagination: *Frog Diving in the Water with His Hind Legs in the Air*, *Hippopotamus with Carmen Miranda Hat*, and *Flipper*, which does indeed look just like a bottle-nose dolphin in a playful mood.

After the tour, you are invited across the highway to the Factory and Gift Shop, where Gaskins can often be found preparing knees and swapping tales with tourists. The Gift Shop is crammed with cypress knees of all shapes and sizes; you can see why one visitor described them as "toothpicks for dinosaurs."

A young visitor appreciates one of Tom Gaskins' unusual cypress knees at The Cypress Knee Museum.

Courtesy of The Cypress Knee Museum

For a look at cypress knees in their natural habitat, there is a three-quarter-mile-long boardwalk that wends its way through the swamp and cypress grove behind the store. It is a lovely stroll past rare and colorful flora and fauna, and maybe a 'gator or two, but the two-plank boardwalk with railing is only for the sure-footed. You can see Gaskins' experiments with still growing cypress knees: one has been carved in the shape of a giant hand, with well-defined fingers and thumb, and another has grown around a glass jug.

Unique cypress knees naturally shaped like a dog, penguin, and bear.

Max Hunn, The Cypress Knee Museum

Ripley's Believe It Or Not Museum

19 San Marco Avenue
St. Augustine, Florida 32084
(904) 824-1606
Open: November 1 to April 30, daily, 9:00 A.M. to 7:00 P.M.; May 1 to October 31, daily, 9:00 A.M. to 9:00 P.M.
Admission: $4.50 for adults, $3.50 for seniors, $2.50 for children under 13, free for children under five

Would you believe that elephant tails were used as money in Angola or that Italian sculptor Niccolo Tribolo slept with one eye open? Would you believe that an Irish woman sat on a nest of eggs for three weeks and became the mother of 100 chickens? Believe it or not, there are eight Ripley Museums, from Myrtle Beach, South Carolina, to San Francisco, California, that celebrate the odd, the curious, and the incredible.

Robert Leroy Ripley was a sports cartoonist who seized on the idea of presenting the unusual and the bizarre in a syndicated cartoon in 1918. An intense man with strange idiosyncrasies, he owned many cars but could not drive, liked to have chipmunks run around his desk while he drew, and relaxed by moving heavy furniture in his mansion in Mamaroneck, New York. In his quest for the unusual, Ripley traveled to 198 countries and uncovered such curiosities as a nine-year-old mother in Java, a rare decorated skull from New Guinea, and the Iron Maiden torture device of Nuremberg. By

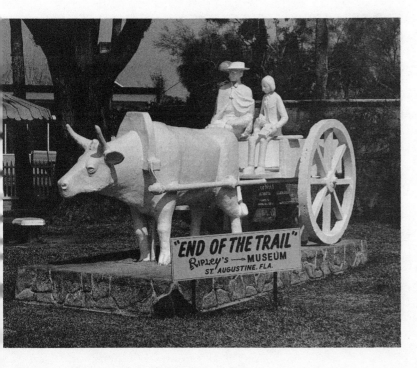

The *End of the Trail* ox cart outside the Ripley's Believe It Or Not Museum.

Courtesy of Ripley's Believe It Or Not Museum

1940, his collection filled three museums and at the time of his death in 1949 was valued at $2 million.

In St. Augustine, Florida, Ripley's Believe It Or Not Museum is housed in a Venetian-style former hotel, once owned by author Marjorie Kinnan Rawlings, who wrote *The Yearling* while living there. As in each of the Ripley Odditoriums, there is an unnerving collection of wax figures; here visitors will find the incredible Double-eyed Man, the Chinese man with the cleft skull who could insert a candle in it, along with an assortment of shrunken heads and a bible the size of a bean. Other amazing items include a painting of the Golden Gate Bridge on the head of a pin, the handkerchief Mary Todd Lincoln held when her husband was shot at Ford's Theater, and a collection of tattoos that were once on the body of a tattooed man.

Ripley's personal obsessions are highlighted: the Oriental Room has all the exotica he brought back from China, his favorite land, and great eccentrics like himself are featured, notably The Bathtub Marshall, a uniformed figure sitting in a tub of water; as Governor of Lyons, France, Marshall de Castellane (1788-1862) had three uniforms—one for day, one for sleep, and one for bathing.

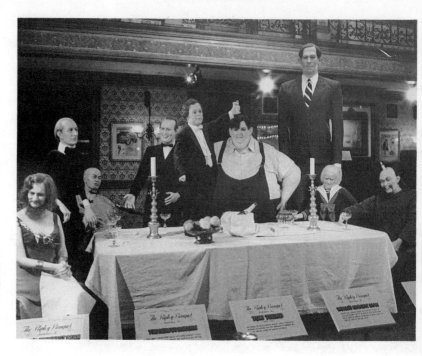

Depicted at this Ripley Banquet are such curiosities as *Tom Thumb*, the *World's Heaviest Man*, *The Human Unicorn*, and Ripley himself.

Courtesy of Ripley's Believe It Or Not Museum

Lionel Train and Seashell Museum

8184 North Tamiami Trail
Sarasota, Florida 34243
(813) 355-8184
Open: daily, 9:00 A.M. to 5:00 P.M.
Admission: (for train exhibits only)
$2.50 for adults, $.50 for children
under 11
Wheelchair accessible

For serious train collectors, creating a private world of locomotion is a lifetime pursuit. Two such dedicated hobbyists, Joe Lionel Rudley and Dick Paul, share their passion for Lionel Trains and accessories at the Lionel Train and Seashell Museum in Sarasota, Florida, which they opened in 1976. They spent a year creating two delightfully complicated and detailed layouts—one a standard gauge, the other O gauge. Their treasures are housed in a small building that resembles a Victorian railroad station a mile north of the Ringling Museum complex.

The standard gauge layout consists of trains built between 1925 and 1937. According to Dick Paul, it is the world's most complete set on public view. Imagine the young visitor's face as he marvels at 700 feet of track, and hundreds of signals and relay controls placed on a 36-foot-by-27-foot glass-enclosed set. The scene depicts small towns and cities, mountains, five round-

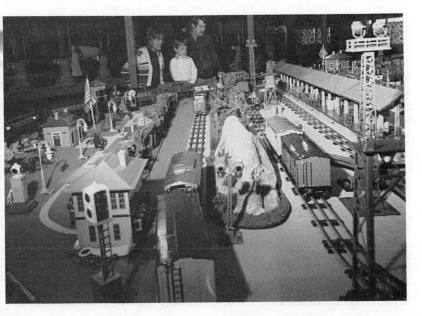

Visitors enjoying the elaborate standard gauge layout at the Lionel Train and Seashell Museum.

Florida Department of Commerce, Division of Tourism

houses, power stations, and a freight yard with switchmen and other workers; a Goodyear blimp floats lazily above the action. Throw a switch to go from day to night—homes, billboards, and streetlights illuminate detailed urban vistas.

While the 1945 O gauge layout is smaller, it is even more detailed. Ten trains on three levels haul passengers and freight around a myriad of track, stopping to debark passengers and take water onboard. A Hiawatha train streaks out of a tunnel as FM diesels pull freight across elaborate tressels.

One long wall displays hundreds of individual cars, showing the evolution of Lionel trains from the turn of the century through the company's peak in popularity in the 1950s. The tiny world of electric toy trains began in 1901, when Joshua Lionel Cowan invented a new toy for a store window display. These fascinating miniatures tapped into America's obsession for trains and captured the imagination of countless young collectors. Over the years, designers of Lionel trains perfected the art of duplication. The Hudson engine, created by Lionel in 1940, is considered a perfect model. Complete with valve actuator, Baker reversing gear, booster wheels, and injector delivery pipe, the little O gauge engine is impeccably accurate in detail and scale.

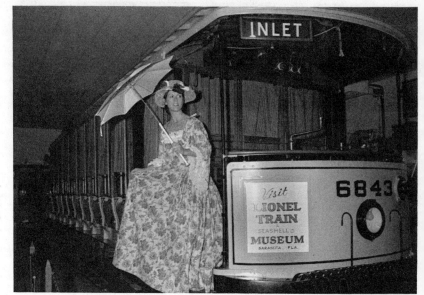

Inside the restored 20-ton trolley car, museum visitors can view film footage of vintage trains or dress up in costumes and pose for a souvenir photograph.

Florida Department of Commerce, Division of Tourism

In the center of the museum is a 20-ton trolley car that once ran in Atlantic City at the turn of the century and has been restored to mint condition. Inside, visitors can view footage of old trains, and you're invited to dress up in period costumes and pose for a souvenir photograph.

Museum co-owner Joe Rudley has also been busy amassing exotic shells and coral, which are on display with a multicolored coral wishing pool in a corner of the museum. The gift shop sells shells and coral, Lionel train sets and parts, engineer's hats, Lionel train books and magazines, and assorted train memorabilia.

The Ringling Museum Of the Circus

Of the five Ringling Brothers, John had the shrewdest business mind. In 1909, he bought Barnum and Bailey's Circus for a fraction of its worth and by the 1920s was one of the richest men in America. He moved the winter home of the circus from Connecticut to Sarasota, Florida, and built a Venetian Gothic estate on the shores of the Gulf of Mexico for himself and wife, Mable. Quite an art lover, he amassed the country's largest collection of Baroque paintings and built a Florentine villa on his 38-acre landscaped grounds, calling it the John and Mable Ringling Museum of Art. It is doubtful whether he would have considered the circus a fit subject for a museum, but upon his death in 1936, he bequeathed the entire complex to the state of Florida, which established the Ringling Museum of the Circus in his honor.

In this large rotunda, reminiscent of a circus tent, visitors can enjoy displays that document the fascinating history of The Greatest Show on Earth. Tom Thumb artifacts recall the 25-inch-tall General, who won the hearts of Americans and European royalty. See his dog-drawn wagon, miniature walking stick, gloves, and the tuxedo he wore when he married his beloved bride, Lavinia, whose tiny gown is also displayed. A memorial to the Flying Wallendas includes a photograph of the family's breathtaking seven-person pyramid on the high wire. Emmett Kelly, the sad-faced clown known as Weary Willie is

Ringling Museum Complex
U.S. 41 North
Sarasota, Florida 33578
(813) 355-5101
Open: Monday through Friday, 9:00 A.M. to 7:00 P.M.; Saturdays, 9:00 A.M. to 5:00 P.M.; Sundays, 11:00 A.M. to 6:00 P.M.
Admission: $4.50 for adults, $1.75 for children ages six to 12 (includes admission to Ringling Museum of Art and Ringling Estate)
Wheelchair accessible

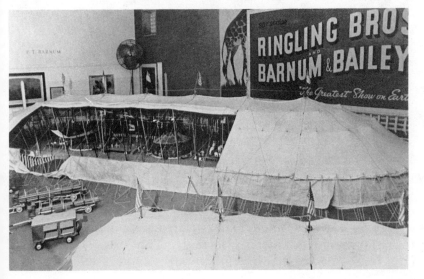

An 18- by 30-foot platform in The Ringling Museum of the Circus displays this scale model of the famous *Big Top* used by the Ringling Brothers and Barnum and Bailey Circus. Created by George Barlow of Binghamton, New York, the big top has three rings and four stages, with miniature performers presenting their acts in all seven areas.

Courtesy of The Ringling Museum of the Circus

Historic circus poster (1897) of the five Ringling brothers, Alf, Al, John, Otto, and Charles.

Courtesy of The Ringling Museum of the Circus

honored with photographs and costumes from his many years in show business.

A 30-foot scale model shows the arrangement of the big top, sideshow, and menagerie tents. The "backyard" of the circus is recreated, showing the support wagons used before the

circus traveled by train, complete with cookhouse and harness and blacksmith shop. Flamboyant multicolored parade wagons, circus lithographs, and posters heralding the circus coming to town are seen throughout the museum.

Huge plaques advertise fire-eaters, tattooed ladies, and three-legged men on the exterior of a sideshow tent. Guides tell amusing anecdotes about characters like Alice From Dallas, who weighed 695 pounds, had a six-foot waist, and, as the pitchman out front would say, "It took two men to hug her and 10 men to lug her"; or Chang and Eng, the original Siamese twins, who were joined at the breastbone. At 17, they were brought to America and became a touring sensation. By the time they were 28, they had saved $60,000, enough to retire, marry a set of twins, and settle down to farm in North Carolina, where they raised 22 children between them.

THE FRED BEAR MUSEUM

Fred Bear Drive at Archer Road
Rural Route 4
Gainesville, Florida 32601
(904) 376-2411

Walk among the wild things at this tribute to Fred Bear, the founder of Bear Archery. See stuffed elephants, caribou, moose, lions, and many other animals, all brought down with a bow and arrow by Mr. Bear. He often collected on his numerous bow-hunting expeditions, and you can browse among authentic spears, shields, carvings, artwork, and artifacts from Indian, Eskimo, and African tribes. Also displayed are bow and arrow paraphernalia from cultures all over the world.

SPACEPORT USA

VC TWA 810
Kennedy Space Center
Florida 32899
(800) 432-2153

Explore the past and future of the space program through space movies, demonstrations, and exhibits. See the triumphs and the tragedies depicted in moving exhibits and there's no better seat to view lift-offs.

PLANET OCEAN

3979 Rickenbacker Causeway
Miami, Florida 32084
(305) 361-9455

Explore the mysteries of the world's oceans. Walk through an indoor cloud, see and feel a hurricane, tour a submarine.

AMERICAN POLICE HALL OF FAME AND MUSEUM

14600 South Tamiami Trail
U.S. 41
Northport, Florida 33596
(305) 891-1700

Police artifacts throughout history include an electric chair, a futuristic police pursuit vehicle and a complete crime scene for the visitor to solve. The hall of fame honors those who have fallen in the line of duty since 1960.

OLDEST STORE MUSEUM

4 Artillery Lane
St. Augustine, Florida 32084
(904) 829-9729

An authentic turn-of-the-century store contains more than 100,000 items on display just as they were when the store was a thriving retail center. You'll find kerosene lamps, kitchen utensils, high-wheeled bicycles, guns, hats, bonnets, an unusual collection of groceries, and a cigar store Indian.

BELLM'S CARS AND MUSIC OF YESTERDAY

5500 North Tamiami Trail
Sarasota, Florida 33580
(813) 355-6228

AMERICA ON DISPLAY

This spacious building presents over 170 antique automobiles, some dating back as far as 1897, as well as more than 1,200 Victorian-era music machines.

BLACK ARCHIVES RESEARCH CENTER AND MUSEUM

Florida A & M University
Tallahassee, Florida 32307
(904) 599-3020

Informative displays and research materials on the history of black Americans from early slavery to the present.

BEAL-MALTBIE SHELL MUSEUM

Rollins College Campus
1000 Holt Avenue
Winter Park, Florida 32789
(305) 646-2364

Imagine two million shells and nearly 100,000 species on display; from the biggest species to the smallest, from the historical to the commonplace, this collection, gathered by Dr. James H. Beal, is one of the largest in the world. Look for shells that were used for money, the sacred shell of the Hindus, and edible eggs laid by land snails.

JIMMY CARTER LIBRARY

1 Copenhilo Avenue
Atlanta, Georgia 30307
(404) 331-0296

This $25 million center, completed in 1986, houses a library with more than 27 million documents, a conference area, and a museum, which presents the highs and lows of the Carter years, from Camp David to the Iranian hostage crisis. An outstanding audiovisual exhibit consists of a town meeting area where visitors ask the former president questions and he answers, courtesy of a state-of-the-art videodisk player.

UNCLE REMUS MUSEUM

US 411 South
Eatonton, Georgia 31024
(404) 485-6856

Joel Chandler Harris was a poor kid, who grew up in Eatonton listening to plantation slaves spin fantastic tales. Later as a newspaper reporter, he wrote stories of Br'er Rabbit, Br'er Fox and "all de critters," based on the stories he heard. This museum, consisting of two original slave cabins, depicts the fictional life of one of Harris's most popular characters, the old slave Uncle Remus. See many artifacts of slave life before Emancipation as well as first edition works of Mr. Harris.

LITTLE WHITE HOUSE AND MUSEUM

P.O. Drawer 68
Warm Springs, Georgia 31830
(404) 655-3511

President Roosevelt enjoyed the warm buoyant waters of Warm Springs at his modest retreat on the slopes of Pine Mountain. See many of his personal artifacts, including the 1938 Ford convertible, outfitted with hand controls so he could drive it, and the famous *Unfinished Portrait*, which was being painted when he suffered his fatal stroke. A 12-minute movie entitled *FDR In Georgia* is shown.

KENTUCKY

Oscar Getz Museum of Whiskey History

Spalding Hall
114 North Fifth Street
Bardstown, Kentucky 40004
Open: Monday through Saturday,
9:00 A.M. to 5:00 P.M.
Admission: free

American history buffs are probably aware that many of our distinguished forefathers, including John Quincy Adams and Thomas Jefferson, distilled and traded whiskey and rum. A still, reputed to have been George Washington's, is on display at the Oscar Getz Museum of Whiskey History in Bardstown, Kentucky, as is Abraham Lincoln's liquor license and a diorama depicting Honest Abe behind the bar in a tavern he owned briefly in New Salem, Illinois.

Located within an hour's drive of Louisville, Bardstown is also the home of Jim Beam and other distillers and the plantation that inspired Stephen Foster to write *My Old Kentucky Home*. Oscar Getz, a local liquor distributor, began collecting whiskey memorabilia in 1933, and when he died in 1983, his widow sponsored the museum as a gift to the historic town.

A diorama of the tavern Abraham Lincoln ran in 1832 and 1833 in New Salem, Illinois, and a copy of his liquor license at the Oscar Getz Museum of Whiskey History.

Courtesy of Oscar Getz Museum of Whiskey History

George Washington's whiskey still, manufactured by R. Bush, Bristol, England, in 1787.

Courtesy of Oscar Getz Museum of Whiskey History

The museum's collection of more than 200 years of American liquor artifacts, dating from pre-Colonial to post-Prohibition days, is housed on the first floor of Spalding Hall, a stately 160-year-old former Catholic college. On the walls around an old-time bar, hang whiskey advertisements, calendars, and antique bar bottles and shot glasses.

It may go down smooth and easy, but how is it made? The museum offers visitors a chance to learn the process handed down through the ages: corn is cooked and fermented in huge "mash tubs" and active yeast is added; the whiskey is placed in charred white oak barrels for the long aging process. On view is a charred white oak barrel, a copper moonshiner's still on loan from the Internal Revenue Service, and historic documents, including America's oldest known liquor license (circa 1759), and letters from Washington's secretary of war concerning the Whiskey Insurrection of 1791.

In his 50 years of collecting, Getz amassed a fascinating variety of antebellum whiskey flasks and bottles. The Hayner Lock Top Bottle had a combination lock stopper to foil thirsty

servants. One pint-size flask was designed for stagecoach travelers; it fit snugly into the leg of a boot and could be refilled at taverns along the route, giving us the term "bootlegger." A brown bottle in the shape of a cabin was the trademark for E.G. Booz's Old Cabin Whiskey, and yes, it was due to old E.G.'s marketing expertise that we now refer to the hard stuff as "booze."

The Kentucky Derby Museum

704 Central Avenue
at Churchill Downs
Louisville, Kentucky 40208
(502) 637-1111
Open: daily, 9:00 A.M. to 5:00 P.M.; closed Christmas Day and Derby Day
Admission: $3 for adults, $2.50 for seniors, $1.50 for children ages five to 12, free for children under five
Wheelchair accessible

The year was 1875 and a horse named Aristedes won the first Kentucky Derby, setting an American record. Today, you can pet a Thoroughbred and relive that first race at the $7 million Kentucky Derby Museum in Louisville, Kentucky. The museum, which opened in 1985, celebrates the tradition of the derby and highlights all the elements of thoroughbred horse racing. Situated next to the entrance of Churchill Downs, the museum's architecture reflects the famed twin spires of the grandstands nearby.

The two-minute competition of the best and brightest three-year-old horses in the world was the brainchild of Colonel Merriweather Lewis Clark. Viewers can experience the excitement of Derby Day via an audiovisual spectacular; images flash around the room on a 360-degree screen, taking spectators through the day, beginning with workouts at dawn and continuing through post time and the midday celebration.

At this equine museum, you can weigh in like a jockey does, mount a horse at the starting gate, assess your own horsepower, bid in a yearling sale, and test your betting skills against a computer to see if you can pick a winner. At the Winner's Circle display, enjoy old photographs, wonderful quotes, and interesting facts about great horses, such as Whirlaway, Seattle Slew and Secretariat, that have won the Kentucky Derby.

Hundreds of artifacts enliven the history of the Thoroughbred, whose lineage can be traced to three Arabian sires in 17th century England and which eventually made its way to the Blue Grass State with Daniel Boone. A small side gallery has a Derby Time Machine; punch in a year and old news clips review famous races from the 1930s to the 1980s. Visitors can sip a mint julep and eat a relaxing lunch in the museum's Stallion Stakes restaurant or on the garden terrace.

THE SCHMIDT COCA-COLA MUSEUM

1201 North Dixie Avenue
Elizabethtown, Kentucky 42701
(502) 737-4000

If you think things go better with Coke, you'll want to survey the world's largest private collection of Coca-Cola memorabilia, covering 100 years of advertising, including trays, calendars, glasses, silverware, and dishes, all sporting the Coke logo.

THE VENT HAVEN MUSEUM

33 West Maple
Fort Mitchell, Kentucky 41011
(606) 341-0461

The museum claims to have the world's largest collection of material relating to ventriloquism—imagine more than 500 dummies and an extensive library of ventriloquial publications. Once a year, the museum hosts a ventriloquist convention for performers from all over the country.

INTERNATIONAL MUSEUM OF THE HORSE

Kentucky Horse Park
4089 Iron Works Pike
Lexington, Kentucky 40511
(606) 233-4303, ext: 231

On a 1,000-acre horse farm are beautifully presented equine exhibits, lots of horses, and computer video screens that tell of different breeds from Thoroughbreds to Clydesdales.

LOUISIANA

What happens to those magnificent floats from the Mardi Gras parade after they've made their stately way through New Orleans? The answer can be found in a warehouse on the west bank of the Mississippi River in the Old Algiers section of town. Called Mardi Gras World, it was created by Blaine Kern, whose company is the largest float builder in the city, as a place to see the elaborate floats and figures and the jewels, crowns, and tiaras worn by the kings and queens of Mardi Gras. Watch new floats being created in the workshop for upcoming celebrations.

Year-round group tours start with a film explaining the history and traditions of Mardi Gras, an annual event in New

Mardi Gras World

233 Newton Street
P.O. Box 6307
New Orleans, Louisiana 70174
(504) 362-8211
Open: Monday through Friday,
9:30 A.M. to 4:00 P.M.
Admission: $3.50 for adults, $2 for children under 12
Wheelchair accessible

Realistically detailed parade float figures can be seen close up at Mardi Gras World.

Courtesy of Mardi Gras World

Orleans since 1857. Held on the day before Ash Wednesday and based on the *carnivale* celebrations held in Catholic Spain, France, and Italy since medieval times, the festival is an all-out hedonistic bash before the beginning of the 40 days of Lent.

There are 200 major "krewes," or private carnival clubs, in New Orleans, with names like Rex, Zulu, and Bacchus. Each commission stages a parade, competing for prizes for the most elaborate floats, costumes, and headpieces. Float themes are often derived from Greek or Roman mythology, but Hollywood's influence is also felt. Recent parades featured a giant Lee Iacocca dressed as Godzilla crushing Japanese cars and Ronald Reagan as Obi-Ron-Kenobi from *Star Wars*.

As you'll learn at Mardi Gras World, the extravagant floats cost between $10,000 and $30,000 to build and the price of the biggest can run up to $100,000. All are complicated creations, requiring coordinated teams of carpenters, metalworkers, painters, electricians, and scenic artists. Carrying as many as 80 people, they are powered by heavy-duty tractors. Kern's factory turns out more than 350 floats a year and you can see them in varying stages of readiness.

Lined up side by side in the spacious warehouse, the large floats from past parades are a three-dimensional catalog of symbols, from King Kong to the Statue of Liberty, all intricately rendered in papier-maché or fiberglass. Of course, the floats aren't complete without the costumed kings, queens, jokers, and bathing beauties waving from them, but the next best thing i

Float builder Blaine Kern frequently draws on contemporary images, like this character from the Strawberry Shortcake Gang.

Courtesy of Mardi Gras World

seeing the costumes on mannequins in the exhibit room. The staff encourages photographs; you can even have your picture taken in King Kong's hand or with any of the other large figures. The gift shop sells posters and souvenirs, and you can even order a float for your own parade.

JIM BOWIE MUSEUM

220 South Academy
Opelousas, Louisiana 70570
(318) 948-6263

Jim Bowie may have lost his life defending the Alamo, but his memory lives on in this collection of Bowie lore. Top among the artifacts is a replica of the famous Bowie knife.

MISSISSIPPI

The Jimmie Rodgers Museum and Monument

Highland Park
Meridian, Mississippi 39301
(601) 483-5202, 485-1808
Open: Monday through Saturday,
10:00 A.M. to 4:00 P.M.;
Sunday, 1:00 P.M. to 5:00 P.M.
Admission: $2 for adults, free for
children under 12
Wheelchair accessible

"The underest dog is just as good as I am: and I'm just as good as the toppest dog." These words are engraved on the monument tribute to James Charles Rodgers at the Jimmie Rodgers Museum and Monument in his birthplace, Meridian, Mississippi. Called the Father of Country Music, Jimmie Rodgers wrote and sang about grassroots America in the 1920's. With lyrics about glistening rails and lonesome prairies, quiet bayous, and thundering boxcars, he helped share a form of music that comminicated from the heart.

Rodgers was born in 1897 into a railroad family, and in his youth, he worked the rails, as a brakeman, handler, switchman, and baggageman all over the South and Southwest during the great era of steam-driven trains. As he passed through countless small towns across the country, he met traveling musicians and eventually developed a unique style of guitar strumming, singing, and yodeling. The museum, which was built to resemble a railroad depot, exhibits artifacts of the steam era, including a refurbished steam engine (circa 1916), a railroad baggage cart, and the railroad box in which The Singing Brakeman stored his personal articles when he was on a run.

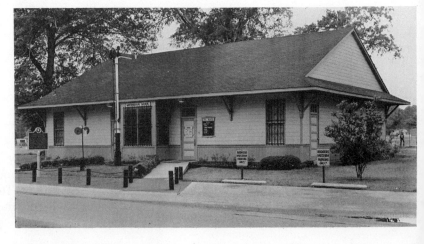

Since he spent so much time on the rails, The Jimmie Rodgers Museum and Monument was built to resemble a railroad depot.

Courtesy of The Jimmie Rodgers Museum and Monument

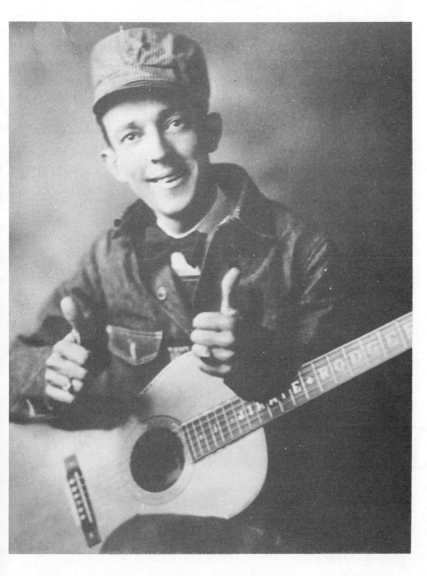

Jimmie Rodgers, The Singing Brakeman, is also considered The Father of Country Music.

Courtesy of The Jimmie Rodgers Museum and Monument

In 1924, suffering from tuberculosis, he left the rails and focused on his chief hobby—singing. Trying to support his family, Rodgers struggled for several years to establish a musical career, touring music venues in the South and Southwest. In 1927, he eventually became a best-selling recording star after doing a test pressing for the Victor Talking Machine Company (later to become RCA). Ill health restricted his personal appearances and he died during a recording session in New York in 1933.

In tribute to The Blue Yodeler's special style—his yodeling had a bluesy, soulful quality—the museum displays Rodgers' hand-tooled leather cowboy boots and spurs, theatrical trunk, and shaving kit, embossed with his name. There is, of course, his guitar and even the big iron bed Rodgers and his wife, Carrie, shared in the early years of their marriage, along with portraits of his family, memorial plaques honoring his achievements, old records, and sheet music of his songs.

The museum's well-stocked Jimmie Rodgers Souvenir Shop includes Jimmie Rodgers bronze ash trays, bells, and thermometers, T-shirts, train pins, railroad caps, and songbooks. In recognition of his contribution to country music, many well-known country stars participate in a weeklong Jimmie Rodgers Music Festival, held in Meridian every May.

DELTA BLUES MUSEUM

Box 280
Clarksdale, Mississippi 38614
(601) 624-4461

Established in 1979 by the Carnegie Public Library, this small museum invites you to enjoy audiovisual programs of great blues singers like Muddy Waters, Robert Johnson, and John Lee Hooker.

DIZZY DEAN MUSEUM

4736 Clinton Boulevard
Jackson, Mississippi 39209
(601) 969-2404

Baseball Hall of Famer Jay Hanna Dean had such an array of pitches to confuse batters with that he was nicknamed "Dizzy." Displays highlight his life in Mississippi and his career as a strikeout king for the St. Louis Cardinals during the 1930s.

CASEY JONES MUSEUM

P.O. Box 605
Vaughan, Mississippi 39179
(601) 673-9864

This refurbished railroad depot has been set aside to celebrate the legendary railroad engineer. On view are personal artifacts and railroadiana.

NORTH CAROLINA

Golfers come from around the world to tee off on seven exquisitely crafted, gently rolling golf courses in the village of Pinehurst in the North Carolina Sandhills. Here, where Ben Hogan won his first professional tournament in 1940 and the most prestigious amateur golf events were held, is the home of the PGA/World Golf Hall of Fame.

Operated by the Professional Golfers' Association, the contemporary-style building is surrounded by meticulously landscaped grounds. Under the guidance of golf historian and collector Ray Davis, the hall has assembled equipment that traces the game's evolution from 16th century Scotland to the present. Displayed in a 92-foot-long cabinet, called The History Wall, are clubs, balls, and clothing from the long history of the sport. You'll learn how early golf balls, called "featheries," were made of compressed gull feathers stuffed inside a handsewn leather cover. Special emphasis is given to 19th century artifacts, such as Dr. David Palmer's collection of hand-carved Scottish and English woods and irons.

PGA/World Golf Hall of Fame

PGA Boulevard
P.O. Box 1908
Pinehurst, North Carolina 28374
(919) 295-6651 or (800) 334-GOLF
Open: March 1 through
November 30, daily,
9:00 A.M. to 5:00 P.M.
Admission: $3 for adults, $2 for
students ages 10 to 18, free for
children under 10
Wheelchair accessible

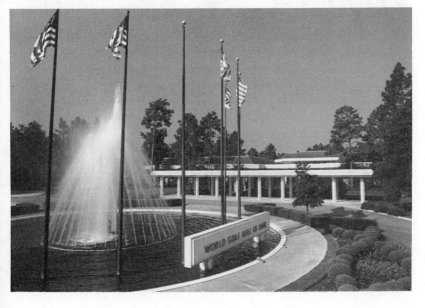

The landscaped gardens and fountains of the World Golf Hall of Fame.

Jeff McBride, PGA of America

Antique clubs and feather-filled
leather balls, known as "featheries."

Jeff McBride, PGA of America

A highlight of the museum is a full-scale replica of a Scottish club maker's workshop, complete with anvil, forge, and woodworking tools. The two oldest pieces of sporting equipment in the museum are a putter and a driver (circa 1690). Trophies on display include replicas of the PGA Championship cup, the Masters Trophy, and an ornate silver belt buckle presented to the first winners of the British Open.

Exhibited throughout the hall are oil paintings and watercolors with golf as the theme. A *Sports Illustrated* exhibit consists of 35 color photographs of great players shown in the magazine

over the past 30 years. In the Hall of Fame Room, "golficianados" can view bronze plaques, paintings, and photographs of the great duffers of history: Bobby Jones, Babe Didrikson Zaharias, Walter Hagen, and Patty Berg, to name just a few.

THE COUNTRY DOCTOR MUSEUM

515 Vance Street
Bailey, North Carolina 27278
(919) 235-4165

Honoring the sometimes thankless, often low-paying profession of the country doctor, this quaint little museum presents an 1857 Apothecary Shop, complete with ornate glass cabinets of bottles, phials, books, and medicines. Step into the Doctor's Office and Examining Room (circa 1890), which presents the instruments and equipment used by country doctors during the last century.

SOUTH CAROLINA

"From the halls of Montezuma to the shores of Tripoli . . ." the U.S. Marines have distinguished themselves by their toughness and bravery in every war fought by the United States, from the Revolution through the Vietnam war. Marines train on Parris Island, South Carolina, in Port Royal Sound, and Marine boot camp is a grueling 11-week course that separates the men from the boys. Some 46,000 Marines went through Parris Island's hellish obstacle course on their way to World War I and the center trained more than 200,000 during World War II, up to 20,000 at a time.

Although Parris Island was once off limits to civilians, the Marine Corps has eased its visitor policies, perhaps to help recruitment, and it is now a tourist attraction of sorts. The Parris Island Museum, located in the War Memorial Building on the base, honors the proud tradition and history of the Marines.

The Parris Island Museum

Marine Corps Recruit Depot
Parris Island, South Carolina 29905
(803) 525-2951
Open: Monday through Friday,
7:30 A.M. to 4:30 P.M.; weekends and holidays, 9:00 A.M. to
4:30 P.M.
Admission: free
Wheelchair accessible

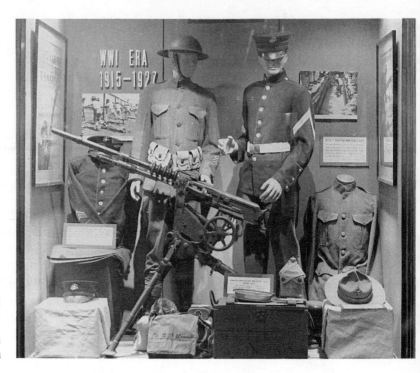

World War I exhibit showing Marine uniforms and weapons.

Courtesy of The Parris Island Museum

Here is Marine Corps Art, more than 20 historic uniforms on posed mannequins and a collection of weapons, including a Brown Bess musket from 1775, the year the Marines were formed. In the Contemporary Room, civilians will see weapons, tools, and uniforms, as well as a talking mannequin drill instructor used for modern recruit training. The Woman Marine Room recounts the history of women in the corps who served as Marine reserves in World War II and became a permanent part of the Marine Corps in 1949.

To explore the four-mile-long island, pick up a map at the Visitors Center. As you tour the rifle range and grounds, you'll spot crew-cut "boots" sweating through their combat training. From the access road see the awesome obstacle course, designed to help recruits "build confidence." At formal parades held twice a week, watch impeccably attired graduates marching to the crisp military music of the Marine Band. A covered grandstand offers protection from the sun; nearby is a reproduction of the famous Iwo Jima monument that depicts Marines struggling to raise the flag. The gift shop at the Visitors Center sells Marine souvenirs, such as Parris Island T-shirts; a snack bar serves "D.I. Burgers" and "Recruit Burgers."

SOUTH CAROLINA

One of the many models on display at The Parris Island Museum, this one is of the Spanish Fort San Felipé (circa 1867).

Courtesy of The Parris Island Museum

THE MACAULAY MUSEUM OF DENTAL HISTORY

Medical University of South Carolina
171 Ashley Avenue
Charleston, South Carolina 29425
(803) 792-2288

Located on the campus of the Medical University of South Carolina, this collection of more than 6,000 dental artifacts and books was compiled by Dr. Neill W. Macaulay. See an array of historic dental chairs, foot-powered dental drills, a Civil War set of instruments, and a unique dental instrument designed by Paul Revere for Dr. Josiah Flagg, the first native-born American dentist.

JOE WEATHERLY STOCK CAR MUSEUM

P.O. Box 500
Darlington, South Carolina 29532
(803) 393-2103

The Darlington 500 is one of the premier stock car races in the world, and this museum, next to the track, displays one of the largest collections of stock cars in the world. Don't miss the simulator that allows you to experience a couple of laps around the track in Richard Petty's souped-up Dodge Charger.

THE RICE MUSEUM

Corner of Front and Scriven Streets
Georgetown, South Carolina 29440
(803) 546-7423

Located in two pre-Civil War buildings, this museum features displays and artifacts pertaining to the Carolina low country's antebellum rice industry.

THE OLD SLAVE MART MUSEUM

Box 446
Sullivan's Island, South Carolina 29482
(803) 722-0079

This building was constructed in 1820 for exhibiting slaves and auctioning them off to the highest bidder. Interviewing booths, where plantation owners questioned potential slaves, slave tags, and bills of sale for slaves are on view.

TENNESSEE

The Soda Mart Collection

Ridgecrest Drive
Goodlettsville, Tennessee 37072
(615) 859-5236
Open: Monday through Saturday,
8:00 A.M. to 5:00 P.M.
Admission: $2 for adults, $1 for children ages six to 12, free for children under six
Wheelchair accessible

Paul Bates and his son, Tom, are in the *Guinness Book of World Records*. They have the largest collection of soda pop and beer cans in the world and you can see it, neatly shelved, at The Soda Mart Collection in Goodlettsville, Tennessee. This one-of-a-kind collection, spanning 50 years, comprises more than 20,000 cans and related paraphernalia such as printed labels and embossed soda bottles.

Father and son became ardent can collectors in 1972 and they've traveled the country searching dumps, roadsides, and bottle shows. Son Tom approaches can collecting like an archeologist on a dig: "It's fun because you learn the history of the area you find them in."

Early soda cans were made of tin; an example is the museum's rare 1939 Cliquot Club can with a cone-shaped top. But the acids in the soda often corroded the bottoms, and glass bottles replaced tin cans. The real breakthroughs were aluminum cans and a succession of pop tops, which appeared in the late 1960s and 1970s. Before soft drink conglomerates dominated the market, local bottlers and breweries made pop and hops with names like Mule Kicker and Snake Venom.

Just a few of the 25,000 soda and beer cans on display at The Soda Mart Collection.

Courtesy of The Soda Mart Collection

Wisconsin-based Worm Soda's label boasted "a can of worms." Olde Frothingslosh was a hippie-era beer, claiming to be "pale, stale ale with the foam on the bottom"; its label had a picture of "Miss Olde Frothingslosh," a scantily clad bathing beauty on the hefty side.

The big-name soft drink companies often use cans to commemorate events or provide information, e.g., Seven-Up's Bicentennial cans and Canada Dry's series of professional sports teams. Others make game offers, such as Coke's Treasure Tops or Every Can's a Winner contests, and the Soda Mart Collection has many complete sets. But the independents were the true marketing innovators. In the mid-1950s, Esslinger Beer issued Parti-Quiz cans with the idea that party-goers would entertain themselves with amusing trivia games while they guzzled down the brew. The Nebraska-based Storz Brewery tried to appeal to women consumers with a beer can decorated in a dainty floral print; the beer was called Storz-ette.

They're all here and the collection continues to grow. Hobbyists will be glad to know that the Bates maintain a unique database notebook, with current listings of can collectors and their collectibles.

The Museum of Ancient Brick

General Shale Corp. Headquarters
3211 North Roan Street
Johnson City, Tennessee 37601
(615) 282-4661
Open: Monday through Friday,
8:00 A.M. to 4:30 P.M.; closed:
public holidays
Admission: free
Wheelchair accessible

About 10,000 years ago, man discovered that if he shaped clay with his hands and dried it in the sun, he could produce a brick. Goodbye caves and animal skin tents, hello upscale housing. Indeed, brick has helped pave the way of progress, and its importance is explored at the Museum of Ancient Brick, appropriately installed in the lobby of a striking 16-sided brick building that is the corporate headquarters of the General Shale Corporation, one of the nation's largest brick manufacturers. Complete with a brick plaza and elaborate brick fountain, it serves as a distinctive landmark for travelers on Highway 23, the Johnson City-Kingsport highway.

The challenge of collecting and preserving the industry's history is in the competent hands of museum curator Basil Saffer, a former British merchant sailor, self-taught archaeologist, and General Shale's marketing director. Since 1964, he has been traveling the world to build the foremost collection of old, rare, and historic brick, and the company has spent hundreds of thousands of dollars on his quest. Saffer has logged more than 100,000 miles on brick-hunting expeditions and has sought brick in more than 60 countries, often having to wade through bureaucratic red tape, and some of his finds have taken years to export. Two of the valued antiquities he has added are 10,000-year-old bricks found beneath the biblical city of Jericho, which, according to Saffer, are examples of the oldest brick ever discovered. His most recent aquisition is a brick from the Roman wall in London, built about 150 A.D.

The collection pays particular tribute to brick from American history. Here you'll find a brick that was used as ballast on the *Mayflower* and then laid into a foundation at Plymouth Colony, and brick from the White House, and from Jefferson Davis' Montgomery, Alabama, home. There is even a

The General Shale Museum of Ancient Brick features the oldest brick ever found and possibly one of the first bricks ever made, this 10,000-year-old brick from a settlement discovered beneath the biblical city of Jericho.

Courtesy of The General Shale Museum of Ancient Brick

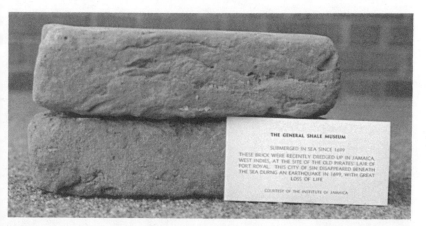

These bricks were dredged up in Jamaica, West Indies, at Port Royal, a pirate city that disappeared beneath the sea during an earthquake in 1699.

Courtesy of The General Shale Museum of Ancient Brick

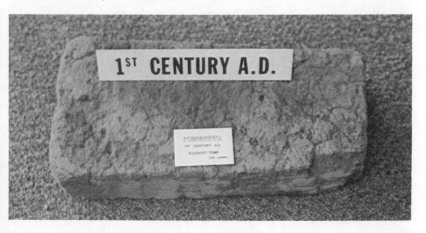

This brick from Pomparippu, Sri Lanka, was found at the site of a Buddhist tomb.

Courtesy of The General Shale Museum of Ancient Brick

brick from the Springfield, Illinois, law office where Abraham Lincoln began his career.

The museum also includes terra firma trophies from every continent and subcontinent in the world, with the exception of Japan and Greece. The 180 pieces in the collection are identified with a small placard and displayed in glass cases. Among the imported artifacts are rare brick from an ancient Egyptian tomb, the Roman Forum, the Coliseum, the doomed village of Pompeii, and the Great Wall of China, as well as brick made by Alexander the Great's soldiers.

Visitors to the museum will learn about the evolution of brick-making techniques, from primitive sun drying to the modern "tunnel kiln," which involves a complicated process of brick-making in an oven hundreds of feet long. The process is overseen by chemists and ceramic engineers.

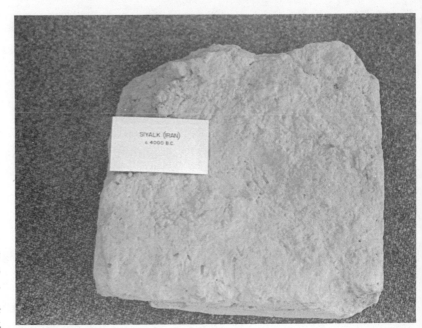

This specimen is from Siyalk, now Iran, and dates back as far as 4000 B.C.

Courtesy of The General Shale Museum of Ancient Brick

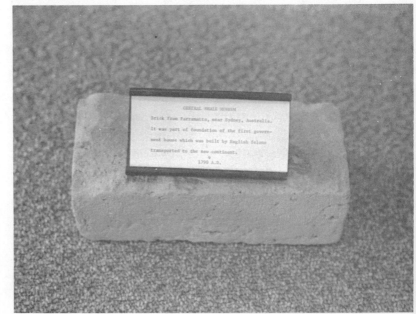

This brick, from Parramatta, Australia, was part of the foundation of the first government house built by English convicts who had been exiled Down Under.

Courtesy of The General Shale Museum of Ancient Brick

He crooned "Love Me Tender" and his millions of fans around the world haven't stopped. Elvis Presley continues to be big business, and devotees of the King of Rock and Roll continue to flock to his home, Graceland Mansion, in the rolling hills of Memphis, Tennessee, since it opened to the public in 1982. Set in the front gates are musical notes and the familiar figure of the man playing his guitar. Ninety-minute tours begin every few minutes from the headquarters of the 32-acre entertainment complex along Elvis Presley Boulevard. Special vans carry visitors to the mansion's front steps, and inside, guides tell stories about each room and relate anecdotes about Elvis.

First on the tour are the Dining, Living, and Music Rooms on the main floor of the two-story mansion; the second floor bedrooms and office are off limits. You'll learn that Elvis liked to dine in Memphis tradition at nine or 10 o'clock at night and

Graceland

P.O. Box 16508
377 Elvis Presley Boulevard
Memphis, Tennessee 38186
(800) 238-2000 (outside Tennessee)
(901) 332-3322 (inside Tennessee)
Open: June through August, daily,
8:00 A.M. to 6:00 P.M.; September
through May, Wednesday through
Monday, 9:00 A.M. to 5:00 P.M.
Admission: $11.95 for adults, $8.95
for children over three, free for
children under three

A highlight of the Graceland tour is the Trophy Room, which includes this collection of Elvis Presley's million-selling gold records. Costumes used on tour, guitars, and hundreds of certificates, plaques, and awards accumulated throughout Presley's 20-year career are also on display.

Courtesy of Graceland

formally entertained in the Living Room, which has a 15-foot-long couch. In the Music Room you'll see his nine-foot gold-leaf concert grand piano. Members of his band would often drop by for a jam session and Elvis liked to relax here and sing gospel songs.

Visitors then proceed to the TV Room and Pool Room on the lower level. The TV Room contains three sets in a row so Elvis could watch three football games at once. The den on the main level, nicknamed the Jungle Room, has an African motif, with plastic greenery, carpeting on the ceiling, and a large artificial waterfall; it was Elvis' favorite room and its acoustics were so good, he recorded his last album, *Moody Blue*, there.

The tour continues outside at the Carport. Elvis owned hundreds of cars and gave many away. Several of his hot wheels are on display, including the 1955 pink Fleetwood Cadillac he gave his mother, although she never used it because she didn't drive; two Stutz Blackhawks; a 1975 Dino Ferrari; the pink Jeep from his film *Blue Hawaii*; and a Harley Davidson motorcycle. Also on display are a dune buggy and two three-wheeled Supercycles, which he rode all hours of the day and night. Elvis used to drive a John Deere tractor all over the grounds, pulling a group of friends in a large wagon.

Included in the tour of Graceland Mansion is the TV Room, with its mirrored ceiling and walls. Above the three television sets (Elvis was always afraid he would miss something) is a pull-down screen used by Elvis and his friends for home movies, including the late singer's memorable appearance on the "Ed Sullivan Show."

Courtesy of Graceland

There was a party atmosphere at Graceland and Elvis liked to be surrounded by his friends and his animals. Although he sang "You Ain't Nothin' but a Hound Dog," Elvis' dog was no mere hound. While touring, you may hear his Pomeranian, Edmond, barking. "Eddie" is cared for by Elvis' Aunt Delta, who still lives at Graceland. Also see the little house he built for his pet chimp, Scatter; it has central heating and air conditioning. Horses were another love, and behind the mansion is the barn complex, named The House of the Rising Sun, after his favorite quarter horse.

Then it's on to the Trophy Room, near the kidney-shaped swimming pool. Here you can see his 16-carat diamond-studded TCB (taking care of business) ring, his instruments, his 1958 Army uniform and the hundreds of letters fans wrote to the draft board protesting his induction. Early mementos include his birth certificate and family pictures taken at home in Tupelo, Mississippi. A glittering 80-foot-long Hall of Gold is lined with his gold records (he sold over a billion records, more than any artist in history). Here also are the many awards he garnered and a dazzling collection of choice costumes—the black leather biker get-up he wore for his 1968 "Comeback" television special and the white leather jump suit and rhinestone-studded cape from his "Aloha from Hawaii" special in 1973.

The next stop is a tour of Elvis' recreation facility, where he often played racket ball, and then it's on to the solemn Meditation Gardens, where Elvis, his parents, and grandmother are buried. Visitors are shuttled to Graceland Plaza, where they are encouraged to browse through several gift shops, eat at the Heartbreak Hotel restaurant, and for an added admission price visit Elvis' customized tour bus and step aboard his 880 Convair four-engine jet, *The Lisa Marie*, named after his daughter. Elvis was afraid to fly but not in his own plane. A permanent crew of four was always on call to satisfy his flights of fancy, e.g., a 3 A.M. flight to Denver for peanut butter and jelly sandwiches. Reservations for this memorial museum are accepted up to six months in advance.

National Ornamental Metal Museum

374 West California Street
Memphis, Tennessee 38106
(901) 774-6380
Open: Tuesday through Sunday,
12:00 noon to 5:00 P.M.
Admission: $1.50 for adults, $1 for
students and seniors, free for
children under 12
Wheelchair accessible

The clank of hammer to metal as the metalsmith shapes a pewter pot or bends a piece of hot iron on the anvil reverberates throughout history. The time-honored art of metalsmithing has been preserved at the National Ornamental Metal Museum in Memphis, Tennessee, under the direction of James Wallace, a blacksmith and metal historian with a special interest in iron. Pass through ornate wrought iron gates and enter a historic three-acre complex on a bluff overlooking the Mississippi River. Here you can see exquisitely crafted metal works, ranging from large iron lawn sculptures to delicate pieces of gold jewelry.

A two-story Federal-style brick building houses the museum's permanent collection, visiting exhibits, gift shop, library, and offices. Metalworks and photographs of the creative process are showcased in wall displays and freestanding lighted cabinets. In the permanent collection, visitors can see everything from intricately etched metal plates and decorated swords to handmade nails, jewelry, and an assortment of kitchen utensils.

Mr. Wallace also arranges temporary exhibits that feature historical works, such as "Trench Art," small metal creations made from artillery shell casings by soldiers awaiting battle during World War I; one-man shows by prominent metal artists; and juried exhibitions of contemporary metalsmiths. Past thematic shows have included Weathervanes and Whirlygigs, Japanese Metalsmithing, and The Art of the Armorer.

One of the museum's most popular shows was Ferrous Finery, a collection of iron and steel jewelry from 1800 to the present. While gold and silver are the metals of status jewelry; iron was once used for personal adornment. Primitive cultures have traditionally worn iron bracelets and neck pieces, believing that they offered protection against evil. Nineteenth century Germans sported elegant cast iron brooches, earrings, and buckles. Iron is fashionable once again among New Wave jewelry designers, and Ferrous Finery presents imaginative free-form pins, bracelets, chokers, and earrings.

A smithy and several forges offer metalworking demonstrations on the museum grounds. A highlight of the annual calendar is Repair Days, a weekend event when the public is invited to bring their broken metal objects (no jewelry) to the museum for repair. Thirty craftspeople are on hand to volunteer their services and you can watch and ask questions as they

The ornate wrought iron gates leading to the National Ornamental Metal Museum.

Courtesy of National Ornamental Metal Museum

work. "It's always fun to see what people will bring in," said director Wallace, who also repairs objects. "We've fixed entire flocks of swan and goose sculptures for front yards, not to mention all the spoons which once belonged to Grandma and accidentally went down the garbage disposal."

The sculpture garden presents many elaborate cast and wrought iron works scattered around the grounds. A popular picnic spot is the Riverbluff Pavilion, a Victorian-style gazebo made of intricate architectural castings that once adorned a building on historic Beale Street.

Overlooking the Mississippi River, the Riverbluff Pavilion, created entirely from antique architectural castings, is a popular spot for relaxing.

David Graham, National Ornamental Metal Museum

The Country Music Hall of Fame and Museum

4 Music Square East
Nashville, Tennessee 37203
(615) 255-5333
Open: June through August, daily, 8:00 A.M. to 8:00 P.M.; September through May, daily, 9:00 A.M. to 5:00 P.M.
Admission: $6 for adults, $1.75 for children ages six to 11, free for children under five
Wheelchair accessible

Billed as America's Favorite Music Museum, no visit to Nashville would be complete without a tour through the Country Music Hall of Fame and Museum, right in the heart of Music Row. Dizzying displays—such as Elvis' customized 1960 Solid Gold Cadillac, with its six gold records embedded in the ceiling, gold record player, and refreshment bar—bring the country music saga to glittering reality.

Detailed exhibits trace the careers of the great country and western stars of the past: Jimmie Rodgers, The Father of Country Music, the Carter Family, and the singing cowboys, Gene Autry, the Sons of the Pioneers, and Roy Rogers, to name a few. See Tex Ritter's colorful hand-tooled leather guitar strap, Minnie Pearl's hat, complete with price tag, and Patsy Montana's boots. Patsy was the first singing cowgirl to sell a million records.

Great country music is heard throughout the large barn-shaped museum, and rare film footage of Hank Williams, Patsy Cline, and Roy Clark, among others, is presented in a special screening theater. In another action-packed corner of the museum, called Country Music and the Movies, you'll see film clips featuring such performers as Roy Acuff and Elvis. Here

TENNESSEE

America's Favorite Music Museum, the barn-shaped Country Music Hall of Fame and Museum.

Courtesy of The Country Music Hall of Fame and Museum

Elvis Presley's Solid Gold Cadillac, with six gold records embedded in the roof.

Courtesy of The Country Music Hall of Fame and Museum

also is the 1980 Pontiac Trans Am that was used in the filming of *Smokey and the Bandit II*, donated by country singer Jerry Reed. Nearby, the Willie Nelson exhibit salutes the international superstar with handwritten song manuscripts, family photographs, and personal memorabilia, e.g., his sneakers and bandana.

The great personalities of America's folk music are represented in the Country Music Hall of Fame. Engraved bronze plaques and special mementos document the lives and careers of the likes of Johnny Cash, Chet Atkins, and Kitty Wells.

Around the corner, stop by RCA's historic Studio B to see the place where many hits of the stars were made during country music's heyday. A videotape presents Dolly Parton, Waylon Jennings, and Chet Atkins recalling personal anecdotes about recording at Studio B. Visitors are encouraged to play the studio instruments and visit the control room to participate in a simulated mix-down session of a recent country hit.

Barbara Mandrell Country

1510 Division Street
Nashville, Tennessee 37203
(615) 242-7800
Open: June through August, daily, 8:00 A.M. to 8:00 P.M.; September through May, daily, 9:00 A.M. to 5:00 P.M.
Admission: $5.50 for adults, $4 for seniors, $2 for children ages six to 12, free for children under six
Wheelchair accessible

Only in-the-know Barbara Mandrell fans know what "MTYLTT" stands for, because it's a special code the country and western star and her husband, Ken, share. "More Than Yesterday, Less Than Tomorrow" is how they sign their letters; it's engraved on their jewelry, it's even inside their wedding rings, and you'll discover this and more intimate details at Barbara Mandrell Country, located in the heart of Music Row in Nashville, Tennessee, just across the street from The Country Music Hall of Fame and Museum.

The sleek glass and brick museum is a huge walk-in scrapbook filled with personal memorabilia from the family life and career of one of the all-time sweethearts of country music. In the pages of a *Living Family Album*, her parents, Irby and Mary, share family memories of Barbara as daughter, sister, wife, and mother. Relive her early performing career, including her surprise debut performance at age five, as recalled by her father. Glass cases display a range of family heirlooms, from Barbara's Grandma and Grandpa McGill's wedding portrait and her mother's doll collection to Aunt Linda and Uncle Al's

Barbara was so proud of the Winnie-the-Pooh mural she painted in her children's playroom that she duplicated it for the museum.

Don Putnam, Barbara Mandrell Country

crocheted bedspread, and a birthday present from sister Louise, an original Roy Rogers cup. Barbara calls it a make-yourself-at-home, stay-as-long-as-you-like kind of place.

At this museum, you'll find out why St. Bernards mean a lot to the couple. They once raised the hefty hounds, and Barbara did her first television commercial for Purina Puppy Chow with a St. Bernard puppy. The museum houses a number of wood-carved and ceramic statues of the breed. Special gifts from friends in sports and show business also share the limelight;

Jimmy Dickens' customized 400 Gibson guitar is among the many instruments on display.

Courtesy of Barbara Mandrell Country

Charlie Daniels' fiddle, Jimmy Dickens' customized 400 Gibson guitar, Don Meredith's frisbee trophy, Charlie Pride's license plate, and Tom T. Hall's favorite hunting jacket and rifle are but a few of the mementos neatly arranged in glass cases.

To share more of this down-home personality's important moments, see the first gift Barbara ever received from a boy, her

wedding dress, and the nightgown she wore on her wedding night, as well as some of her jewelry and glittering stage gowns. You couldn't get much closer—unless you moved in—than to watch a film tour of the superstar's home and see an exact reproduction of the couple's plush white bedroom and their handsome black and gold bathroom. Barbara was so proud of the Winnie-the-Pooh mural she painted in her children's play-room that she duplicated it for the museum.

In the trophy room, which presents her numerous awards from the Country Music Association, People's Choice Awards, Academy of Country Music, and a Grammy, you can almost hear the applause. Throughout the museum, performance videos from Barbara's television specials and Las Vegas shows provide toe-tapping entertainment.

It will come as exciting news to some aspiring performers that the museum has its own recording studio on the lower level, complete with a great song selection and a professional en-gineer. Select your favorite song from over 130 country, pop, and gospel all-time superhits, then enter a private recording booth and practice singing as you hear the music. Simply sing into the microphone and you can experience the excitement of recording, and get a cassette to take home, all for a small fee. Remember, Elvis got started that way. On the way out, after you've browsed through the extensive gift shop, don't forget to leave a message for Barbara in her autograph book for visitors.

TWITTY CITY

1 Music Village Boulevard
Hendersonville, Tennessee 37075
(615) 822-6650

The Conway Showcase, located on country music star Conway Twitty's estate just outside of Nashville, has a multimedia auditorium and museum. After a film presentation on his life and loves, see his guitar, gold records, and performance videos. A model of his two tour buses, Twitty Bird I and II, draws a lot of attention. The tour culminates with a look at his Colonial-style brick house. If visitors are lucky, Mr. Twitty will be out raking leaves and might stop to sign autographs.

THE AMERICAN MUSEUM OF SCIENCE AND ENERGY

300 S. Tulane Avenue
Oak Ridge, Tennessee 37830
(615) 576-3200

The world's largest energy museum, operated by the U.S. Department of Energy, is at the site of the first atomic reactor used to produce uranium 235 and plutonium 239 for the first atomic bombs during World War II. Explore oil, solar, wind, electrical, and nuclear energy in nine exhibition halls that feature a nuclear reactor simulator, a gravity machine, an oil rig, and lots of informative film and video programs. See live demonstrations on various forms of energy, from the history of coal min-

ing to the harnessing of the atom. Hands-on displays include a pair of mechanical hands for handling radioactive materials and energy-related computer games and quizzes.

DOLLY PARTON MUSEUM

Dollywood
700 Dollywood Lane
Pigeon Forge, Tennessee 37863
(615) 428-9401

Visit a re-creation of Dolly's humble birth-place—a two-room tar paper shack where she grew up with 11 brothers and sisters—on her 140-acre theme park nestled in the Great Smoky Mountains.

TEXAS

The Lyndon Baines Johnson Library and Museum

2313 Red River Street
Austin, Texas 78705
(512) 482-5137
Open: daily, 9:00 A.M. to 5:00 P.M.; closed Christmas Day
Admission: free
Wheelchair accessible

The second most popular attraction in Texas, next to the Alamo, is The Lyndon Baines Johnson Library and Museum. Located on the campus of the University of Texas at Austin, it is a vast repository of 31 million historical documents and a monumental shrine to a formidable man who was president during a tumultuous era.

Although LBJ spent time planning the museum after retiring from the White House in 1969, he had already directed Lady Byrd to begin preparations for it after his inaugural in 1965. The University of Texas won Johnson's approval as the site when it proposed to build the museum and a graduate school of public affairs in his name. Gordon Bunshaft, a leading architect in the modernist style, designed a hulking, windowless, eight-story structure, clad in travertine marble, that reflected his impressions of Johnson. "I thought the President was a really

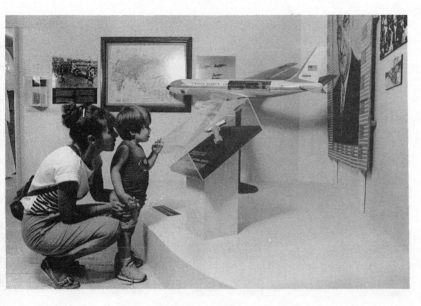

Two visitors take a close look at an exhibit called A White House Diary.

Courtesy of The Lyndon Baines Johnson Library and Museum

virile man," Bunshaft commented at the time, "a strong man with nothing sweet or sentimental or small about him."

Johnson certainly was sentimental about the museum, which opened in 1971. He spent much of his time there until his death in 1973, and even set up a small office just off the replica of the Oval Office on the top floor. He wanted very much for it to be the most popular presidential museum and would often make suggestions for improvements, such as serving free donuts or opening at 7 A.M.

He need not have been concerned. The sheer amount of material and the impressive exhibits, using the latest in audiovisual techniques, make this the presidential museum against which to measure all others. It's certainly the largest.

Fortunately for LBJ, his mother, Rebecca Baines Johnson, began recording the events of his life from the day he was born, and it's all here: early photographs and artifacts of his youth, such as his grade school report card, right up through his career as a schoolteacher, aide to a congressman, congressman, senator, vice-president and finally president. In fact, there are 35,000 historical items, miles of motion picture film, thousands of yards of audiotape, and a half million still photographs.

The tour begins with a 20-minute audiovisual presentation documenting the life and times of LBJ and setting the tone for the exhibits. Near the entrance to the Orientation Theater are

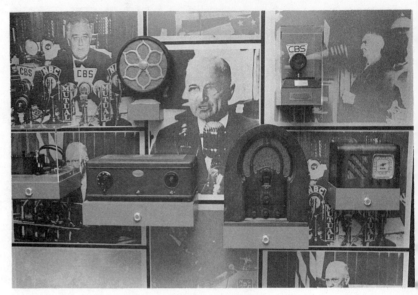

The Political Campaign exhibit at the LBJ library.

Frank Wolfe, The Lyndon Baines Johnson Library and Museum

photographs and objects from the Early Years and a Family Album, with mementos of the Johnson daughters and grandchildren. Visitors can also see the black 1968 "stretch" Lincoln that Johnson used in Washington and Gifts from Around the World, which include sculpture, jewelry, jewel-studded swords, and Oriental rugs given to the Johnsons by visiting heads of state.

As you ascend the steps to the second-floor exhibition areas, thousands of red boxes of manuscript, each bearing a gold presidential seal, are displayed on four floors creating a dramatic sight overlooking the Great Hall. The First Lady Theater features a motion picture and exhibits on the life and work of shy Lady Byrd Johnson. Nearby, the Hall of American History presents changing exhibitions on many aspects of American heritage, such as The War to End All Wars and The 1920s, The Decade That Roared. To the Moon and Beyond presents the story of NASA and the space program that was so important to Johnson; you can see a chunk of moon rock, the American flag carried on the *Gemini VI* mission, and a model of the Russian *Sputnik* that started the space race.

The rambunctious spirit of LBJ permeates the museum. Throughout the exhibition areas, video monitors present the *Johnson Style* and the *Humor of LBJ*. Those who want to learn

even more about the man and his times can visit the library and archives by appointment for access to the presidential papers and documents, many of which were classified during the Johnson era. Also available are the private papers of members of Johnson's cabinet. The Lyndon B. Johnson Oral History Project contains more than 900 taped recollections of Johnson's friends, political opponents, and close associates. If you're not too exhausted after visiting the eighth floor, Life in the White House exhibit and the replica of the Oval Office, stop into the museum store for books and LBJ mementos.

Babe Didrikson Zaharias Memorial

1750 East I-10
Off the Gulf Street Exit, #854
Beaumont, Texas 77703
(409) 833-4622
Open: daily, 9:00 A.M. to 5:00 P.M.
Admission: free
Wheelchair accessible

In an era when most famous women were movie stars, Mildred "Babe" Didrikson Zaharias will be remembered as a great female athlete. The Associated Press voted her Woman Athlete of the Year six times, a feat not equaled since (no man has ever won the award Athlete of the Year six times).

The year was 1932 and Babe was already famous as a college basketball star, when she set new world records at the Los Angeles Olympics for the javelin throw and the 80-meter hurdles. Babe played organized baseball in a men's league, mastered tennis, and even gave diving exhibitions, but golf was her game and she did more to popularize women's golf than any other person in history. Golf great Bobby Jones called her one of the 10 best golfers of all time—male or female. Not bad for a game she stumbled onto by happenstance. After her spectacular showing at the Olympics, Babe played her first game with three male sports writers and outdrove them on the first tee.

The daughter of Norwegian immigrants, Babe never forgot her hometown of Beaumont, Texas, which honored her with a memorial, a domed building set in a landscaped garden designed in the shape of the five symbolic rings of the Olympics. A true community project, Beaumont citizens helped fund it, and the city donated 10 acres and the adjoining 18-hole putting green, where a golfer can drive up, park, and sink a few. Right next door is the Babe Zaharias Memorial Stadium for local high school teams.

Visitors can see a 3 1/2 minute videotape highlighting Babe's unparalleled career; trophy cases line the walls, contain-

The Babe Didrikson Zaharias Memorial, which pays tribute to the great Olympic athlete, is designed in the shape of the five symbolic rings of the Olympic logo.

Courtesy of Babe Didrikson Zaharias Memorial

ing her Olympic medals, awards, and the winning trophies from 82 major golf tournaments (as a golfer, she won every major pro championship at least once). Also on view are her tennis racket, golf shoes, clubs, and numerous photographs, including some with her beloved husband, George, who initiated this living tribute to his wife.

Visitors to the memorial will learn about Babe's unique courage and ambition. Often a one-woman team, she won the 1932 Texas AAU track and field meet single-handedly, and at the Olympic tryouts in Chicago Babe alone scored 30 points, while the runner-up team of 22 women scored 22 points. A United Press International reporter covering the meet called Babe's feat "the most amazing performance ever accomplished by an individual, male or female." In the 1950s, she inspired millions by returning to the golf circuit within months of cancer surgery to continue winning. She died in 1956 at the age of 45. Her autobiography, *This Life I've Led,* is available at the memorial.

LIVE STEAM MUSEUM

RTE 1 Box 11A
Alamo, Texas 78516
(512) 787-1941

A large collection of steam engines and pumps, including an old steam-powered cotton gin and an oil field steam engine.

BULLFIGHT MUSEUM

5001 Alameda
El Paso, Texas 79905
(915) 772-2711

Those who wish to pay tribute to the brave matador will like the displays featuring all aspects of bullfighting, from clothing and equipment to art and artifacts.

CONFEDERATE AIR FORCE FLYING MUSEUM

Harlingen International Airport
Box 2443, CAF
Harlingen, Texas 78550
(512) 425-1057

See more than 50 aircraft from the World War II era that still fly in air shows all over the country, including a B-17 Flying Fortress, P-51 Mustang, and P-38 Lightning. Displays outline the aviation history of World War II.

MUSEUM OF AMERICAN ARCHITECTURE AND DECORATIVE ARTS

Houston Baptist University
7502 Fondren Road
Houston, Texas 77036
(713) 774-7661, ext. 331

A fine selection of American arts and crafts, including furniture, interiors, china, and an extensive collection of dolls and miniature furniture.

PRESIDENTIAL MUSEUM

622 North Lee Street
Odessa, Texas 79761
(915) 332-7123

American history buffs will appreciate this collection of campaign items, signatures, and memorabilia of U.S. presidents.

BUCKHORN HALL OF HORNS

600 Lone Star Boulevard
San Antonio, Texas 78297
(512) 226-8301

It's a hunter's world and this potpourri of big-game trophies was established in 1881. Big fish that didn't get away are on view in the Hall of Fins and the Hall of Feathers presents a flock of stuffed native and exotic birds. The Boar's Nest Gallery features modern and antique hunting firearms.

VIRGINIA

The Mariners' Museum

Museum Drive
Newport News, Virginia 23606
(804) 595-0368
Open: Monday through Saturday,
9:00 A.M. to 5:00 P.M.;
Sunday, 12:00 noon to 5:00 P.M.
Admission: $3 for adults, $1.50 for
children ages six to 16, free for
children under six
Wheelchair accessible

I must down to the seas again,
to the lonely sea and the sky,
And all I ask is a tall ship
and a star to steer her by.
—From "Sea Fever"
John Masefield

If you, too, hear the call, you'll enjoy the seafaring world of the Mariners' Museum in Newport News, Virginia. Located on the Chesapeake Bay, it was opened in 1930 by Archer M. Huntington, owner of the Newport News Shipbuilding and Dry Dock Company. The museum is situated on a sprawling 550-acre park, strewn with objects from the sea—an antique cannon, anchors, and even a small Japanese submarine.

Inside, visitors are greeted by a giant 1 1/2-ton hand-carved eagle with a wingspan of 18 feet that once proudly served as the figurehead of the steam frigate *Lancaster*. Galleries present an assortment of carved miniature boats, figureheads, marine paintings, and U.S. Navy memorabilia.

Surely the pride of the museum is the August F. Crabtree Collection. Crabtree, a sculptor and model maker for

In the Carvings Gallery, a woodcarver is on hand to give demonstrations in his specialized craft.

Courtesy of The Mariners' Museum, Newport News, Virginia

Hollywood films, created a collection of miniature ships that trace the development of vessels from a dugout canoe to a steam liner. Working with an adapted set of dental tools, Crabtree continually experimented with different types of wood and other materials to achieve just the right effect. Each little vessel is constructed the same way its full-sized counterpart was built, with hull framed and planked, and, for sailing vessels, operable rigging. Visitors may admire the details using the magnifying glasses and mirrors that are part of the displays. Sixteen superbly crafted models, reflecting 28 years of his work, are on view in their own gallery.

Among the beautiful examples of sailing ships of the past is an Egyptian vessel with an intricate bas-relief carving on its stern, an English royal yacht adorned with delicate nude

Traditional sailing boats of all types are displayed.

Courtesy of The Mariners' Museum, Newport News, Virginia

figurines, and a stunning 15th century Venetian galleass that is lavishly decorated and populated by 359 carved figures, each performing a task.

In the Great Hall of Steamships, you'll find engaging displays, such as a 32-foot half model of the Cunard liner *Queen Elizabeth*, a model of Lord Nelson's historic *Victory*, as well as less romantic vessels, such as a tugboat and a Japanese freighter. Outstanding examples of the woodcarver's art can be found in the Carvings Gallery. There are trail boards, rudderheads, paddle boxes, and intricately carved figureheads that once adorned a prow. A woodcarver is on hand to give demonstrations.

For carvers and scholars seeking information, an extensive library houses thousands of books, photos, and films. To support the ancient tradition of model building, the museum holds an international model ship competition every five years and displays the winners.

OYSTER MUSEUM OF CHINCOTEAGUE

Beach Road
Chincoteague, Virginia 23336
(804) 336-6117

What better way to celebrate the Chesapeake Bay's hearty watermen, who ply the waters for oysters and crabs in their skipjacks? This museum presents the story of the Chesapeake sea food industry with dioramas, films, tools, shells, and live oyster beds.

WASHINGTON, D.C.

Located within earshot of the Washington Monument, The National Firearms Museum displays $1.5 million worth of rifles, handguns, and accessories that were given to the National Rifle Association (NRA) over the years. If guns are your sport or you want to learn more about them, you'll enjoy this museum housed on two floors in the NRA building. Under the glare of fluorescent lights, surrounded by animal heads on the walls—Asian boar, lion, cape buffalo, wildebeast, antelope—visitors wander past numerous glass cases of guns, each clearly labeled with model, date, and nation of origin. Prominently displayed is the Pennsylvania-Kentucky-style muzzle loader that resembles a gun Davey Crockett might have used; it was presented to president Ronald Reagan in 1981 after the attempt on his life.

According to the NRA, there are four reasons that law-abiding people carry a gun: protection, target shooting, hunting, and collecting, and this collection is organized with these categories in mind. A highlight for target-shooting enthusiasts are seven revolvers belonging to the amazing Ed McGivern (1874 to 1957), who was known and documented to be one of the fastest shot artists in the world. He could cut cards edgewise that were tossed in the air, and he could hit a tin can thrown in the air six times before it hit the ground. He didn't even reach his peak performance until after the age of 50.

An Olympics display case celebrates U.S. sharpshooters, showing their competition rifles, pistols, and medals won. Nearby is an extensive display of ominous-looking weapons favored by different armies throughout history. For example, a muzzle-loading rifle with unique curved stock was used by Moslem armies in the 19th century. Other impressive firearms on view are mystery writer Erle Stanley Gardner's single-action revolver and holster, and a double-barreled flintlock, elaborately engraved and inlaid with gold, which was originally presented by Napoleon to the Marquis Faulte de Vanteaux of Limoges.

The National Firearms Museum

1600 Rhode Island Avenue N.W.
Washington, D.C. 20036
(202) 828-6194
Open: daily, 10:00 A.M. to
4:00 P.M.; closed holidays
Admission: free

143

Guns are serious business to the NRA, which is the primary lobbyist in support of the Second Amendment right of the individual to keep and bear arms, but it also trains private citizens in gun safety and sponsors target-shooting events all over the country. It publishes many pamphlets, which are available to museum visitors, on everything from gunsmithing schools to self-defense with handguns. A pamphlet titled *Gun Safety* includes such helpful hints as "Always point the muzzle in a safe direction," "Know how your gun operates," "Keep your finger off the trigger until you are ready to shoot," "Don't mix alcohol or drugs with shooting," and "Be sure of your target and what's beyond."

The Potato Museum

704 North Carolina Avenue, S.E.
Washington, D.C. 20003
(202) 554-1558
Open: tours by appointment, arranged by mail or telephone
Admission: $2.50 suggested donation

If New York City is The Big Apple, E. Thomas Hughes, founder of The Potato Museum in Washington, D.C., wonders why the nation's capital shouldn't be called The Hot Potato. "Can you think of a city that handles more hot potatoes?" wonders Hughes. The Potato Museum occupies the ground floor of his house, just a few blocks away from the Library of Congress.

What sort of chap would start a potato museum? Tall and slim as a potato stick, Mr. Hughes, who currently teaches at the Potomac School in Virginia, became intrigued with spuds when he taught at the International School in Brussels. He asked his fifth-grade students to find out about the *Solanum tuberosum* and was deluged with material, verifying Louis Pasteur's quote: "Curiosity and interest are immediately aroused when you put into a young person's hands a potato."

Hughes' passion took root and he began to collect potato folklore and specimens from around the world. When the family moved to Washington in 1983, wife Meredith and son Gulliver, referred to as their "tater tot," set up a permanent exhibition and potato library. There are potato songs, poems, jokes, recipes, and postage stamps, as well as potato paper, jewelry, and toys made of or resembling potatoes.

At the museum, we learn that the tuber can be traced to the Indians of Peru and Bolivia and that it was introduced to Europe via the Spanish conquistadors and to North America

through the British colonists. The evolution of potato cultivation is represented by early hoes and pickers' belts through the modern potato combine. One of the most striking exhibits is a potato-powered digital display clock, encased in an oblong plexiglass cube. The contraption uses two potatoes stuck with zinc and copper probes that cause a flow of electrons. "There's enough electrical power in two potatoes to power this little clock for five weeks," boasts Hughes.

The museum's monthly newsletter, *Peelings*, reports on things like the artistic styles of potato mashers and contains potato esoterica. For example, in Lithuania, it was the custom for people dining together to pull each other's hair before digging into a dish of new potatoes. Previous issues have covered such tuber topics as "The Well Traveled Potato," "Mashies," and "Polish, Soviet and Scandinavian Potatoes." Perhaps A.A. Milne summed it up when he said, "If a man really likes potatoes, he must be a decent sort of fellow."

Y ou don't have to know how to read rugs to see the beauty in richly colored handwoven carpets from Armenia or know what a *huipil*, *tzut*, and *smadeh* are to appreciate the delightful clothing from exotic cultures in Central America, the Middle East, and the Orient. These and much more are regularly displayed at The Textile Museum, an elegant establishment on quiet, tree-lined Embassy Row in the nation's capital.

Founded by textile collector George Hewitt Meyers in 1925, this stately museum is housed in two turn-of-the-century Georgian Revival buildings. Its purpose is to encourage a deeper appreciation of textiles by displaying them in a historical and cultural context. Exhibitions draw from a collection of more than 10,000 textiles and 1,000 rugs from all over the world, particularly pre-Columbian Peruvian textiles and Near and Far Eastern fabrics. Two floors of intimate, well lit galleries display changing exhibits with informative plaques and panels. Intricately designed rugs hang on the wall and unique garments are often presented with looms and photographs demonstrating how the designs were created. Due to the fragility of the fabrics—some date back 1,700 years—exhibitions change frequently.

The Textile Museum

2320 "S" Street N.W.
Washington, D.C. 20008
(202) 667-0441
Open: Tuesday through Saturday,
10:00 A.M. to 5:00 P.M.;
Sunday, 1:00 P.M. to 5:00 P.M.
Admission: $2 suggested donation
for adults, $.50 for children
Wheelchair accessible

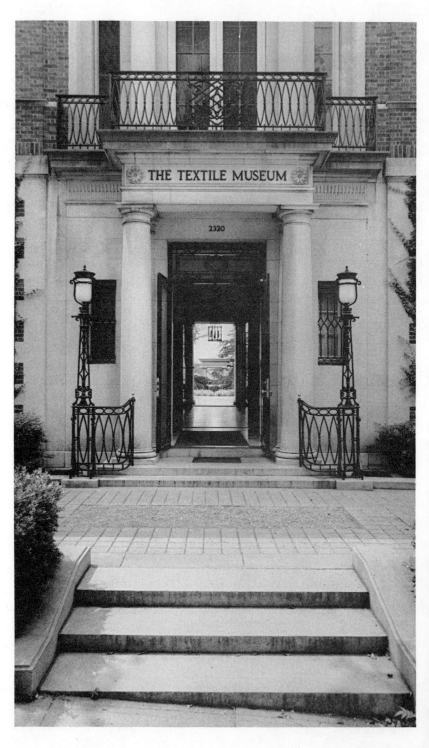

The elegant front entrance to The Textile Museum.

Courtesy of The Textile Museum

Patola are always exotic textiles because the technique of double ikat used to create the patterns is extremely difficult. Indians in the western state of Gujarat, India, perfected this art, in which patterns were tied off in the warp and weft yarns before weaving, enabling them to create intricate patterns in luxurious silks. The four elephants that march along this cloth are rare design species for this type of textile.

Courtesy of The Textile Museum

This fragmentary curtain, or hanging, with medallion portrait from fourth century A.D. Egypt is one of a group acquired by George Hewitt Meyers in 1947.

Courtesy of The Textile Museum

147

The museum's interior creates a serene atmosphere, as does the formal garden behind the buildings, designed around a dragon-shaped fountain. The Arthur D. Jenkins Library is open to the public and the Museum Shop offers an assortment of items, including books, baskets, woven Kelim pillows, shawls, knitting kits, and silk ties.

The Washington Dolls' House and Toy Museum

5236 44th Street, N.W.
Chevy Chase
Washington, D.C. 20015
(202) 244-0024
Open: Tuesday through Saturday, 10:00 A.M. to 5:00 P.M.; Sunday 12:00 noon to 5:00 P.M.
Admission: $2 for adults, $1 for children 14 and under

Founded by dolls' house historian and collector Flora Gill Jacobs in 1975, the Lilliputian world of the Washington Dolls' House and Toy Museum in Washington, D.C., is a treasure trove of antique miniatures. According to Mrs. Jacobs, who continues to oversee museum operations, there is as much to enjoy as there is to learn from dolls' houses of the past.

Her playful inventory amazingly illustrates the architectural styles and decorative arts of byegone eras. A seven-foot-high mansion from turn-of-the-century Mexico is full of subtle details, including a rooftop aviary, working lights, an elevator, and a chapel complete with ecclesiastical furnishings. A mid-19th century New York town house is tastefully appointed with a Biedermeier bed, a marble-topped table, and a baby grand piano with music stand and sheet music. Another ingenious replica is an 18th century Nuremberg kitchen with real earthenware bowls, cooper pots, working kitchen scales, and an ice-cream maker. Mrs. Jacobs points out that these miniature kitchens were more than playtime fantasies; they helped school young German girls for future housekeeping.

The museum's many elegant dollhouses are displayed in glass cabinets that resemble old-fashioned shop windows. An actual antique shop window presents a Main Street of fully stocked and furnished shops, such as a British butcher's shop and a late-Victorian milliner's shop. Rare toys on view are just as incredibly detailed, particularly a Go-Fish game with magnetic fish and bait, a George and Martha do-it-yourself assemblage, and a toy figure fashioned to be Teddy Roosevelt on safari; he's even wearing his familiar pince-nez. The miniature set is replete with wild animals, game rifles, and African warriors.

For young people and serious dollhouse collectors, two gift shops on the second floor stock everything imaginable down to the last elegant detail, including door knockers, hinges, wain-

scoting, and miniscule wallpaper samples. Those who want to stay in touch with the museum and other collectors can subscribe to the *Nutshell News*, the museum's newsletter. Also on the second floor, Mrs. Jacobs has created a charming Edwardian Tea Room, with potted palms and turn-of-the-century decor. Here the museum hosts parties, especially children's birthday parties, and serves sandwiches, lemonade, and cake. The guest of honor receives an autographed copy of Mrs. Jacob's book *The Doll's House Mystery*.

ARMED FORCES MEDICAL MUSEUM

Walter Reed Army Medical Center
14th Street and Alaska Avenue N.W.
Washington, D.C. 20306
(202) 576-2418

Medicine and history mesh at this repository. See the bullet that killed President Abraham Lincoln and the leg of Major General Daniel Sickles, which he lost at Gettysburg and later donated to the museum. Among the artifacts on view are handwritten medical journals of the Vietcong and a mammoth collection of microscopes.

NAVY MEMORIAL MUSEUM

Building #76 Washington Navy Yard
Washington, D.C. 20374
(202) 433-4882

This is the official museum of the U.S. Navy and many items tell the rich history of its warships and sea battles as well as its peacetime contributions to oceanography, space exploration, and navigation. See the 25-ton bathyscaphe *Trieste*, which set a world record by descending 35,800 feet below sea level.

WEST VIRGINIA

BECKLEY EXHIBITION MINE

New River Park
Paint Street
Beckley, West Virginia
(304) 255-6386

Ride in a remodeled coal car through this once working mine as the guide, a former miner, recounts mining stories. Not recommended for the claustrophobic, since you travel through 1,500 feet of underground passageways. But remember, miners often had to crawl on their stomachs to reach the seams of coal.

INTERNATIONAL MOTHER'S DAY SHRINE

Andrews Methodist Church
11 East Main Street
Grafton, West Virginia 26354
(304) 265-1589

Anna Jarvis, a native of the old railroad town of Grafton, thought mothers ought to have a day of recognition and on May 10, 1908 this beautiful church was the scene of the first Mother's Day observance.

TOY TRAIN AND DOLL MUSEUM AND SHOP

High Street
Harpers Ferry, West Virginia 25425
(304) 535-2372

AMERICA ON DISPLAY

Step into the child's world of playthings, both antique and modern. See an operating train layout, celebrity dolls, and some unusual toys.

BLUESTONE MUSEUM

Route 87
Hinton, West Virginia 25951
(304) 466-1454

Almost 100 different stuffed animals, including polar bear, grizzly bear, giant moose, and mountain lion, are on view in natural poses. Indian arrowheads, artifacts, and West Virginia fossils are also displayed.

THE MIDWEST

I f you have a weak stomach, you probably won't want a graphic look at the practice of surgery, from the earliest known brain surgery, discovered on 4,000-year-old Incan skulls in Peru, through 20th century developments in abdominal surgery. Created in 1954 by Chicago physician Dr. Max Thorek and operated by the International College of Surgeons, the International Museum of Surgical Science and Hall of Fame in Chicago has one of the largest collections of medical equipment in the world, and it displays advancements in microscopes, radiology, and urology, among other things. Medical artifacts from 63 countries and every civilization are displayed throughout an elegant four-story mansion, built in 1917 to resemble the Petit Trianon on the palace grounds at Versailles.

Each marble-floored room of the stately lakefront building is devoted to a different country or surgical specialty. On the first floor the United States Room displays Revolutionary War amputation kits, early American microscopes, an exhibit on syringe development, and an iron lung (circa 1920s). The X-Ray Room on the fourth floor documents the history of radiology and includes early X-ray tubes developed at the turn of the century by William Conrad Roentgen and Gustav Bucky (who both died of cancer from overexposure to radiation). On a lighter note, you'll learn that modest Victorians, fearful of this new ray that could "see" through impenetrable solids, developed X-ray-proof underwear.

On the second floor the Speidell Hall of the Immortals is filled with life-size stone sculptures of surgery's contributors, from I-Em-Hetep, an Egyptian physician who wrote the earliest known surgical text 3,700 years ago, and Hippocrates, the Greek surgeon who penned the ethical code of behavior for

International Museum of Surgical Science and Hall of Fame

1524 North Lake Shore Drive
Chicago, Illinois 60610
(312) 642-3555
Open: Tuesday through Saturday,
10:00 A.M. to 4:00 P.M.;
Sundays, 11:00 A.M. to 5:00 P.M.
Admission: free
Wheelchair accessible

physicians, known as the Hippocratic Oath, to Marie Curie, who discovered radioactivity, and Louis Pasteur, who proved the existence of germs and devised the science of immunology.

Before Pasteur and Curie, the Healing Arts were in the dark ages, as you'll learn in the European rooms, where the instruments of bloodletting are displayed. Also called cupping, scarifying, or leaching, this method of "balancing the humours" was prescribed for almost every ailment, from fever to insomnia. Cauterization was another commonly prescribed treatment to remove tumors and close wounds; the tools and descriptive illustrations of this practice can be seen in the Indian Room and the Turkish Room.

Significant advances in surgery came on the battlefields of Europe, where military surgeons were called upon to treat the battered bones, torn flesh, and other gruesome hazards of war. One can't help but wince at some of the primitive knives, forceps, and speculla used before the discovery of anesthesia. Of particular interest in the Dr. Max Thorek Memorial Room is the death mask of Napoleon Bonaparte, who is credited with championing medicine on the battlefield and in the cities he occupied, spreading medical awareness throughout Europe.

Large historical murals and oil paintings on surgical themes can be seen throughout the museum, such as a reproduction of Rembrandt's *The Anatomy Lesson of Nicholas Tulp* in the Netherlands Room. The Hall of Murals displays oil paintings illustrating surgical procedures from childbirth to leg amputation in gruesome detail. Look through a window on the first floor and see an authentic turn-of-the-century Apothecary Shop, complete with mannequin pharmacist and well-stocked shelves and cases.

Three handsomely paneled libraries provide access to rare medical texts, manuscripts, autographs, and letters from famous scientists. A weekly series of free lectures presents surgeons discussing their profession.

It was the late great Ray A. Kroc who, in the mid-50s, foresaw the fast-food future and a Big Mac-ed America. McDonald's, the pinnacle of fast food, has become a sanctuary for millions of families in a hungry hurry, and millions more motorists who aim their stomachs toward the Golden Arches. The sanctity of Kroc's very first McDonald's has been preserved at the McDonald's Museum in the Chicago suburb of Des Plaines, Illinois, a few minutes from O'Hare Airport.

If you deserve a break today and want to salute the McDonald's motto, QSC & V (Quality, Service, Cleanliness, and Value), then tour the vintage 1955 red-and-white-tiled museum, which has been painstakingly restored and refurbished. Fifties nostalgia buffs will enjoy the authentic flashback to the days of bobby socks, pony tails, and Elvis, when windowmen bagged a burger, fries, and a milkshake, and the bill came to 45 cents. Yes, a 15 cent burger was a sweeter time.

McDonald's Number One, a true American landmark, is crammed with period items and memorabilia gathered from basements of McDonald's restaurants across the country. Fresh-scrubbed teenage employees are brought to life in photographs as "Earth Angel," "Rock Around the Clock," and "Hound Dog" play softly in the background. In the gleaming stainless steel kitchen, larger-than-life male mannequins (Kroc didn't hire females until 1968) are posed making cheeseburgers at the grill, peeling potatoes, and running the Multimixer milkshake machine. It's all so real that people driving by have been known to comment to museum guides that they thought they saw the mannequins move. Hamburgerologists will note the classic white shirts, skinny black ties, and paper crew hats of the clean-cut all-male staff. Kroc didn't cotton to long hair, sideburns, mustaches, or tattoos, and his meticulous *Operations Manual* laid down the law: "Hats, shirts, and aprons should never be in a soiled state. In the summertime, it will be necessary for the employees to change their paper hats often as a band of sweat will be noticeable around the front of the hat."

Fifty-two billion hamburgers ago, back in the days when everything was prepared on site, a carefully orchestrated team was required to make hamburgers during peak volume hours. Bunmen placed bun "crowns" and "heels" on the grill as coworkers systematically grilled patties with onions. Meatmen seasoned the patties with salt and pepper as bunmen added a pickle and exactly "twice as much catsup as mustard." Shakemen

The McDonald's Museum

400 Lee Street
Des Plaines, Illinois 60016
(no telephone)
Open: Wednesdays and Saturdays,
10:00 A.M. to 4:00 P.M.
Admission: free
Wheelchair accessible

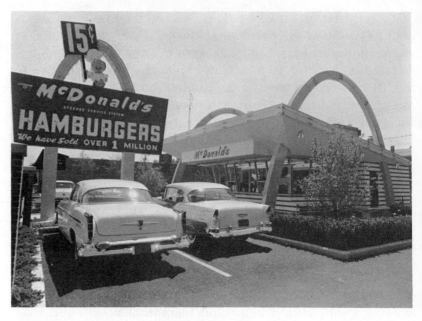

Ray Kroc's very first McDonald's, built in 1955, offers a step back in time, down to the last detail, including vintage 1950s cars parked out front.

Courtesy of The McDonald's Museum

and frymen also had detailed instructions, so that the whole system ran like "Krocwork."

Kroc, a milkshake machine salesman from Chicago, didn't start cooking until 1954, when he became intrigued by a California drive-in that kept eight of his Multimixers running continuously. He flew out to investigate and the rest is "McHistory." Always a loyal guy, Kroc even named the Big Mac after Mac McDonald, one of the brothers who began the original drive-ins. (Would he have dared to name it after Mac's brother, Dick or even himself? Somehow, the Big Kroc doesn't ring as true.)

For many, the McDonald's Museum will serve up memories of that first date, first car, first love. To add to the mood, four immaculately kept cars from the era gleam in the parking lot. A blue and white Super 88 Olds, complete with hydromatic drive, has a sticker on the window, which lists its price at $2,979.36; on the seat of a Chevy Bel Air sport coupe is a high school varsity sweater and a 1955 yearbook; large red foam dice dangle from the rearview mirror of a Ford Crown Victoria; a Davy Crockett coonskin cap nestles on the backseat of a Chrysler St. Regis hardtop.

The museum is particularly busy in summer. As many as 1,200 visitors a week take the 10-minute tour, and see a short

video. Guides tell the entire McDonald's story, from the original "I'm Speedee" logo, which has gone the way of the 15 cent hamburger, to today's high-tech, computerized preparation at more than 8,000 McDonald's worldwide. It's as easy to find a Chicken McNugget on the Champs-Elysees as it is on the Ginza in Tokyo, where the sign reads: Maku-Donarudo. In 1984, a new McDonald's opened every 17 hours. But still, today's milkshake tastes exactly like the one you had last week. Which is just the way Ray Kroc wanted it.

R emembrances of sweet things abound at the one and only Cookie Jar Museum in Lemont, Illinois, where 2,000 cookie jars of all descriptions have been lovingly arranged by curator, owner, and duster Lucille Bromberek, who's one smart cookie.

There is a story under every lid and Ms. Bromberek will recite many of them as she takes you on a tour. A Mickey Mouse cookie jar resides next to Minnie Mouse, Dumbo, Pluto, and Donald Duck cookie jars. Prominent too are Porky Pig and Miss Piggy and a whole brood of piglet cookie jars. In the menagerie you'll see cat, dog, and cow cookie jars in addition to fairy tale cookie jars, like Raggedy Ann, Peter Pumpkin Eater, and Hansel and Gretel.

Lucille began adopting old cookie jars as well as stray lids, tops, and bottoms as part of her rehabilitation as a recovering alcoholic. Her counselor suggested she either travel or collect something. "Travel was out and I didn't know what I could collect. One night, I sat upright in bed and said, 'Cookie jars.' I don't know why, except it was different," she recalled.

The value of a cookie jar depends on its shape, rarity, appeal, and condition. Some of Lucille's jars are domestic, others made in Europe or the Orient. The first in her collection was a present from her husband, a white cookie jar decorated in gold leaf with the name "Happy" on it. She began to build her inventory at garage sales, flea markets, antique shows, and estate sales from Maine to Florida. When she began collecting, cookie jars were inexpensive and easy to find. The Indian Chief she purchased in 1975 for $1.50 is now worth $125. She has paid

The Cookie Jar Museum

111 Stephen Street
Lemont, Illinois 60439
(312) 257-5012
Open: daily, 10:00 A.M. to 3:00 P.M.
Admission: $1.50 for adults, $.50 for children

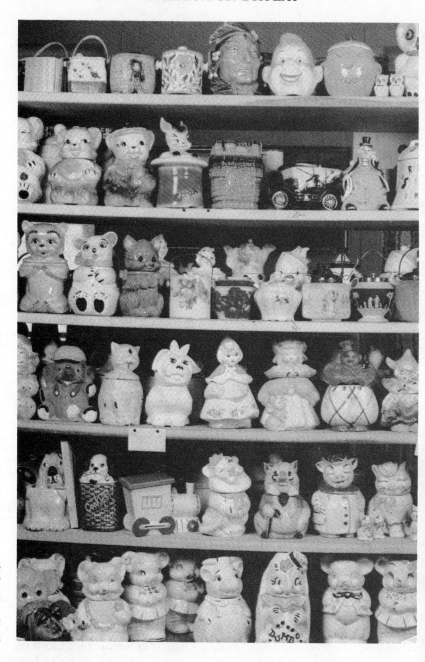

Just a few of the vintage cookie jars on display at The Cookie Jar Museum.

Courtesy of The Cookie Jar Museum

as little as 25 cents for some and as much as $1,500 for the elegant Crown Milanol. Her prized two- and three-color Wedgewood cookie jars with silver lids and other rare glass jars are protected in lighted shopkeepers' cases.

Lucille doesn't have to wonder where to put her Girl Scout cookies. "Can you imagine the mountains of cookies that have gone into these jars," she mused. "I can almost smell the aroma of maple and black walnut." Ever the enthusiastic collector, she collects cookie tins, cookie jokes, and cookie cutters. Her goal is to own one million cookie jars, and she imagines one day enlarging the museum to incorporate a restaurant that reflects the decor, dress, and pastries of different countries. The museum also offers a Cookie Jar Matching Service for your lidless cookie jars and vice versa.

The Bradford Museum of Collector's Plates

9333 N. Milwaukee Avenue
Niles, Illinois 60648
(312) 966-2770
Open: Monday through Friday,
9:00 A.M. to 4:00 P.M.; Saturdays
and Sundays, 10:00 A.M. to
5:00 P.M.
Admission: $2 for adults, $1 for seniors, free for children under 12

There are an estimated eight million plate collectors worldwide, and at the Bradford Exchange in the Chicago suburb of Niles, Illinois, $100 million worth of limited-edition plates are traded in an average year. The Bradford Museum of Collector's Plates, in the same building, displays more than 1,200 porcelain, china, crystal, silver, and wood plates.

Worth more than $250,000, the museum's plate art is suspended from the ceiling in a unique system of transparent plexiglass cases, allowing visitors to view the front and the identifying backstamp. A three-screen video presentation introduces novices to the artists and manufacturers who create these dishy works.

Beautifully decorated plates became a collector's item in 1895, when the famous Copenhagen porcelain house Bing and Grondahl issued *Behind the Frozen Window*, a limited-edition plate on a Christmas theme; it continues to issue one every Christmas.

The Bradford Exchange, created in 1973 by plate importer J. Roderick MacArthur, is modeled on the New York Stock Exchange. Brokers buy and sell plates on a computerized trading floor. It is the most collected artwork in the world; 13,000 plates change hands daily at the exchange. You can watch brokers, in their bright red jackets, from an elevated observation gallery, as they wheel and deal the fragile commodities.

The museum's collection is a three-dimensional catalog of what's available on the market, with its current asking price list-

ed with each plate, and it's displayed in groups by manufacturer. In addition to the complete series of blue-and-white Bing and Grondahl Christmas plates are series issued by Lalique of France, Rosenthal of Germany, and Rorstrand of Sweden. Well known artists, including Renoir, Norman Rockwell, LeRoy Nieman, and Sister M.I. Hummel, have created limited edition plates. *She Walks in Beauty* by Incolay Studios of California, winner of the 1977 Plate of the Year Award, is an intricate example of cameo carving, as is Wedgewood's elegant *Windsor Castle*. Others take a whimsical approach, such as *Scarlett*, the first in a popular Gone With the Wind series, and Norman Rockwell's *A Young Girl's Dream*, both issued by the Edwin M. Knowles China Company.

The award-winning museum exchange building encompasses three lush tropical gardens, complete with bubbling streams, fountains, glass suspension bridges, and stone walkways under a striking series of fiberglass tents and skylights that create the tranquillity of a rain forest. After viewing the collection, stroll through the garden atriums or have lunch on the patio.

The Time Museum

Clock Tower Inn
7801 East State Street
Rockford, Illinois 61125
(815) 398-6000
Open: Tuesday through Sunday, 10:00 A.M. to 5:00 P.M.; guided tours available
Admission: $3 for adults, $2 for seniors, $1 for students ages six to 18, free for children under six
Wheelchair accessible

Time is money, but for Seth G. Atwood, a businessman who made a fortune in automotive supplies, time has a deeper meaning. Fascinated with the history of measuring time, he has amassed a multimillion dollar collection of more than 3,500 timepieces, which are on public view at The Time Museum he founded in Rockford, Illinois. This unusual museum, which draws 50,000 visitors annually, is housed in the Clock Tower Inn, a resort complex built in 1981.

The handsome interior of the museum, with its white walls and Kelly green carpeting, displays intricate models of early timepieces and an amazing assortment of clocks in rich wood-trimmed exhibition cases. There are clocks set in thermos bottles, miniature windmills, and Eiffel Tower replicas. There are examples of early American clocks, Mickey Mouse clocks, Bambi watches, Beatle watches, and even a talking watch that gives the time in English with a Japanese accent. There is, no doubt, the world's most complicated astronomical clock, which

shows the motions of all the planets; the clock arm carrying Pluto revolves once every 248 years.

The exhibition begins with man's earliest attempts at measuring time. There is a model of Stonehenge, the enigmatic circle of stones on England's Salisbury Plain dating to 2800 B.C., which is believed to have been used to determine the solstices and equinoxes on which the calendar is based. The oldest timepiece on view is a 3,100-year-old ceramic lion water clock. Sun dials, astrolabes, and a reconstruction of a complex waterwheel from a Chinese clock designed in 1088 A.D. are equally fascinating examples of ancient timekeeping that show ingenuity and a developing sense of science.

The collection contains accurate reconstructions of a number of 14th and 15th century mechanical clocks. Popular in European churches and monasteries, these devices had no numerical dials, and rang bells to tell the hour. In fact, the word clock is derived from the Old English *clokke*, meaning bell. As timepieces became recognized elements of fashion and cherished pieces of furniture, ornately decorated clocks with moving scenes and sound effects became a symbol of prestige and prosperity. Of special interest is the museum's 10-by-10-foot Goliath clock, built in the late 1800s by German clockmaker Christian Gebhard. It shows time zones, moving angels, and the four stages of life, and every hour one of the 12 apostles passes before a figure of Christ.

As you move from era to era in the chronologically arranged collection, sensors in the museum floor automatically turn lights on as you approach each display. Time flies when you tour this museum, but you'll want to time your arrival at a major piece to see its hourly performance.

AMERICAN POLICE CENTER AND MUSEUM

1130 Wabash Avenue
Chicago, Illinois 60605
(312) 431-0005

To increase civilian understanding and appreciation of police work, visitors view a number of displays showing everything from traffic signals and signs to police equipment from around the world. A panel of the 10 most wanted men is a must-see. In the cooperative spirit of reducing crime, museum curators offer information on how con artists operate and burglars enter homes. A short film depicting police officers at work is followed by a lively question-and-answer session.

**OLIVER P. PARKS
TELEPHONE MUSEUM**

529 South 7th Street
Springfield, Illinois 62761
(217) 753-8436

More than 100 telephones collected by Mr
Parks, an employee of Illinois Bell for over 40
years, are displayed; they include antique
telephones, an underground cable, and the
one millionth pay phone installed in the
Illinois Bell region.

INDIANA

Indianapolis Motor Speedway Hall of Fame Museum

4790 West 16th Street
Speedway, Indiana 46224
(317) 241-2500
Open: daily, 9:00 A.M. to
5:00 P.M.; closed Christmas
Admission: $1 for adults, free for
children under six
Wheelchair accessible

The first Indianapolis 500 road race was held in 1911.
After 235 miles and three fatalities, Ray Harroun was
declared the winner, averaging 55.6 miles per hour, an
astonishing speed at that time. At the turn of the century, In-
dianapolis was America's "motor city," with more than 45 auto
manufacturers in residence. On the 2.5-mile oval-shaped In-
dianapolis Motor Speedway, originally built as a test track in
1909, such innovations as shock absorbers, four-wheel drive,
and experimental fuels progressed.

Set like a giant white monument within the huge oval in-
field, the Indianapolis Motor Speedway Hall of Fame Museum
displays more than 25 winning race cars and other classic and
antique passenger cars that recall earlier days. The jewel of the
collection is the *Marmon Wasp*, the car that won the first Indy
500, which has been restored so that it can circle the track dur-
ing pre-race festivities. Also on view are the Maseratis that won
in 1939 and 1940 with three-time race winner Wilbur Shaw
behind the wheel, and the fuel injection special that carried Bill
Vukovich to checkered flags in 1953 and 1954. Film footage of
old races, including the first race and a close-up of a mechanic
falling out of a roadster, look rather like episodes of the Key-
stone Cops.

In addition to honoring the drivers and mechanics who
won the race, the museum documents the colorful history of the
track, which was named in the National Register of Historic
Places in 1976. The original surface of the roadway was crushed
stone and tar, but potholes threatened the safety of the race and
the owners resurfaced it with 3.2 million paving bricks, which is

The monumental Indianapolis Motor Speedway Hall of Fame Museum is set within the large oval field.

Courtesy of Indianapolis Motor Speedway Hall of Fame Museum

An aerial shot of the famous Indianapolis Motor Speedway on race day.

Courtesy of Indianapolis Motor Speedway Hall of Fame Museum

why old-timers still refer to the track as "the brickyard." Eddie Rickenbacker, the World War I flying ace and former Indy 500 winner, bought the Speedway in 1927 and added a nine-hole golf course in the infield. But the track fell into disrepair during World War II, when all racing was halted, and Rickenbacker sold it to Indiana businessman Tony Hulman, who has continued to make major improvements each year, including the museum-office building in 1976.

For $1, take a bus ride around the track, banking on the turns and following the groove burned in the straightaway. A special memorial to Louis Chevrolet, an early Indy 500 competitor, is adjacent to the snack bar and the "500" Gift Shop, where you can pick up racing jackets, T-shirts, decals, and a wide selection of "500" jewelry.

With improvements in tires, engines, and aerodynamic design, today speeds average more than 200 miles per hour. The bricks are gone now, except for a strip at the start-finish line, but familiar rituals remain: the checkered flag still flutters in the breeze, and every May 25, weather permitting, an official still starts the race with the declaration: "Gentlemen, start your engines."

Wilbur H. Cummings Museum of Electronics

Valparaiso Technical Institute, Hershman Hall
Box 1130
Valparaiso, Indiana 46384
(219) 462-2191
Open: Monday through Friday, 8:00 A.M. to 5:00 P.M.; Saturday, 8:00 A.M. to 12:00 noon (call first for an appointment)
Admission: free
Wheelchair accessible

In an age of radio head phones, transistors, and minirecorders, it's hard to imagine that at the beginning of this century, it required two people to carry a "portable radio." You can see the bulky contraptions, which evolved into today's microelectronic devices, at the Wilbur H. Cummings Museum of Electronics on the campus of Valparaiso Technical Institute (VTI) in Valparaiso, Indiana.

Named for an instructor who once taught at the school, when it was called the Dodge Institute of Telegraphy, the museum was created by a group of students in 1973, when they discovered a warehouse of vintage equipment that was being raided for spare parts. Currently, six students are selected to serve as curators during their senior year, and they create new displays, conduct tours, restore equipment, and solicit donations of artifacts from alumni.

Located in three cluttered rooms of Hershman Hall, the

Just a few of the antique radios on display at the Wilbur H. Cummings Museum of Electronics.

Courtesy of Wilbur H. Cummings Museum of Electronics

museum could be the back room of an old electrical repair shop, except that many of the 1,000 items on display are in glass curio cases. Most of the electronic innovations of the early 20th century—from vacuum tubes to television tubes—are here. Many of them have been restored to working condition and the museum has a "hands-on" policy. Turn on the 1924 Grebe Synchrophase radio receiver, with its three radio bands that once broadcast the music of Toscanini and Bessie Smith, and you'll get a contemporary station in Chicago; crank up the streamlined Seeburg jukebox that plays only 78s, or play a 1930s pinball machine that has real duckpins.

Among the notable gizmos are a 1902 Edison wax cylinder phonograph player, an early model television from the 1940s, and a first-generation IBM computer. There are telegraph machines and antique telephones, a crank-operated switchboard, a series of RCA Radiola radios, a display of speakers, antennae, and vacuum tubes, and a Jacob's ladder, which has a blue spark that perpetually rises between two vertical conducting wires and looks like some instrument from Dr. Frankenstein's laboratory.

The streamlined Art Deco Seeburg jukebox plays only 78s.

Courtesy of Wilbur H. Cummings Museum of Electronics

In addition to all the spare parts on display—microphones, transformers, oscillators, etc.—see the journals used at VTI in 1909, when the school offered the first classes on wireless telegraphy in the country. Photographs of the school's alumni grace the walls.

AUBURN-CORD-DUESENBERG MUSEUM

1600 South Wayne Street
Auburn, Indiana 46706
(219) 925-1444

The Auburn Automobile Company made the stately Cords and Duesenbergs that are now classics, and you can see more than 140 vehicles. There's also a display that spans the history of home entertainment, from the Victrola to radio and television.

NATIONAL TRACK AND FIELD HALL OF FAME

200 South Capitol Avenue
Suite 140
Indianapolis, Indiana 46206
(317) 638-9155

Here is a collection of memorabilia relating to the best American track and field athletes since the late 1800s, with exhibits that honor Jesse Owens, Jim Thorpe, and Ralph Boston, among many others.

IOWA

JOHN DILLINGER HISTORICAL MUSEUM

Van Buren and Franklin
Nashville, Indiana 47448
(812) 988-7172

Find the artifacts and a history of the famed outlaw John Dillinger at this slightly morbid museum, including graphic photographs of his bullet-ridden body, a wax figure of him lying on a slab, along with the trousers, hat, and eyeglasses he was wearing when he met his fate.

THE BIRD'S EYE VIEW MUSEUM

325 South Elkhart Street
Wakarusa, Indiana 46573
(219) 862-4133

Although it started out as a miniature feed mill for his son's electric train layout, Mr. DeVon Rose continued construction until he had replicated the town of Wakarusa in every detail. His layout has won numerous awards.

VAN HORN'S ANTIQUE TRUCK COLLECTION

Highway 65
Mason City, Iowa 50401
(515) 423-0550

The truck stops here, where you'll discover a mint collection of some of the earliest trucks ever made, from 1909 to 1928.

BILY BROTHERS CLOCK EXHIBIT

Spillville, Iowa 52168
(319) 562-3569

In summer, Frank and Joseph Bily worked their farm, but during the long cold winters, they carved elaborate timepieces. More than 20 handcrafted masterpieces are on view in a small brick building. Their Apostle Clock parades the 12 Apostles, one each hour; an American Pioneer Clock shows important events in American history; and others tell time with musical chimes. One clock is made entirely of wood, including the wheels, shaft, and dial hands.

KANSAS

The Eisenhower Center

Kansas Highway 15
Abilene, Kansas 67410
(913) 263-4751
Open: daily, 9:00 A.M. to
4:45 P.M.; closed Thanksgiving,
Christmas, and New Year's Day
Admission: $1 for visitors 16 and
older (for museum only)
Wheelchair accessible

America's 34th president, Dwight David Eisenhower, was born and raised in a small white clapboard house in Abilene, Kansas. Today, the 23-acre Eisenhower Center surrounds his humble homestead with a complex of windowless buildings made of Kansas limestone, including a Visitors Center, library, museum, and Place of Meditation.

Planning for the tribute began in 1945, when a group of local citizens formed the Eisenhower Foundation to preserve the family home and create a memorial to Ike's wartime heroics. The complex grew over the next 30 years and now it's one of the foremost research centers of historical data on World War II and the postwar years, housing over 34,000 objects, 20 million pages of documents, and 300,000 photographs.

At the Visitors Center, a half-hour film, *A Place in History*, highlights the general's life. Nearby is the Eisenhower Home, where David and Ida Eisenhower raised six sons (Ike was the fourth). With its floral-patterned wallpaper, heavy upholstered furniture, and homemade bedspreads and coverlets, it is the quintessential American home of the early 20th century. The furnishings and decor are just as they were when Ida passed away in 1946, even her plants are still thriving in the front parlor's bay window.

The museum is divided into four major exhibition areas: an introductory gallery, a military hall, a presidential display, and special exhibits gallery. In the lobby a large mural of scenes from Ike's life sets the tone. The introductory gallery presents artifacts from his youth and early military career, from West Point to World War II. The military hall documents the war efforts of the four-star general and Commander of the European Theater of Operations. See his uniform, with the famous "Eisenhower jacket," his weapons, and the communications he issued to launch the Normandy invasion, which led to the end of the war. Also on display are his car and other military memorabilia.

The presidential galleries cover the major events of the Eisenhower administration. There are exhibits on his political campaigns ("I Like Ike"), the Korean war, and the many in-

A display of foreign decorations received by General Eisenhower.

Courtesy of The Eisenhower Center

ternational conferences held at the White House. Ike was the first president to utilize television to present his policies, and the Press Conference Room has two video monitors that show selected addresses. Many of the gifts presented to him by heads of state are on view, including a pair of 2,000-year-old Mycenaen cups from the king and queen of Greece, among other treasures. A special area devoted to Mamie shows gowns and jewelry the first lady wore to some of the gala events in Washington.

Across the landscaped lawn from the museum is a formidable Library, with a grand marble lobby. Lectures and seminars are often held in its 175-seat auditorium. Ike's presence is felt throughout the center, but nowhere is it more powerful than in the chapel-like Place of Meditation, where he and Mamie are buried.

A glass model of the U.S.S. *Constitution*, one of many thousands of presidential gifts in the museum.

Courtesy of The Eisenhower Center

Museum of Independent Telephony

412 South Campbell
Abilene, Kansas 67410
(913) 263-2681
Open: April through October, Monday to Saturday, 10:00 A.M. to 4:30 P.M.; Sunday, 1:00 P.M. to 5:00 P.M.; November through March, weekends
Admission: $.50 for adults, free for children under 12
Wheelchair accessible

Alexander Graham Bell's company had exclusive rights to make and distribute telephone instruments, but the patent expired in 1894. Thousands of non-Bell "independent" companies, many of them small mom-and-pop operations, appeared to serve the growing demand for telephone service, especially in rural areas. The Museum of Independent Telephony in Abilene, Kansas, opened in 1973 to honor the men and women who laid the first cables, sometimes on barbed-wire posts, and ran the early switchboards in small towns across the country.

This historical institution presents a unique parade of telephones and memorabilia and a slide show that narrates telephone history. Before computerized switching centers and fiber optic cables, making a long-distance or local call required cranking up a big wooden telephone. One said, "Hello, Central?" and a friendly sounding operator, maybe named Millie or Madge, would connect your call on the switchboard; it was impossible to know if she was listening in on the conversation.

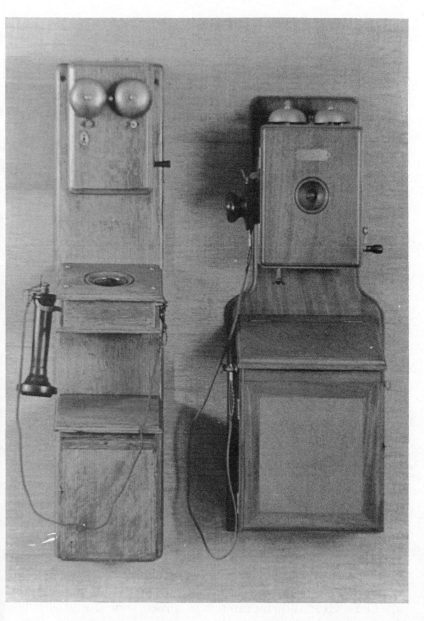

Two early magneto telephones that exhibit fine cabinetry at the Museum of Independent Telephony.

Courtesy of Museum of Independent Telephony

Before there was a telephone in every home, folks had to journey to the nearest pay station at the local hotel, corner drugstore, or telephone central to place or receive calls. The museum tour has a special exhibit of these early commercial telephones on loan from the Smithsonian Institution. Fine cabinetry and shiny brass hinges illustrate their high level of

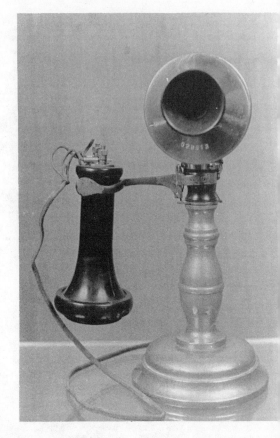

"Hello Central? Get me
Pennsylvania 6-5000."

Courtesy of Museum of
Independent Telephony

craftsmanship. Several have five coin slots, designed to fit
nickels, dimes, quarters, half dollars, and silver dollars.

Glass and ceramic insulators are displayed in specially
made cases. Cast in aqua, amber, and emerald green and shown
against a black and white mural of Main Street (circa 1900),
these unique glass objects resemble delicate works of art. A dis-
play of telephone poles, complete with cable, cross beams, and
insulators, demonstrates the developments in wiring over the
years. Follow the wires to an antique magneto telephone, pick
up the receiver and you can talk to someone on the other side of
the room on a similar telephone.

In one corner of the museum, find a reproduction of a
turn-of-the-century telephone office, featuring one of the last
magneto switchboards still operating in Kansas. Notice the
Calculagraph clock, which was used to time the duration of
long-distance calls, and the iron cot where the night operator
napped between calls.

The largest exhibit in the museum is a chronologically arranged collection of telephones that begins with Bell's first talking machines and progresses through a century of devices to today's sleek push-button systems. Another interesting display traces the evolution of the telephone dial (an innovation introduced by the independents). Pick up an antique earphone at an exhibit of sheet music from the early 1900s and hear tunes, such as Al Jolson's "Hello Central? Get Me No Man's Land," that relate to the telephone.

Hill City Oil Museum

What is a museum dedicated to oil doing knee deep in corn country? The fact is that Kansas has rich deposits of petroleum, natural gas, and other minerals, especially in the northwestern part of the state. To celebrate the good fortune, the Chamber of Commerce of Hill City, Kansas, seat of Graham County and the hub of the Kansas oil industry, opened the Hill City Oil Museum in 1958.

It's hard to miss the one-story wooden building as you drive west on Highway 24—it stands directly beneath an 80-foot-high steel oil derrick; in front is a huge set of bull wheels from an early cable-drilling rig and a pumping unit (circa 1940). Inside this unpretentious little museum, exhibits offer a look at the history and methods of finding, extracting, and processing valuable crude oil.

Set against walls of pegboard and pine paneling are displays that tell how physicists and geologists pinpoint oil deposits and how oil and other minerals were created underground over millions of years. One display of large drilling bits and perforating tools shows what oil men used to bore through clay, limestone, and granite to find oil, and another shows actual core samples from the first oil well drilled in Graham County.

Exhibitions about all forms of oil drilling, from the big ocean-going rigs to the process of grinding shale, were donated by local oil companies. Two pieces of oil-laden shale from Rifle, Colorado, are on view and a plaque informs visitors that oil processors were able to extract 35 to 40 gallons of oil per ton of that particular shale. The most popular exhibit is a working model of an early "cable-tooled," wooden derrick oil well,

821 West Main Street
Hill City, Kansas 67642
(913) 674-5621
Open: year-round, by appointment through the Hill City Chamber of Commerce
Admission: free
Wheelchair accessible

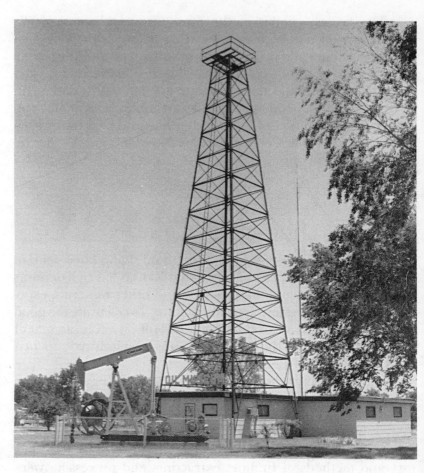

The Hill City Oil Museum stands directly below an 80-foot-tall steel oil derrick; in front are a set of bull wheels from an early cable-drilling rig and a 1940 pumping unit.

Courtesy of Hill City Oil Museum

complete with boiler, walking beam, forge, and miniature tools that move and operate just as an oil well would have at the turn of the century. A collection of old photographs shows men working rigs all over Kansas and Nebraska on similar derricks. Also on view are fossils and mammoth bones excavated on oil expeditions in the area.

The museum is proud to inform its visitors that it covers the story of oil "from start to finish," and so one of the crude's end products is represented by a nine-foot-high bright red Skelly Premium gasoline pump (1922) that stands in front of a mock-up facade of an early gas station.

This display shows how oil and other minerals were created undergound over millions of years.

Courtesy of Hill City Oil Museum

"Don't Fence Me In" is certainly not the theme song of The Barbed Wire Museum in La Crosse, Kansas, where over 500 varieties of barbed wire are on display, as well as fencing and splicing tools used to erect such wire. La Crosse proudly bills itself as The Barbed Wire Capitol of the World and is the home of the Kansas Barbed Wire Collectors Association, cosponsors of the museum. "Until I started working here, I had no idea how many different types of barbed wire there are; some of it can be quite beautiful," says Marlene Woods, secretary-treasurer of the museum.

Located in the La Crosse Chamber of Commerce Building, the museum was established in 1971 and serves as a clearinghouse for collectors—there are more than 10,000 worldwide—seeking information on over 1,000 varieties of the Devil's Rope. Set in framed display cases, each strand is labeled with the wire's name—Glidden's Coil Four Point, Scutt's Plate—and date of manufacture. Clearly, barbed-wire designers of the late-19th century were creative. Scutt's Block and Barb from 1880 has small woodblocks interwoven in the wire for high visibility. J. Brinkerhoff's thick strand from 1881 looks like it would stop a charging elephant. Antique cutters, hammers, pliers, and other tools are on display.

The Barbed Wire Museum

614 Main Street
La Crosse, Kansas 67548
(913) 222-3116
Open: Monday through Friday,
10:00 A.M. to 12:00 P.M.,
1:00 P.M. to 3:00 P.M.
Admission: free
Wheelchair accessible

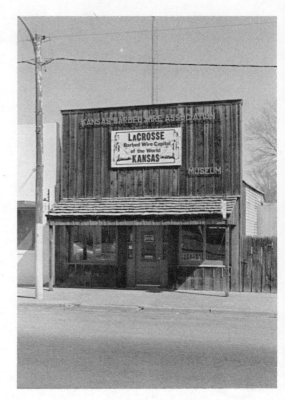

The Barbed Wire Museum, established in 1971, is located in the La Crosse Chamber of Commerce building.

Courtesy of The Barbed Wire Museum

At a safe distance, the history of barbed wire is interesting, but anyone who's gotten torn breeches or a punctured hide knows that the point of barbed wire is to inflict pain. Barbed wire started the bloody range wars between cattlemen and farmers in the late 1800s, but as traveling wire salesmen used to say, "It's light as air, stronger than whiskey, and cheaper than dirt." The rolling fence helped farmers by protecting cultivated fields from wandering cattle and sheep and helped ranchers by containing their Longhorns, eventually taming the West. Today, you can't drive anywhere in the rural West, from Canada to Texas, without seeing the horizontal strands of galvanized fence running alongside the road.

A high point on the calendars of barbed-wire buffs is the annual barbed-wire convention held each May in La Crosse. Here collectors talk, swap wires, and enjoy a barbed-wire auc-

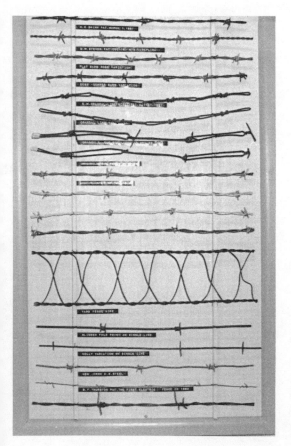

A wide selection of 18-inch strands of barbed wire, the rolling fence that helped tame the West, is set in framed display cases.

Courtesy of The Barbed Wire Museum

tion. Members of the association can participate in the World Champion Barbed Wire Splicing Contest, where each participant struggles against time and tension to splice a strand of barbed wire into an existing fence. Gloves are worn, but no tools are allowed. To choose a winner, a 75-pound weight is placed in the center of each fence to test the strength and sag. Ladies also compete in a Powder Puff contest.

The Swap and Sell session is like a class reunion or pie social, where talk runs to 18-inch lengths of old wire and rare finds; festivities include checking displays and buying, selling, and trading barbed wire; prices range from 25 cents to $500 and higher for a single strand.

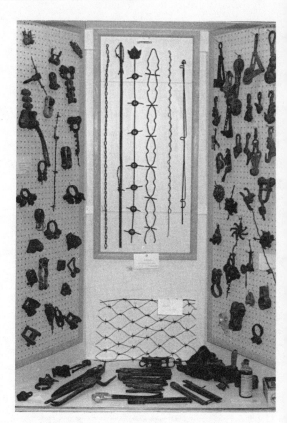

Antique cutters, hammers, pliers, and other tools are featured in display cases.

Courtesy of The Barbed Wire Museum

GREYHOUND HALL OF FAME

407 South Buckeye
Abilene, Kansas 67410
(913) 263-3000

Located in the heart of Greyhound Country, where there are more than 200 breeding farms, the Greyhound Hall of Fame honors the swiftest canines, including famous racers like Gangster, Beach Comber, and Sunny Concern. Exhibits include a history of the breed, which dates back to ancient Greece, and a behind-the-scenes look at dog racing.

AGRICULTURAL HALL OF FAME
AND NATIONAL CENTER

630 North 126th Street
Bonner Springs, Kansas 66012
(913) 721-1075

Dedicated to the rapidly disappearing American family farm, the Ag Hall displays rare and antique farm machinery, a $100,000 barbed-wire collection, and 270 acres of farm-land that is farmed the old-fashioned way. The Hall of Rural Living has antique tools, sewing machines, and handcrafts. The Hall of

Honors pays tribute to American heroes, including George Washington, Thomas Jefferson, and Eli Whitney, inventory of the cotton gin.

THE POST ROCK MUSEUM

202 West 1st Street
La Crosse, Kansas 67548
(913) 222-3645

Wire and post—their functions are intertwined and this museum displays a variety of limestone posts used to support barbed-wire fences in north-central Kansas.

MICHIGAN

As Henry Ford's stature grew as an industrialist, he began to collect the artifacts and mementos of American inventiveness, especially those of his heroes, Thomas Edison and the Wright brothers. Today, the Henry Ford Museum and Greenfield Village in Dearborn, Michigan, is the foremost museum dedicated to the study of American ingenuity.

Never a man who thought small, Ford was inspired to recreate an American small town down to the last detail. Calling the town Greenfield Village, he conceived it as "a walk through American life as lived." More than 100 buildings set on 240 acres depict life from 1800 to 1950. Visitors stroll down shady, tree-lined lanes, past picket fences, through a residential section and a trades and manufacturing area, where craftspeople in period dress perform such tasks as weaving and steam-powered milling. There is even a working farm.

Ford reveled in Americana, traveling the country to amass an enormous collection of historical artifacts. For his passion, he relocated the Wright brothers' old cycle shop from Dayton, Ohio, purchased Edison's laboratories in Fort Myers, Florida, and Menlo Park, New Jersey, and shipped them by boxcar to Dearborn, including 10 tons of red New Jersey clay for authentic dust. No stone was left unturned; even Edison's last breath is preserved in a sealed jar!

The Henry Ford Museum and Greenfield Village

20900 Oakwood Boulevard
Dearborn, Michigan 48121
(313) 271-1620
Open: daily, 9:00 A.M. to 5:00 P.M.
Museum admission: $8 for adults, $7 for seniors, $4 for children ages five to 12
Village admission: $8 for adults, $7 for seniors, $4 for children ages five to 12
A two-day unlimited admission ticket to both the museum and village is available also: $15 for adults, $13 for seniors, $7.50 for children ages five to 12
Group tours are available
Wheelchair accessible

In this study, at the desk in the back of the room, Noah Webster wrote his *American Dictionary of the English Language* in 1828. Built in New Haven, Connecticut, in 1822, the Webster home is an example of classic revival architecture.

Courtesy of The Henry Ford Museum, Dearborn, Michigan

The historic Wayside Inn, moved from South Sudbury, Massachusetts, stands ready to take in weary travelers just as it did centuries ago; a railroad station, shipped from Smiths Creek, Michigan, is the same station where young Thomas Edison was ejected from a train for setting it on fire. You'll see Ford's birthplace, Noah Webster's house, the courthouse where Lincoln practiced law, and the home where H.J. Heinz developed the first of his "57 varieties."

The Henry Ford Museum, located in a sprawling building that covers 12 acres, presents an amazing assortment of historical artifacts, such as the chair Abraham Lincoln sat in the night he was shot, along with the shawl and theater program he was holding, Gandhi's spinning wheel, and a camp bed George Washington used during the Revolutionary War. American furniture, agricultural implements, musical instruments, and domestic items further document the past. The theme of the museum is "American change" and objects are seen as milestones on a steady continuum, from pre-Colonial life through the present. Ford's fascinating Transportation Collection includes his original Quadricycle, a Singer "Ordinary" bicycle, and an assortment of vintage automobiles, motorcycles, bicycles, and airplanes.

Greenfield Village brings a big slice of American history to life and you will want to explore it at a leisurely pace. Take an

A portion of the Henry Ford transportation collection, which displays cycles, trains, boats, and aircraft, as well as automobiles.

Courtesy of The Henry Ford Museum, Dearborn, Michigan

old-time steam railroad around the village or relax on a cruise aboard a paddle wheeler called *The Suwanee*. The Eagle Tavern, a charming riverfront restaurant, and assorted lunch stands offer sustenance. Museum crafts and gifts are available at numerous locations and there are seasonal events, such as the Fall Harvest Celebration and the Fourth of July Parade.

Gerald R. Ford Museum

The Gerald R. Ford Museum, in downtown Grand Rapids, Michigan, Ford's hometown, was built and funded by a group of local businessmen in 1981 to commemorate the life and career of our 38th president. The large triangular-shaped glass and steel structure houses over 10,000 Gerald Ford artifacts, from his World War II Navy uniform and footlocker to the gavel he used to open the 1960 Republican convention; even his christening gown and booties are on view.

The spacious 15,000-square-foot exhibition hall is divided into subject areas, each featuring a different era of Ford's career, tracing his rise as the quintessential all-American boy: Eagle Scout, football star, Navy man, congressman, president. Throughout the hall, his tape-recorded voice can be heard and videotape and film presentations focus on important moments in Ford's life. The result is a comprehensive record of Ford's 25 years in the House of Representatives, the issues he grappled

303 Pearl Street N.W.
Grand Rapids, Michigan 49504
(616) 456-2674, 456-2675
Open: Monday through Saturday, 9:00 A.M. to 4:45 P.M.; Sunday, 12:00 noon to 4:45 P.M.; closed Thanksgiving, Christmas and New Year's Day
Admission: $1.50 for adults, free for children under 16
Wheelchair accessible

The large Gerald R. Ford Museum displays more than 10,000 artifacts of the 38th U.S. president.

Courtesy of Gerald R. Ford Museum

with as president, and events of the Bicentennial and the 1976 campaign, as well as special contributions made by Betty Ford.

Displays of special interest are head-of-state gifts presented to Ford, three dresses worn by Betty, and a full-scale reproduction of the Oval Office, decorated as it was during Ford's two-year term of office, complete with the pipes he smoked and his pen and pencil holder. From behind a velvet rope, visitors can

The museum has a full-scale replica of the Oval Office.

Courtesy of Gerald R. Ford Museum

read plaques that explain interesting facts about the furniture and other appointments; one plaque mentions that Ford had the hidden microphones of the Nixon administration removed from the presidential desk shortly after taking office.

Gerald Ford fans will certainly find the gift shop a must. A popular item is the 75 cent Gerald Ford commemorative coin and there are Gerald Ford pencils, campaign buttons, and candy dishes, a cookbook of Betty's recipes, matchboxes embossed with the presidential seal, and a postcard featuring the Ford's golden retriever, Liberty, on the White House lawn.

Two cement crypts, where Gerald and Betty Ford are to be buried, are situated on a grassy slope off to one side of the museum.

AMERICAN MUSEUM OF MAGIC

107 East Michigan Avenue
Marshall, Michigan 49068
(616) 781-7666

If tricks that baffle the mind are your pleasure, you'll enjoy browsing artifacts once used by Houdini, Harry Blackstone, and other world famous magicians, along with magic apparatus, photographs, films, and paintings all relating to magic.

MINNESOTA

United States Hockey Hall of Fame

Hat Trick Avenue
P.O. Box 657
Eveleth, Minnesota 55734
(218) 744-5167
Open: June 15 to Labor Day,
Monday through Saturday, 9:00
A.M. to 8:00 P.M.; Sunday, 10:00
A.M. to 8:00 P.M.; remainder of
year, Monday through Saturday,
9:00 A.M. to 5:00 P.M.; Sunday,
12:00 noon to 5:00 P.M.
Admission: $2 for adults, $1.25 for
students, $1 for children under six
Wheelchair accessible

Up north, where ice forms nine months of the year and the only thing stopping the chilling arctic winds are a few strands of barbed wire, kids strap on skates and play hockey almost as soon as they can walk. Many of the great players in the National Hockey League are from small American towns like Eveleth, Minnesota, in the Iron Range area of northern Minnesota, site of the United States Hockey Hall of Fame. (There's also a Canadian Hockey Hall of Fame in Toronto, Ontario, and an International Hockey Hall of Fame and Museum in Kingston, Ontario.)

According to the local businessmen and mining executives who conceived the museum, Eveleth is The Capital of American Hockey. A perennial winner of the Minnesota State Hockey Tournament, this mining town of 6,000 has sent more than a dozen hometown boys to NHL teams, including goaltender Michael Karakas, who played for the Montreal Canadiens, Sam Lopresti, a goalie for the Chicago Blackhawks, and Frank Brimsek, "Mr. Zero," who guarded the net for the Boston Bruins.

Believed to have been invented in 1855 by the Royal Canadian Rifles stationed in Kingston, Ontario, hockey (from the French *hoquet*) spread throughout Canada and was introduced to the United States in the 1890s. Today, the Canadian national game is enjoyed in Russia, Sweden, Czechloslovakia, Norway, and Japan.

Completed in 1973, the modern three-story Hockey Hall of Fame presents the world of "hat tricks," "icing," and "zambonis." On the first floor, the Great Hall shows hall of famers' biographies and photographs. The mezzanine level houses the library and a special exhibit to commemorate the gold medal-winning U.S. Olympic hockey teams of 1960 and 1980. The second floor showcases exhibits of high school, college, international, and professional hockey teams and players. An eight-minute four-screen slide show outlines the history of the sport and its popularity.

At many exhibits, pick up an audiophone for information on hockey equipment, skates, and early teams. Experience the game through the eyes of the fearless goaltender, posted at the net, as he deflects the hard rubber puck, which can travel at speeds of 100 miles per hour. In the theater, half-hour hockey films are shown throughout the day and the souvenir shop sells pucks, sticks, and hockey garb in addition to books and trinkets.

The Baaken Library Of Electricity In Life

Scientists, physicians, and anyone interested in plugging into the medical uses of electricity will find the Baaken Library of Electricity in Life, in Minneapolis, Minnesota, a fascinating place to explore. As far back as 1660, Otto von Guericke developed the first electric generator, but for 200 years, before Edison, Marconi, and Tesla, the only uses for electricity were medical therapies. Earl Baaken, an electrical engineer and inventor of the first wearable pacemaker for the heart, began collecting artifacts and books about electrotherapy, primarily from the 18th and 19th centuries. His collection of printed material and more than 1,000 early electrical devices are housed in a vast Tudor-style mansion on the shores of Lake Calhoun.

Among the electrical rarities in this unique museum, which opened in 1976, are a D'Arsonval Spiral, a six-foot-high circular wire cage, used in the 19th century to treat a range of illnesses, from cancer to syphilis. The patient would stand inside a metal spiral that beamed high-frequency radio waves; a plaque notes that this therapy had a healthy effect on tissue but provided no cure. There is also an ornate electric bath (circa 1770), live electric fish, and a collection of artifacts once used by Benjamin Franklin, who was in his day the world's foremost authority on electricity.

The seeds of today's electrosurgery, pacemakers, and electrocardiography can be traced to many of these early tools, but a number of the contraptions were the creations of deluded optimists and downright quacks, such as Dr. Albert Abrams' infamous Hemodimagnometer from the 1920s, which he claimed diagnosed and cured disease. Housed in a handsome Art Deco cabinet, it has a mass of important-looking switches and dials

3537 Zenith Avenue South
Minneapolis, Minnesota 55416
(612) 927-6508
Open: by appointment, Monday through Friday, 9:00 A.M. to 5:00 P.M.
Donations encouraged

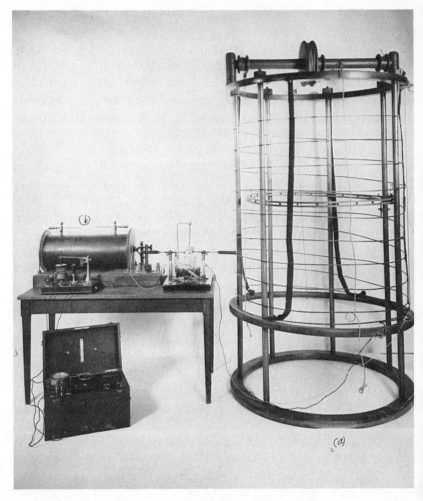

The D'Arsonval Spiral (circa 1894), just the right size for the average modern woman, with its associated equipment. This is the earliest production diathermy machine and includes a medical battery, a Ruhmkorff coil, and a spark-gap oscillator, as well as the spiral itself.

Courtesy of The Baaken Library of Electricity in Life

and when switched on it would glow and hum. Dr. Abrams would pass a blood sample near the antenna and "read" the vibrations for his diagnosis (one of his favorites was "bovine syphilis"). After his so-called treatment, patients were tested and appeared miraculously cured.

The pride of the museum is its collection of 12,000 rare books, manuscripts, and journals, stored in a humidity-controlled vault. Among the documents are a first edition of Benjamin Franklin's 1751 book on electricity, an 1818 edition of Mary Shelley's *Frankenstein*, and at least six books on electricity printed before 1500, some written in Latin before the invention of the printing press.

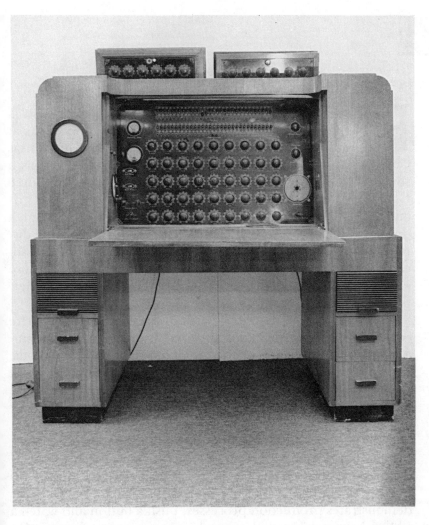

This Hemodimagnometer from the 1930s was purported to diagnose and cure all forms of disease but was actually designed as a painless method of extracting money from a patient's wallet.

Courtesy of The Baaken Library of Electricity in Life

AUNTIE CLARE'S DOLL HOSPITAL AND MUSEUM

22 Greenway Avenue N.
Oakdale, Minnesota 55119
(612) 739-1131

Clarice Erickson collected so many dolls that she opened a museum just to give them a home. Dolls are displayed in various thematic settings—the Saturday night bath, dressing up in mother's clothes—complete with miniature furniture and costumes, and visitors can also see the Doll Hospital, where repairs are made.

MISSOURI

Hallmark Visitors Center

Hallmark Square
Crown Center Complex
P.O. Box 580,
Kansas City, Missouri 64141
(816) 274-5672, 274-3613
Open: Monday through Friday,
9:00 A.M. to 5:00 P.M.; Saturdays
and holidays, 9:30 A.M. to
4:30 P.M.; closed Thanksgiving,
Christmas, and New Year's Day
Admission: free
Wheelchair accessible

For those who really "care enough to send the very best," a tour through the annals of Hallmark Greeting Cards at their $1.5 million Hallmark Visitors Center in Kansas City, Missouri, is just the thing. Hallmark, which began as a small picture postcard publishing company, founded by Joyce C. Hall in 1910, currently produces 11 million greeting cards and 1.5 million products each day. Visitors can stroll through a dozen exhibit areas, ranging from a 40-foot-long time-line display, linking Hallmark cards with 75 years of historical and social change, to graphic and manufacturing displays, where Hallmarkers demonstrate the processes that distinguish their products.

The center features a videotape highlighting the company's sophisticated computerized distribution system, and a display showing state-of-the-art photo-retouching methods. In another exhibit, step onto a huge artist's drawing board and sit on giant paint pots, amid paint tubes, pens, brushes, and markers 15 times their normal size, and view a videotape of artists painting, sculpting, stitching, and drawing.

In the Graphic Arts area, an artist engraver etches delicate images onto metal plates that are used to emboss greeting card designs and an overhead video screen shows close-ups of his work. At the Manufacturing Exhibit, a press operator demonstrates production processes; push a button and watch a ribbon bow-making machine make a star bow just for you. On your way to the Hall of Fame exhibit, see original artwork by Sir Winston Churchill, Norman Rockwell, and Grandma Moses. There you can push a button to select video excerpts from Hallmark Hall of Fame television presentations and see Hallmark television advertising. The tour ends with a 35-millimeter public relations film about the company and its subsidiaries.

Joyce C. Hall was only 18 years old when he arrived in Kansas City to start a picture postcard business. The year was 1910 and the company's first inventory was kept in shoe boxes under Hall's bed at the YMCA.

Courtesy of Hallmark Visitors Center

The Dog Museum of America

Jarville House
1721 Mason Road
St. Louis, Missouri 63131
(314) 822-2112
Open: Tuesday through Saturday,
10:00 A.M. to 5:00 P.M.
Admission: $2 suggested donation

Jonathan Swift once said that every dog must have his day. Now it appears that every dog has a museum. The Dog Museum of America is the place to bone up on the cultural value of man's best friend, and it's surely the only museum where dogs are welcome.

Founded in 1982, this scholarly institution, with corporate support and a Rockefeller on the board, is located in its temporary home, the historic Jarville House in Queeny State Park on the outskirts of St. Louis, Missouri. The museum presents educational programs on various aspects of dogs and their role in man's culture. Intimate galleries throughout the antebellum house show artworks and artifacts relating to the dog. A replica of Elizabeth Taylor's Double Pet Love Seat, upholstered in velvet with convenient pop-open compartments for storing brushes, is an important part of the museum's permanent collection.

A recent exhibition, Presidential Pets: finny, feathered, and furry friends in the White House, displayed a series of black and white prints and photographs illustrating pets and their chiefs of state. It's not surprising to discover that Teddy Roosevelt kept a lion, and that Jimmy Carter was a goldfish man. Warren G. Harding's dog, Laddie Boy, had his own special chair at Cabinet meetings. Harry Truman's cocker spaniel was named Feller. If

Visitors to The Dog Museum of America's exhibition entitled Presidential Pets learned that: A Cocker Spaniel puppy arrived at the White House in December 1947 during the Administration of Harry Truman.

Courtesy of United Press International

190

Queen, a polychromed wood carousel figure of American origin, built in the late-19th century. Artist unknown.

Courtesy of The Dog Museum of America

only these pets could talk—what state secrets, what family indiscretions such pups as Franklin Roosevelt's Fala or Richard Nixon's Checkers could yelp. Several past exhibitions underwritten by dog food companies have toured the country, most notably Fidoes and Heros in Bronze and Hound and Horn.

Museum curator, Barry Neuman, a serious young man with a degree in arts administration, does not own a dog and has never owned a dog, although if animals bear a certain resemblance to their owners, he might own a basset hound. Nonetheless, he is very knowledgeable about the dog in art: "Primitive cave paintings are alive with dogs and the ancient Egyptians worshiped certain breeds as a deity called 'anubis,'" he informed, not at all dogmatically. Mr. Neuman noted that people visit the museum by the busload when dog shows are in town. "Since we started opening on Saturdays, we've gotten a whole

A Dog Walking His Man. This etching from France (circa 1844) was part of an exhibition, The Era of the Pet: Four Centuries of People and Their Dogs.

Courtesy of The Dog Museum of America

new crowd, including couples on dates, families, and groups of young people who come in to browse," he said proudly.

One recent afternoon, a woman wearing a fur coat and fur hat arrived to peruse the show, and the security guard, who might have owned a sleepy boxer, snapped to attention. She took a small wirehaired dachshund out of her designer handbag and set it on the floor, where it wobbled briefly and took a few steps. "Wake up, Maxine," she cooed gently to her miniature pooch, "You'd nap all day if I let you!" Mr. Neuman confided that when true dog lovers come in "they usually get very emotional about the exhibits, and it's really beautiful to see."

At a small gift shop, you can find T-shirts with dog emblems, booklets of past exhibits, and a series of postcards, *Dogs Dressed As Men*, by J.P. Hutto; one shows a white German shepherd dressed in a leisure suit. A unique catalog, *Pampered Pets*, features pictures of a Louis Vuitton dog carrier, a dog's Japanese silk kimono, and a menu from the luxury liner *Ile de France* listing three a la carte meat dishes and a vegetarian platter *pour votre toutou.*

Surely 16th century bowler Martin Luther would be flattered to see himself immortalized in the spanking new 47,000-square-foot National Bowling Hall of Fame and Museum, built in the shadow of Busch Memorial Stadium in downtown St. Louis, Missouri, the bowling capital of the United States. This $7 million shrine to the sport, completed in 1984, commemorates bowling's all-time greats, and features more than 20 comprehensive exhibitions detailing the history of bowling. Touring could easily be an all-day event.

You can begin with a stroll through Tenpin Alley, a curving walkway lined with displays that show the social and recreational development of bowling since its beginning in 5200 B.C. as an Egyptian child's game. One tableau presents cave men tossing rocks in bowling ball fashion.

Brush up on more bowling facts at the American Bowling Congress (ABC) and Women's International Bowling Congress Hall of Fame areas. Did you know that in 1978 the late J. Elmer Reed was the first black to be inducted into the Bowling Hall of Fame? He won his fight for the admission of black bowlers to the ABC in 1950, when convention delegates voted to eliminate the Caucasion-only clause in membership rules. The hall of fame commemorates women champions in lifelike oil paintings and

National Bowling Hall of Fame and Museum

111 Stadium Plaza Drive
St. Louis, Missouri 63102
(314) 231-6340
Open: Monday through Saturday, 9:00 A.M. to 5:00 P.M.; Sunday, 12:00 noon to 5:00 P.M.
Admission: $3 for adults, $2 for seniors, $1.50 for children ages five to 12
Wheelchair accessible

The National Bowling Hall of Fame and Museum has a prime location, across from Busch Stadium and a short stroll from the Gateway Arch.

Courtesy of National Bowling Hall of Fame and Museum

Four lanes dating back to 1924, with pins set by human pinsetters, are featured in the re-creation of an old-time bowling alley. Visitors can bowl four frames on the lanes of their choice for a $1 donation.

Courtesy of National Bowling Hall of Fame and Museum

men in bronze likenesses along with memorabilia of their outstanding achievements.

At the Gallery see special displays donated by star bowlers, such as 81-year-old Maude Woodstrum of Baltimore, Maryland, who gave the blouse and shoes she wore as a member of the championship Diamond Cab duckpin team in 1933-34. A plaque notes that her shoes cost $4 and she purchased them on an installment plan, paying 25 cents a week.

A variety of computer consoles and state-of-the-art audiovisual aids make this one of the most technologically advanced sports museum in the country. Pick up game tips from the pros at *Star Talk*, a sophisticated videodisc program that allows you to "interview" famous players. Then be sure to catch *The World of Bowling*, a widescreen documentary, at the 125-seat *Busch Theater*. On the Hometown Heroics computer, visitors can find out who rolled a perfect 300 in sanctioned competitions anywhere in the country.

Study The World's Most Unusual Collection of Bowling Balls and Pins. No two are exactly alike, and there is a 60-year-old bowling bag in near mint condition, all neatly displayed in

handsome glass cases. The must-see of the museum is the Bowling Pin Car, a 1936 Studebaker coupe remodeled to look like a horizontal pin. Nearby is a patchwork quilt sewn by bowling great Don Carter's mother out of his old bowling shirts.

Ed Marcou, the museum's effervescent director of promotion, is a man who loves his job. He offers an inside tip: "Sure, our hall of fame draws the most oohs and ahhs, but the workable lanes, especially the Oldtime Lanes, are the most fun. Here you have a once-in-a-lifetime chance to bowl the way grandpa and even great grandpa used to bowl."

If you've time to spare, "shake hands with the past" on the Oldtime Lanes, which date back to 1924, located on the museum's lower level. Museum curator Bruce Pluckhahn obtained them as a gift from candy wholesaler Paul Kent of Freeberg, Illinois. They feature 55 laminated planks, compared with today's 39 to 42, and are in surprisingly good condition. For a nominal fee, you can roll a 90-year-old *lignum vitae* (wood) ball at wooden pins set up by pinboys dressed in 1920s garb, or try your hand on the adjacent Ultra Modern Lanes, with all the latest technology, including an automatic computerized scorer.

To recuperate from any gutter balls, stop for refreshments at Cafe 300, just off the spacious lobby-atrium; it has a huge commemorative bowling ball in the middle of the floor, and oversize duckpins hanging from the ceiling. Nearby is the gift shop, with bowling souvenirs and accessories, where you can have your name printed on the back of a bowling shirt.

THE NATIONAL MUSEUM OF TRANSPORT

3015 Barrett Station Road
St. Louis, Missouri 63122
(314) 965-7998

One hundred fifty years of railroad history are shown here, from the pre-Civil War little steam engines to Union Pacific's hulking Big Boy of the 1940s. You'll also find an array of rolling stock—tractors, buses, motorcycles, aircraft, riverboats—displayed over 39 acres.

NEBRASKA

National Museum of Roller Skating

7700 A Street
Lincoln, Nebraska 68510
(402) 489-8811
Open: Monday through Friday,
9:00 A.M. to 5:00 P.M.
Admission: $1 for adults, free for
children under 13
Wheelchair accessible

Blame the mania on madcap inventor John Joseph Merlin, who got the idea of strapping wheels under his boots in 1760 and made roller skating all the rage in Europe. Not without peril, these early skates were impossible to steer, as Merlin himself demonstrated when, unable to stop, he skated through a full-length wall mirror during an exhibition of his new invention in London.

For an in-depth look at the colorful history of the sport—and a collection that includes more than 700 pairs of one-of-a-kind skates as well as costumes, photographs, and related memorabilia—you'll want to walk, not skate, through the National Museum of Roller Skating, located at the Roller Skating Rink Operators Association in Lincoln, Nebraska.

Not until 1863 did James L. Plimpton, a furniture salesman from Massachusetts, come up with a "rocking skate" that allowed skaters to steer by leaning left or right. After patenting

A roller skate made for a skating horse during the 1930s by the Chicago Roller Skate Company is just one of the wheeled objects on display at the National Museum of Roller Skating.

Courtesy of National Museum of Roller Skating

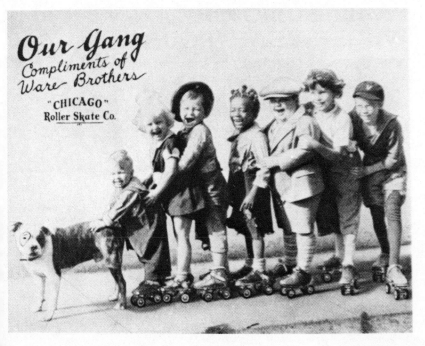

The "Our Gang" characters from the 1930s used roller skates in many of their stories and served as an advertising vehicle for the Chicago Roller Skate Company.

Courtesy of National Museum of Roller Skating

the invention, Plimpton promoted what he considered a genteel activity, and franchised rinks around the country that were carefully regulated—no music, no shouting, and only well-dressed ladies and gentlemen allowed.

But rink operators wanted their rinks to be fun places, and their taste prevailed. To expand the sport's popularity, they initiated teams for roller hockey, speed skating, roller derby, and skate dancing. William Fuller added cachet to the sport when he skated around the world from 1865 to 1869. By the turn of the century, roller skating stars like Jesse Darling, known as the Peerless Princess of the Little Wheels, and Allie Moore packed vaudeville theaters, and entertained the royalty of Europe.

At the 1,400-square-foot museum, rinksters can view videotapes of the annual Artistic and Speed Championships. Here's a chance to see hoof skates for horses, stilt skates for short people, three- and six-wheeled skates, and a pair with interchangeable wheels or blades for all-weather skating. Many historically important skates are on display in large freestanding wooden cases, including a pair of skates (circa 1860) that introduced rubber runners for better traction, and a two-wheeled

A combination skate from 1869, which could be used for ice or roller skating by attaching either the wheels or the blade.

Courtesy of National Museum of Roller Skating

racing skate with aluminum wheels (1903). There are also many skating costumes, which were once worn by such "skatorial" luminaries as Gloria Nord, star of the 1940s vaudeville troupe Skating Vanities; the jersey worn by Bill Henning on his cross-country skate in 1931; and the uniforms of the U.S. World Roller Hockey Team of 1966.

Director and curator Michael Brooslin, who is apt to quip, "Old roller skaters never die, they just lose their bearings," assembled the museum from scratch in 1982. While he knew nothing about roller skating when he began, today Brooslin is a rolling repository of information. "Did you know that a Civil War general contemplated putting his troops on skates? Or that Henry Ford's son Edsel had only one wish for Christmas in 1901—a pair of roller skates?" Hmmm. He edits a quarterly museum newsletter, researches skating history, and continually seeks out skating memorabilia. "I'm still looking for a good set of elephant skates," he sighs.

STRATEGIC AEROSPACE MUSEUM

2510 Clay Street
Bellevue, Nebraska 68005
(402) 292-2001

In this mammoth museum, documenting the U.S. air defense system, are the largest bombers ever built. See a slide show reenactment of a "red alert" as well as uniforms, equipment, and seven different types of missiles.

BOYS TOWN PHILAMATIC CENTER

Father Flanagan's Boys Home
Boys Town, Nebraska 68010
(402) 498-1360

If you collect money, coins, or stamps, there's something to see in this collection, which was donated by Dwight O. Barrett of Tulsa to Father Flanagan's famous home for homeless and handicapped boys just outside Omaha. In addition to international bank notes, see a 600-pound ball of solid stamps, a U.S. Revenue Stamp worth $50,000, and a large assortment of coins, including Swedish *platmynt* money weighing nearly eight pounds.

THE MUSEUM OF THE FUR TRADE

HC 74, Box 18
Chadron, Nebraska 69337
(308) 432-2843

Dedicated to the study of the American fur trade, from Colonial times to the present, this unique collection presents artifacts of trappers, traders, and Indians who made their living hunting buffalo, mink, raccoon, and beaver. Exhibited are trade goods—such as beads, kettles, knives, tomahawks, traps, and Indian blankets—weapons, furs, and the gear used by hunters from different areas of the country. The Bordeaux Trading Post on the museum grounds has been reconstructed at its original 1840 site and is stocked with the typical trade goods of the old West.

CHEVYLAND U.S.A.

Exit 257 I-80
Elm Creek, Nebraska 68348
(308) 856-4208

How would you like to see the only exclusive Chevrolet museum in the country? Pull over to see Chevys in mint condition, e.g., a 1927 Roadster, a 1964 Convair Monza convertible, and a bevy of Corvettes. Don't miss the first Chevy convertible, made in 1950.

NORTH DAKOTA

NORTH DAKOTA SOFTBALL HALL OF FAME

Veterans Memorial Field
Harvey, North Dakota
(701) 324-4227

Equipment and memorabilia of the state's best teams and players.

MUSEUM OF THE YESTERYEARS AT THE GEOGRAPHICAL CENTER MUSEUM

Rugby, North Dakota 58368
(701) 776-6414

Located at the geographical center of North America, this museum celebrates America's past with authentically furnished vintage homes, agricultural implements, and antique vehicles. Don't miss the U.S. Department of Interior collection of stuffed birds.

OHIO

Goodyear World of Rubber

Goodyear Hall
1201 East Market Street
Akron, Ohio 44316
(216) 796-2044
Open: Monday through Friday, 8:30 A.M. to 4:30 P.M.; daily tours at 1:00 P.M.
Admission: free

For centuries, its practical use was to rub out mistakes, which is how "rubber" got its name. Stretch your awareness of rubber as a crucial ingredient of modern life, from baby bottle nipples and basketballs to conveyer belts and tires. These and many more uses are demonstrated at the Goodyear World of Rubber, sponsored by the Goodyear Tire and Rubber Company at its corporate headquarters in Akron, Ohio, the Rubber Capital of the World. Located on the fourth floor of Goodyear Hall, the exhibit pays special tribute to Charles Goodyear, the inventor obsessed with rubber, who devised the method for processing it. You'll find a statue of him clenching two slabs of rubber at the rotunda entrance.

The "vegetable leather," as Goodyear referred to it, is derived from the milky liquid found in wild rubber trees. At the museum, you'll learn that Egyptian hieroglyphics show people

A statue of Charles Goodyear, discoverer of the vulcanization process that made rubber a useful material, stands in the rotunda entrance of the Goodyear World of Rubber.

Courtesy of Goodyear World of Rubber

bouncing rubber balls and that in the 18th and early-19th centuries rubber-coated clothing and mailbags failed because they cracked in winter and melted in summer. But Goodyear was determined to find a solution. In 1839, after years of experimenting, he accidentally dropped a glob on a hot stove and, scraping it off, discovered it had become a hard substance that sustained temperature change. Unfortunately, he died impoverished, never suspecting that one day his name would float on a blimp high above the Super Bowl or that his discovery of "vulcanization," named after the Roman god of fire, would launch the multimillion dollar rubber industry.

Today, vast rubber plantations in Malaysia, Thailand, and Indonesia produce 80 percent of the world's natural rubber.

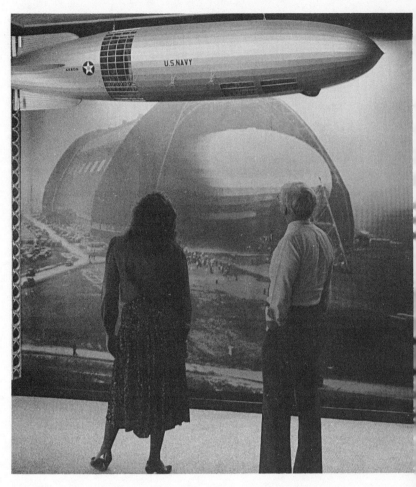

Visitors to the Goodyear World of Rubber inspect a model of the *Akron*, famous U.S. Navy airship, above a photo mural of the huge air dock where the dirigible was built. A film depicting the history of lighter-than-air craft is also part of the exhibit.

Courtesy of Goodyear World of Rubber

Rubber trees are "tapped," much like maple trees, and the sap, called latex, is "sheeted," "creped," "crumed," or "centrifuged" to create a range of rubber products, from tires to foam.

Among the many exhibits that illustrate its uses are a simulated rubber plantation, a moon tire display, and exhibits on rubber making and tire manufacture. Displayed also are two Indianapolis 500 race cars with their fat treadless tires and an artificial heart made of rubber, developed by Goodyear and the Cleveland Clinic, that kept a cow alive for 145 days. Of special note is a re-creation of Goodyear's workshop, complete with an animated mannequin of him performing experiments. Bounce into the Gift Center for a wide selection of Goodyear gifts and rubber souvenirs.

Judging by stadium attendance, television ratings, and opinion polls, football is the most popular game in America. Every year, hundreds of thousands of gridiron pilgrims make the trip to Canton, Ohio, to the Pro Football Hall of Fame. The shrine, which opened in 1965 and has been expanding ever since, honors the men who played the game and presents a living history of football through films, photographs, and artifacts.

The hall consists of four large buildings, and has 51,000 square feet of exhibition space. The main building, with its 52-foot football-shaped white dome pointing heavenward, is truly a temple to the sport. As you enter the lobby, a seven-foot bronze statue of the legendary athlete Jim Thorpe dominates the ramp to the exhibition rotunda. Everywhere you turn you are blitzed with displays detailing the sport: Pro Football Today shows helmets and the current statistics on each National Football League team; in the Pro Football Art Gallery, award-winning professional photographs capture the exciting action; the history of the NFL and the annual Super Bowl blowout are chronicled in the Leagues and Champions Room. The best players in forward passing, receiving, rushing, and scoring are

Pro Football Hall of Fame

2121 George Halas Drive N.W.
Canton, Ohio 44708
(216) 456-8207
Open: Memorial Day through Labor Day, daily, 9:00 A.M. to 8:00 P.M.; remainder of the year, daily, 9:00 A.M. to 5:00 P.M.;
closed Christmas
Admission: $4 for adults, $2 for seniors, $1.50 for children ages five to 13. A special family rate is available
Wheelchair accessible

The exciting action of professional football is captured at the Pro Football Hall of Fame.

Courtesy of Pro Football Hall of Fame

The Walter Payton display commemorates his lifetime rushing record.

Courtesy of Pro Football Hall of Fame

listed in the Top Twenty Display, and figures are changed weekly during football season. In the somber Hall of Heroes, football fans may gaze at bronze busts and detailed biographies of the inductees, such former Sunday heroes as Joe Namath, Gale Sayers, and Vince Lombardi. The Enshrinee Mementoes Room presents famous relics of hall of famers, e.g., the behemoth running shoes of former Chicago Bear running back Bronko Nagurski, and Johnny Unitas' Baltimore Colt uniform, among others.

Test your football trivia skill against Q & A panels, video quizzes, and audiovisual challenges placed throughout the hall. Did you know that professional football in America originated in 1892 in the rough and tumble coal mining towns of western Pennsylvania, or that the NFL was founded in Canton in 1920? You will after a day here, and it's easy to spend the day touring the multitude of exhibits. When your legs get tired, you can watch a different pro football action movie every hour in the 350-seat movie theater.

Every summer, Canton hosts a weeklong Hall of Fame Festival, which includes a grand parade, Festival Beauty Queen Pageant, Fashion Show Luncheon (for the football widows), fireworks, and banquets. The festivities include a ceremony honoring new inductees on the hall's front steps and are capped off by an NFL exhibition game played by two NFL teams across the street on Canton's historic Fawcett Field.

Wyandot Popcorn Museum

No matter how you like it—with butter, garlic, caramel, cheese, chili powder, licorice, or bubblegum flavor—it's almost impossible to eat less than a bucket or see a movie without it. No wonder figures from the Popcorn Institute in Chicago reveal that Americans consume nearly 620 million pounds of popcorn a year.

The best time to pop into a museum dedicated to this irresistible snack is during the Marion, Ohio, Popcorn Festival, held in early September. As the self-proclaimed popcorn capital of the world, Marion goes all out for its annual festival. Traditional events include a grand parade, Popcorn Ball, a Popcorn Queen, Miss Teeny Popper, a popcorn-husking bee, a tug-of-war over a vat of sticky caramel corn, free big-name entertainment, concessions, and exhibits.

Southland Mall
1339 Marion-Waldo Road
Marion, Ohio 43302
(614) 389-6404
Open: Monday through Saturday,
10:00 A.M. to 9:00 P.M.;
Sundays, 12:00 noon to 5:00 P.M.
Admission: free
Wheelchair accessible

This is the third oldest existing Cretors Popcorn Wagon. The Cretors clown and animated cylinder are used for making either popcorn or peanuts. As an attention getter, the machine has a whistle on top triggered by a leather cord. Restoration has been done on all the materials that were used in the original machine.

Courtesy of Wyandot Popcorn Museum

The Wyandot Popcorn Company, sponsors of the museum, located in Marion's Southland shopping mall next to Sears, have been popcorn entrepreneurs since 1935, when W. Hoover Brown began growing popcorn on his 22-acre farm. Today, his sons Warren and George own a company that harvests 22,000 acres of the crop and is one of the world's largest suppliers of raw popcorn.

It may be hard to believe, but popcorn was popular long before it became synonymous with movie theaters. Hundreds of years ago, North American Indians believed demons lived inside the kernels and exploded when heated near an open fire. By America's Colonial days, they regarded it as "friendship food" and introduced it to the pilgrims for their first Thanksgiving. One of the important murals at the ·popcorn museum

depicts a family from the Wyandot Indian tribe, who once inhabited Ohio, enjoying popcorn together.

The museum is proud of its large and skillfully restored collection of gleaming nickel-plated antique poppers and peanut roasters, guaranteed to bring back nostalgic memories of Saturday matinees. The first popcorn machine, invented in 1885 by Charles Cretors, was operated by a steam engine, and by 1899, bright red and yellow popcorn wagons could be seen on street corners across America. The museum has several Cretors machines (circa early 1900s) that are decorated with toy clown ornamentation and show remarkable craftsmanship. A standout in the display is a Stutsman wagon with spring-driven power that proved to be more economical than steam-powered popcorn wagons.

The museum's aroma is hard to resist. Visitors can enjoy a heaping free serving from the intricately designed antique Holcomb and Hoke popper and taste fresh samples from the Wyandot factory. Follow your nose to the gift shop, where you can pick up a variety of corny specialties, including popcorn gift tins, gift boxes, snack packets, and popcorn theme souvenirs. You can even buy Paul Newman's Old Style Picture Show Popcorn—Wyandot is the sole processor—and head home to the VCR.

If you're planning to visit the museum with a group of 10 or more, tours can be arranged by appointment. The program includes speaker, film, and guided walk through the exhibition.

The Hoover Historical Center

I f cleanliness is next to godliness, then William H. "Boss" Hoover—the man responsible for making the vacuum cleaner a household word with his famous slogan "It beats, as it sweeps, as it cleans"—must qualify for sainthood. Women and men across America have a chance to pay their respects to the original dust-buster at the Hoover Historical Center, located on the 82-acre farmland where Hoover was born in North Canton, Ohio.

The serious war against dust began in 1908, when Hoover's cousin, J. Murray Spangler, an asthmatic janitor, invented an Electric Suction Sweeper to reduce his occupational hazards. It was an intriguing contraption with an electric fan mounted to a

2225 Easton Street N.W.
North Canton, Ohio 44720
(216) 499-0287
Open: Tuesday through Sunday,
1:00 P.M. to 5:00 P.M.
Admission: free

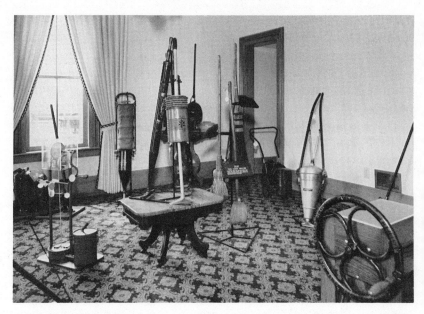

A woman's work was made easier by these early contraptions.

Courtesy of The Hoover Historical Center

brush that swept dust and dirt into an attached pillowcase. When Mrs. Hoover tried out the gadget, her husband was far sighted enough to see its potential. His new business, the Hoover Electric Suction Sweeper Company, was a daring undertaking since electricity was still a novelty and few homes were wired for it. But when he ran an advertisement in the *Saturday Evening Post* that began, "Try this Electric Suction Sweeper ten days free," he was swamped with requests. The rest is floor-care history, much of it presented at the center, which lovingly displays the largest collection of antique and modern cleaning devices and electric carpet sweepers in the world.

The center, which was restored and opened as a museum in 1978 on the 70th anniversary of the company's founding, is a complex of three buildings: the Hoover farmhouse, barn, and tannery, which dates back to the early 1800s. The farmhouse, a showplace of Yankee ingenuity, brings to life the gradual evolution of the vacuum cleaner in photographs, newspaper and magazine advertisements, and historic products. Among the earliest contraptions are hand- and foot-powered carpet cleaners from the mid-1800s, a cumbersome electric sweeper weighing nearly 100 pounds, Murray Spangler's original 1907 upright, as well as the Hoover Model O, which launched the company.

Also on view is the 1926 Model 700, which revolutionized the floor-care business by offering triple-action cleaning—beating, sweeping, and suction—a feature that continues to dominate the industry. New technology and materials —plastics, magnesium, and aluminum, for example—have been used continually to upgrade the Hoover line, and the products that demonstrate these engineering and production advances can be seen along with other recent innovations that have set new standards for housecleaning efficiency and ease.

Guided tours and a 10-minute audiovisual presentation further detail the company's history. Also shown are Hoover products, manufactured and marketed in other parts of the world, where the Hoover name is as famous for laundry appliances as it is for floor care. The center is a hub of community activity and special events that range from old-fashioned sleigh rides to harness making and Victorian crafts demonstrations. Informative lectures on the cultivation and uses of herbs are sponsored by the center's Herb Society, which maintains a spacious herb garden on the grounds.

JOHNSON-HUMRICKHOUSE MUSEUM

300 Whitewoman Street
Coshocton, Ohio 43812
(614) 622-8710

Located in a restored canal village in the quaint town of Coshocton, this museum offers a wide collection of everything from Oriental vases to Hopi *kachina* dolls. In the late 1800s two brothers, David and John Johnson, who were ardent collectors, traveled the world amassing this potpourri, which they left to their small hometown.

TRAP SHOOTING HALL OF FAME AND MUSEUM

601 W. National Road
Vandalia, Ohio 45377
(513) 898-1945

The sport of trapshooting began with live-pigeon shooting in the early 1800s. When pigeons became scarce, sharpshooters began aiming at glass and clay balls launched from catapults. Vandalia is the home of the Amateur Trapshooting Association, the annual Grand American Trapshooting

Tournament, and this unique museum. On view are assorted glass and clay targets, an array of spring-loaded launchers, and patches, medals, and trophies. The hall presents black and white photographic portraits of champion trapshooters and those who've made major contributions to the sport.

NEIL ARMSTRONG AIR AND
SPACE MUSEUM

Interstate 75 at Fisher Road
Wapakoneta, Ohio 45895
(419) 738-8811

Neil Armstrong was the first man to set foot on the moon, and you can set foot in his hometown and visit a fascinating memorial to Armstrong and other Ohioans who blazed the path to space, including Wilbur and Orville Wright. See the F-5D Skylancer jet that Armstrong flew and his *Apollo-11* backup spacesuit in this unique underground museum. The domed Astro-Theater presents a realistic trip to the moon, complete with starry background, and a video room recounts the historic steps taken by Armstrong on July 20, 1969. He planted the America flag and a plaque, which reads: "Here men from planet Earth first set foot upon the moon, July, 1969, A.D. We came in peace for all mankind."

OKLAHOMA

The National Hall of Fame for Famous American Indians

P.O. Box 808
Anadarko, Oklahoma 73005
Open: daily, during daylight hours
Admission: free
Wheelchair accessible

Pocahontas and Geronimo are legendary, but do you know the name of the American Indian who served as vice-president? Former senator and representative from Kansas, Charles Curtis, a member of the Kaw Tribe, was Herbert Hoover's running mate in the presidential election of 1928. For less known, fascinating Native American information not often found in history books, visit the National Hall of Fame for Famous American Indians in Anadarko, Oklahoma, the Indian Capital of the World. It was Allen Wright, chief of the Choctaw Nation (1866-1870), who coined the word *Oklahoma*, meaning "land of the red man," and this state is home to more than one-third of all Native Americans in the United States.

Established in 1952 by a New Yorker named Logan Billingsley, the hall of fame consists of a landscaped outdoor sculpture garden with 25 bronze busts of outstanding Indian statesmen, innovators, and warriors; a brochure is available at the Visitors Information Center that summarizes their con-

tributions. Among the preeminent Native Americas recognized are the great athlete Jim Thorpe; guide and interpreter Sacajawea, a Shoshoni squaw who led Lewis and Clark up the Missouri River in 1805, opening the West to settlement; Sequoyah, a famous leader of the Cherokee nation, who invented the Cherokee alphabet; and Indian historian Roberta Campbell Lawson, a Delaware Indian who became president of the National Federation of Women's Clubs.

The Southern Plains Indian Museum is situated next to the hall of fame and contains an extensive collection of beautiful Indian arts and crafts; Indian City, a nearby attraction, features reconstructed Plains Indian dwellings and a historical museum. If you really want to see more, go to Anadarko in August during the American Indian Exposition, the largest gathering of Native Americans in the world, and enjoy a week full of colorful pageants, ceremonies, and Indian dance competitions.

Will Rogers Memorial and Birthplace

Box 157
Claremore, Oklahoma 74018
(918) 341-0719
Open: daily, 8:00 A.M. to 5:00 P.M.; closed Thanksgiving and Christmas
Admission: free

That very quotable humorist and philosopher, who said, "No man's great if he thinks he is," remains Oklahoma's favorite son, and tribute is paid at the Will Rogers Memorial in Claremore, about 20 miles north of Tulsa. On the 20-acre landscaped hillside of the memorial, which opened in 1938, Rogers lies buried with his wife Betty. Nearby, is a statue of Will loping along on his favorite horse, Soap Suds. "A man that doesn't love a horse, there's something the matter with him," he once quipped.

When visitors enter the foyer of the large stone building, they'll see a bronze statue of Will as he often appeared, in a rumpled suit, hands in pockets, shoulders slightly stooped, with a lock of hair falling on his forehead. Wearing a shy grin, you can almost hear him say the words carved on the statue's base: "I never met a man I didn't like."

Famous for his homespun humor, old Will was a man of many talents: rope artist, trick rider, comedian, daily columnist, movie star, radio commentator, and all-around goodwill ambassador. At the memorial, you can hear Rogers' voice on radio tapes, see him in films and photographs, read his columns, and trace his life through dioramas. Even his trusty Royal port-

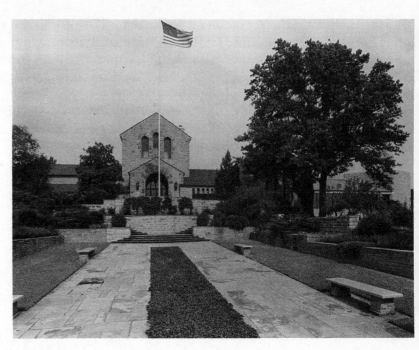

Oklahoma's favorite son is honored at the stately Will Rogers Memorial.

Courtesy of Will Rogers Memorial

able typewriter, which was salvaged from the plane crash that killed him at the height of his popularity in 1935, is on display.

In the Family Room are paintings of Will and a family tree tracing his Cherokee lineage; on view in the Saddle Room is a mural that depicts Rogers' travels from Indian Territory to the polo fields in California, his personal collection of saddles and other Western items, along with mementos from Hollywood. A library contains books by and about Rogers.

"Popularity is the easiest thing in the world to gain and it's the hardest to hold," said Rogers, who starred in 71 films; scenes from such classics as *The Ropin' Fool* and a documentary are regularly shown. Rogers never lost favor, probably because he remained an unpretentious fellow. "I'm just an old country boy in a big town, trying to get along. I've been eatin' regular enough to keep most of the wrinkles out of my belly and the reason I have is because I've stayed an old country boy."

His birthplace is just 12 miles north of the memorial at Will Rogers State Park. There's no admission charge to the comfortable two-story white house, with fireplaces, open porches, and a picket fence, which is in an area of the Cherokee nation. Will was proud of being one-quarter Cherokee: "My ancestors didn't come over on the *Mayflower*," he joked. "They met the boat."

On any summer evening in countless towns across America, teams with names like Doug's Tavern and Elite Coating are playing amateur league softball. More than 202,000 teams are registered with the Amateur Softball Association (ASA), which estimates that over 40 million players in 60 countries—from Botswana to Naru—enjoy the game. In 1973, the ASA opened the National Softball Hall of Fame in Oklahoma City, Oklahoma, and it presents the eventful history of the sport that began as "big ball," "mush ball," "indoor baseball," and "kitten ball."

Legend has it that it all began in Chicago's Farragut Boat Club on Thanksgiving Day 1887, as Harvard and Yale alumni awaited the results of the annual Harvard-Yale football game. When it was announced that Yale had won, one of the celebrating Yalies heaved a boxing glove at a Harvard man, who quickly swatted it away with a broomstick. A reporter named George Hancock put two and two together, and soon two sides had been picked and they began to play an indoor version of baseball.

By the 1920s, it was being played all over the country under a variety of names; it was officially dubbed "softball" at the National Recreation Congress in 1926. Today, softball is split into two devoted camps—fast pitch and slo pitch—and each group claims they are playing the more sophisticated version. Fast pitches are thrown underhand at speeds comparable to major league baseball (the fastest recorded pitch was clocked at 108 miles per hour), while slo pitch deliveries follow a high arc, sometimes 12 feet high at its peak, before dropping down into the batter's strike zone.

The sporty hall, with its crisp astroturf floor, has well lit exhibits and photographs lining the walls that celebrate both forms of the game. A series of stop-action photographs demonstrates the difference between the two styles. Other displays show how aluminum and wooden bats are made, how gloves are manufactured, and how kapok fiber is wound into a sphere and covered with stitched leather to create a ball. Visitors will also learn about "beep ball," a new variation of softball in which an audio signal emitting from the ball enables the blind to play.

In the museum's lower level, visitors sit on wooden bleachers in a miniature softball field and watch video footage from past national softball championships. All types of uniforms, caps, and spikes are displayed on posed mannequins.

National Softball Hall of Fame and Museum

2801 N.E. 50th Street
Oklahoma City, Oklahoma 73111
(405) 424-5266
Open: Monday through Friday,
9:00 A.M. to 4:30 P.M.;
Saturday, 10:00 A.M. to 4:00 P.M.;
Sunday 1:00 P.M. to 4:00 P.M.
Admission: $1 for adults, $.50 for children

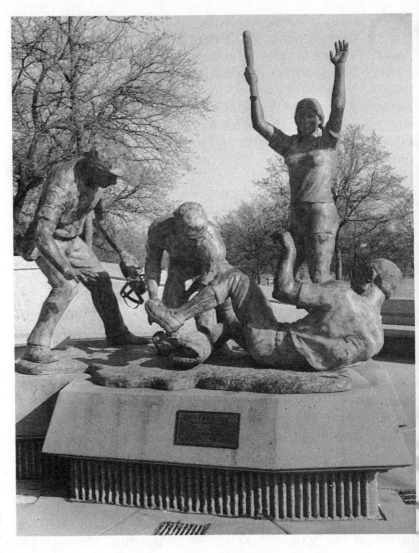

Dedicated to the millions of players and umpires worldwide, the sculpture *Play At Home* greets visitors to the National Softball Hall of Fame and Museum. It cost more than $100,000 and was officially dedicated in 1979.

Courtesy of National Softball Hall of Fame and Museum

The Hall of Honor reveres the great softball players who have excelled at annual championships, such as Harold "Shifty" Gears, who struck out a record 13,244 batters in his career; Joan Joyce, who was voted to 18 consecutive All-American teams; and Margaret Dobson, who set a new record by batting .615 in the 1950 National Tournament. Outside, a large bronze statue, *Play*

At Home, depicts a close play at home plate; an umpire calls the play as a female batter raises her arms in triumph. A small plaque says the sculpture is dedicated "to the softball players and umpires worldwide."

TOM MIX MUSEUM

721 North Delaware
Dewey, Oklahoma 74029
(918) 534-1555

Tom Mix was a real cowboy who broke into silent films in the 1920s and became a major star. In addition to continuously running Tom Mix films, visitors see mementos of his life, including his silver and hand-tooled leather saddle and a full-size replica of Tony the Wonder Horse.

NATIONAL COWBOY HALL OF FAME AND WESTERN HERITAGE CENTER

1700 NE 63rd Street
Oklahoma City, Oklahoma 73111
(405) 478-2250

A 33-foot-high bronze statue of Buffalo Bill astride a rearing horse beckoning the viewer West sums up the sentiment of this proud center. Consisting of a complex built to resemble a group of wagons in a circle, with surrounding landscaped ponds and fountains, the museum displays the art and artifacts of the old West. Dioramas present familiar scenes such as the Silver Dollar Saloon, the Sod House, the Gun Shop, and the Chuck Wagon. Paintings and sculpture include works by Remington and Russell and John Wayne's colorful collection of Hopi Indian *kachina* dolls, guns, knives, and books. Among the monuments to America's vanished past is an immense plaster statue of a defeated Indian on his pony, *The End of the Trail*, by James Earle Fraser, which occupies its own building and is surrounded by Fraser's working models and sculpting tools.

NATIONAL WRESTLING HALL OF FAME

405 West Hall of Fame Avenue
Stillwater, Oklahoma 74075
(405) 377-5243

Learn the history of wrestling through displays, photographs, and audiovisual exhibits; the Wall of Champions honors the great wrestlers, e.g., Olympic champion Jack Van Bebber, coach Billy Sheridan, and Dr. Raymond Clapp, who established many of the rules of wrestling competition.

SOUTH DAKOTA

The Rushmore-Borglum Story Museum

Route 16A
Keystone, South Dakota 57751
(605) 666-4449
Open: mid-April through
mid-October, daily, 7:30 A.M.
to 7:30 P.M.
Admission: $4.50 for adults, $4 for
seniors, $2.50 for students ages
seven to 17, free for children under
seven
Wheelchair accessible

"We will build a monument so high and far away that it will not pay future generations to tear it down," declared the 60-year-old sculptor Gutzon Borglum in 1927 at the ground-breaking dedication ceremony of his colossal creation, Mount Rushmore. Carving the likenesses of four American presidents, George Washington, Thomas Jefferson, Abraham Lincoln, and Theodore Roosevelt, into a massive wall of solid granite was an awesome project that spanned several decades, but Borglum had the vision and talent to match the job.

As you'll learn on a tour through the Rushmore-Borglum Story Museum in nearby Keystone, South Dakota, Borglum was an accomplished artist with political connections and the ability to raise funds for the monumental sculpture, as well as a city planner, political crusader, outspoken critic, and sportsman.

Conceived in 1977, the museum is owned by Dr. Duane Pankratz, a rancher, businessman, and scientist, who became fascinated with telling Borglum's story. His large barn-shaped museum uses the sophisticated lighting and sound techniques developed for the Smithsonian in Washington, D.C.: visitors are guided through Borglum's art and artifacts with hand-held radio receivers that are activated when the visitors approach each exhibit. Attractively presented in intimate displays are Borglum's writings and many photographs of his eventful life, in addition to the largest collection of his artwork—landscapes, busts, figurines, and bas-relief plaques. Borglum studied in Paris with Rodin, and his bronze sculpture *Mares of Diomedes* was the first work by an American to be purchased for the Metropolitan Museum of Art in New York; his early models for it can be seen at the museum. The Lincoln Display shows his working models and carvings for the large marble bust of Lincoln, which is exhibited in the Capitol in Washington, D.C.

A master of inventiveness, Borglum helped devise techniques to accomplish the gigantic Rushmore project. A newsreel film shows him and his crew descending the mountain in specially rigged bosun's seats, which enabled the carvers to work

on the cliffside. The unique tools and measuring devices are on display along with photographs showing how they were used.

The original Rushmore model can be seen in the Men of Rushmore Room; only three figures appear. Teddy Roosevelt, who was the artist's friend and bore a resemblance to him, was a later and controversial addition. Borglum won the fight to have him included, even though critics speculated that it was an egocentric touch. Unfortunately, Borglum never lived to see Rushmore completed. He died in 1941 and the project was finished under the direction of his son, Lincoln, five years later.

WESTERN WOODCARVINGS

Box 747, Highway 16 West
Custer, South Dakota 57730
(605) 673-4404

A unique collection of mechanical woodcarvings depicts scenes from the old West with a humorous touch. Each intricately whittled scenario has been painstakingly carved by the late Dr. H.D. Niblack of Denver, who decorated his creations with clothing, furniture, and miniature props. An Indian beats a drum while his wife rolls her eyes at his insistent pounding, Dusty the Gambler sits at an octagonal table with a beer and a deck of cards, the 1874 Dentist's Office depicts a cigar-smoking dentist struggling to extract a cowboy's tooth as a nurse looks on while picking her nose. The Wooden Nickel Theater presents a biography of Dr. Niblack and shows the creation of a woodcarving from red cedar log to movable figure. The gift shop has hand-carved gifts and starter kits for aspiring woodcarvers.

WISCONSIN

National Fresh Water Fishing Hall of Fame and Museum

Box 33
Hall of Fame Drive
Hayward, Wisconsin 54843
(715) 634-4440
Open: April 15 to November 1,
daily, 10:00 A.M. to 5:00 P.M.
Admission: $3 for adults, $2 for
students 10 to 18, $.50 for children
under 10, free for members
Wheelchair accessible

Bob Kutz is the Walt Disney of freshwater fishing. He and his wife, Fannie, have been hooked on the sport for years, and the National Fresh Water Fishing Hall of Fame in Hayward, Wisconsin, a seven-acre, $2 million complex on the banks of the Namekagon River, is their dream come true. As founder and guiding light, Bob has assembled hundreds of mounted fish displays, antique and classic outboard motors, thousands of antique rods, lures, dated reels, and memorabilia. Founded in 1970, the museum boasts 100,000 visitors a year. It's a must-see for sportsmen and their families who camp and fish in the North Woods.

Surely the biggest attraction is a 500-ton walk-through fiberglass, steel, and concrete replica of a muskellunge, the state fish of Wisconsin. Half a city block long and 4 1/2 stories high, its open mouth is an observation deck that holds up to 30 people. On the landscaped grounds, among paved walkways and colorful flower beds, fiberglass fish sculpture—the Giant Blue

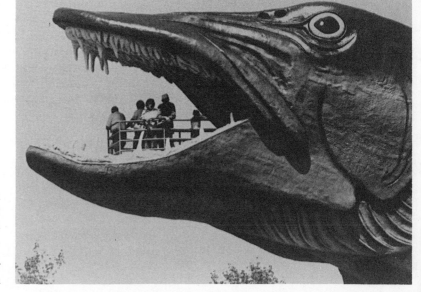

At 4 1/2 stories high, the open mouth of the walk-through "muskie" is an observation deck that can hold up to 30 people.

Courtesy of National Fresh Water Fishing Hall of Fame and Museum

Gill, the Salmon Unlimited Coho—offer a photographic "catch" to amaze fishin' buddies back home.

To sport fishermen, the hall of fame is best known for its Fresh Water Records-Keeping Program. If you're lucky enough to catch a big one and qualify for a record, you receive a certificate of recognition, a world record lapel pin, an embroidered sleeve emblem, and a large embroidered emblem for the back of your fishing jacket. You're also listed in the hall of fame's annual record book, and you get your picture and catch displayed in the World Records Gallery, which occupies an entire museum wing.

The museum's quarterly newsletter, *The Splash*, edited by Bob, is full of recent world and state angling records, as well as news and tips on fishing and boating. For example, did you know that fish can "hear" vibrations? That's why experienced anglers wear rubber soled shoes. You may want to pad your tackle box, too, so as not to scrape the bottom of the boat and scare the fish away. But it's O.K. to holler when you get a bite since fish cannot hear the human voice.

No tribute to the angler and his sport has been overlooked. A variety of mounted fish grace the walls, many of them record catches or unusual species. A 4,000-volume library tells you everything you'd ever want to know about freshwater fishing.

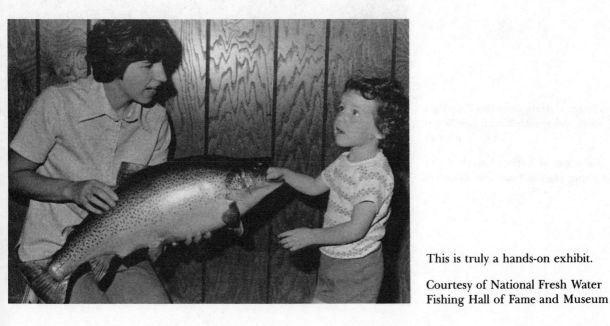

This is truly a hands-on exhibit.

Courtesy of National Fresh Water Fishing Hall of Fame and Museum

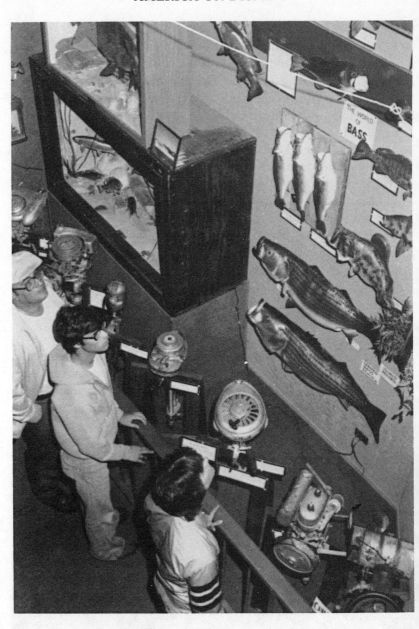

Visitors view the ones that didn't get away, along with antique outboard motors.

Courtesy of National Fresh Water Fishing Hall of Fame and Museum

The museum's outboard motor collection contains many rare engines, including a 1909 Evinrude, invented by Olaf Evinrude, one of the first ever marketed. Also on the grounds is a turn-of-the-century North Woods fishing shack, complete with antique furnishings, an old-fashioned bait shop, and a 19th century reel maker's shop.

WISCONSIN

The gift shop sells fishing caps, books on angling, and hall of fame T-shirts. Kids will find a fish theme playground just for them. For $100, you can even immortalize a deceased loved one on the Memorial Wall in the Big Fish Anglers Shrine; the message is heat-baked onto a glazed ceramic tile. Bob Kutz is proud of the fact that the Fresh Water Fishing Hall of Fame is a living museum with more than 30,000 members. Perhaps his enthusiasm is best summed up in a poem by Betty J. Knauel, a charter member from California:

With an anxious yen
Excited men, seek sport
For which they crave.
With campers packed, the kids
are sacked.
They hit the road and wave!

At the crack of dawn
As the mist wafts on,
They're eager and rarin' to go.
One jerk on the cord,
another one hard,
Across the lake seems slow.

A flip flop here
A fishin's near
Grab the rod and cast.
Out it goes,
plunk, who knows
The fish are workin' fast!

Line one! Line two!
Bait up a few,
The odds are three to one.
Stand up and wait,
anticipate!
By God, but Fishin's Fun!

The Experimental Aircraft Association Aviation Center and Air Museum

3000 Poberezny Avenue
Oshkosh, Wisconsin 54901
(414) 426-4818
Open: Monday through Saturday,
8:30 A.M. to 5:00 P.M.;
Sundays, 11:00 A.M. to 5:00 P.M.;
closed Easter, Thanksgiving,
Christmas, and New Year's Day
Admission: $3 for adults, $1.50 for
seniors, $2 for students ages eight to
17, free for children under eight
Wheelchair accessible

The heroes of Tom Wolfe's book *The Right Stuff* are the tough test pilots and astronauts who pioneered space flight, but he might just as well have been writing about the men and women who design, build, and fly their own aircraft. Their talents are showcased at the Experimental Aircraft Association's (EAA) Aviation Center and Air Museum in Oshkosh, Wisconsin, which records their daring deeds and displays nearly 80 gleaming full-size aircraft that trace the development of flight from the Wright brothers to today's sleek supersonic jets.

Located just a barrel roll from Oshkosh's Wittman Air Field, the sprawling $10 million museum, which opened in 1983, is stocked with planes on loan from EAA members and the association's collection. Paul Poberezny, who founded the organization in 1953, is an aircraft designer and stunt flyer whose energetic promotion of aviation as a sport has culminated in this ultramodern museum.

A museum tour begins in the Hilton Aviation Theater with a short film on the EAA and the experience of flight. When you enter the hangarlike display area, racers, home-builts, antiques, and war planes seem to swoop, roll, and taxi around a reproduction of the original 1903 *Wright Flyer*, complete with Wright brother mannequins, displayed on a bed of sand imported from Kitty Hawk, North Carolina.

Perhaps the most engaging aircraft on view are the home-builts, some constructed in garages from plans in a mechanics

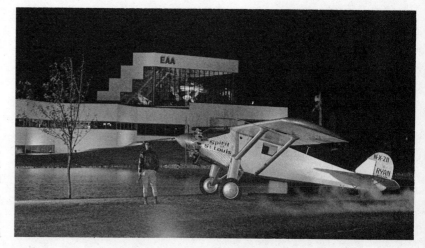

A replica of Lindbergh's *Spirit of St. Louis* at the Experimental Aircraft Association's $10 million Aviation Center.

Courtesy of The Experimental Aircraft Association

Visitors view a Chanute-Herring glider at the Early Flight Exhibit.

Courtesy of The Experimental Aircraft Association

magazine, that have played important roles in shaping modern aviation. Included are Paul Poberenzy's 1954 *Pober Baby Ace* and 1960 *Pober Sport*, which revolutionized homemade aircraft with their simplicity and performance. The home-built that attracts the most attention is a French product, the toylike 1983 *Cricket MC-12*, a miniature twin-engine plane that can be broken down in two minutes for storage in the back of a truck.

On view are aerobatic and racing planes from the 1920s to the present that recall the antic barnstormers and the amazing aerial stunts that pleased crowds at airshows. Among the notable war birds in the collection is the famous Spitfire that defended England so valiantly during World War II; in the Antique/ Classic division, you'll see a replica of Lindbergh's *Spirit of St. Louis*. Miniature helicopters, gliders, solar-powered planes, motorized hang gliders, and the *Double Eagle V* (the first manned balloon to cross the Pacific Ocean, in 1981) round out this extraordinary assemblage.

For flight fans who want more excitement, there are audiovisual stations, models, tools, relief maps, and artwork on view; a popular hands-on exhibit allows you to take the controls and pilot a model of a vintage plane. To witness the craftsmanship involved in restoring or building replicas, there is a viewing

area over the Restoration Shop, where many antique planes are restored to flying condition and occasionally taken out for a spin.

The Boeing Aeronautical Library has a catalog of materials, photographs, films, and audiovisual aids documenting the history of flight. Behind the Aviation Center is a replica of an airfield (circa 1930), called Pioneer Airport. The small hangar, adjacent to a grassy runway, is stocked with antique gas pumps and planes.

DARD HUNTER PAPER MUSEUM

1043 East South River Street
Box 1039
Appleton, Wisconsin 54912
(414) 738-3455

See one of the most complete collections of paper history in the world, covering the entire history of paper making, from ancient China to the present.

GREEN BAY PACKER HALL OF FAME

1901 S. Oneida Street
Box 10567
Green Bay, Wisconsin 54307
(414) 499-4281

Relive the memories of football's "dynasty" team. See mementos of Vince Lombardi, Bart Starr, and Paul Hornung, among many others. In front of the museum, a 15-foot-Packer statue, *The Receiver*, reaches up for a pass while standing on a giant white football that has been autographed by former and current Green Bay Packers. A half-hour film tells the Packers' history as the oldest football team in the country and the first to win four consecutive national championships, including the first two Super Bowls (1967, 1968).

CHRISTMAS TREE STORY HOUSE MUSEUM

3929 80th Street
Box 1157
Kenosha, Wisconsin 53142
(414) 697-XMAS

This museum explains the story of Christmas, from its European roots to its evolution in America.

THE WEST

TOTEM HERITAGE CENTER

601 Deermount
Ketchikan, Alaska 99901
(907) 225-5900

This museum presents a collection of totem poles and the culture of the natives who've hunted and fished the area for centuries. Workshops teach the traditional arts and crafts of the people of the northwest coast of Alaska.

ARIZONA

Industrialist George F. Getz, Jr.'s, passion for fire engines was enflamed in 1955, when he saw an old model in a used-car lot. "It would be kinda fun to have one to drive the kids around on," he commented to his wife. On Christmas morning, a bright red 1924 American La France pumper was parked in his driveway as a gift from her. Today, the museum he established, The Hall of Flame in Phoenix, Arizona, presents the history of firefighting and has more than 130 antique fire engines, some dating back to 1725, as well as helmets, tools, and memorabilia.

Opened to the public in 1974, Getz' international collection brings alive man's constant struggle against fire. Inside the hall, three display areas present hand and horse-drawn pumpers, hook-and-ladder wagons, steamers, parade carriages, and turn-of-the-century motorized fire engines. The oldest is a rare 1725 horse-drawn Newsham Pumper, used to battle blazes in London with firemen working the pump by hand. Also of note is The Badger, a hand-drawn hand pumper from 1860 used in the Great Chicago Fire of 1871 and a five-ton Silsby Steamer from

Hall of Flame

6101 East Van Buren
Phoenix, Arizona 85008
(602) ASK-FIRE
Open: Monday through Saturday, 9:00 A.M. to 5:00 P.M.; closed Thanksgiving, Christmas and New Year's Day
Admission: $3 for adults, $1 for students, free for children under six
Wheelchair accessible

1878, a mammoth steam-driven pump that sucked water from a pond and delivered 600 gallons of water a minute.

Don't miss the international fire helmet collection and an extensive array of British and American fire marks, each with the insignia of the fire insurance company that issued it. If a home had no fire mark, signifying its owner hadn't paid fire insurance, fire brigades would often stand and watch it burn to the ground. Also on view is an elaborate fire telegraph alarm system. The Richard S. Fowler Memorial Library contains more than 4,000 volumes on fire-related subjects. The museum is situated on a park, adjacent to the Phoenix Zoo, Botanical Gardens, and Arizona State University.

THE STRADLING MUSEUM OF THE HORSE

350 McKeown Avenue
Patagonia, Arizona 85624
(602) 394-2264

Railroad heiress Anne Stradling loved horses and opened this museum in 1960 to honor the noble beasts of burden. There are dozens of carts, coaches, and buggies, including a stagecoach once owned by Buffalo Bill and a Conestoga wagon that hauled grain during the Civil War. Equipment on view consists of saddles, harnesses, spurs, bells, and horse-shoes, and there are beautiful examples of equine art by Remington, Russell, and other famous Western painters.

THE BEAD MUSEUM

140 South Montezuma
Prescott, Arizona 86301
(602) 445-2431

This small museum presents a general survey of ancient and contemporary ethnic beads and personal ornamentation. Located in the rear of Liese Interiors, proprietor Gabrielle Liese opened the museum to promote the study of beads. In addition to Asian, Middle Eastern, African, and New World jewelry is a piece from Mesopotamia (circa 2200 B.C.). Don't overlook beads, says Mrs. Liese. After all, a handful of beads purchased Manhattan.

Neon artist Lili Lakich has a unique vision of America's cultural heritage. "Europe has its castles, cathedrals and statues, but America's monuments are her neon signs, like the cowboy on a rearing horse twirling a lasso or the drum majorette spinning her baton on the back of a drive-in movie screen," she says. That's why she and fellow artist Richard Jenkins created the Museum of Neon Art (MONA) in 1981, which collects, restores, and exhibits neon, electric, and kinetic art.

"We focus on art that shares the common bond of electricity and motion," says Lakich, who began the museum in 1981 by donating her studio space in a converted warehouse in Los Angeles to see a long-time dream materialize. Above the entrance to MONA is the museum's logo, created by Lakich—a silkscreen and neon sculpture of the Mona Lisa with pink and blue florescent accents that squiggle and jump. MONA, a fitting acronym, because the museum justifiably elevates neon art to its proper artistic status.

The spacious gallery displays works tapping every sensibility from political satire and humor to abstract geometric shapes and amazing optical effects. New works by Lakich, Jenkins, and other contemporary artists glow and wink next to mechanical sculptures that whirl, bounce, and make odd noises. Dave Quick's tongue-in-cheek homage to Americana delights visitors. In one of his pieces, a mechanized wooden box contains the Pillsbury Doughboy, chained to a suburban kitchen, complete with miniature Campbell Soup cans and cupboard doors that open and close. When you push a button, a giant hand reaches in to poke him in the belly and he squeals and giggles.

MONA's permanent collection of more than 100 works are presented in thematic shows, which change every three months. Past exhibits have included Ladies of the Night and Things That Go Bump in the Night. In addition to presenting new works, the museum preserves and restores the few remaining old signs from neon's glorious heyday. Among the rare relics on display

Museum of Neon Art

704 Traction Avenue
Los Angeles, California 90013
(213) 617-1580
Open: Tuesday through Saturday,
11:00 A.M. to 6:00 P.M.
Admission: $2.50
Wheelchair accessible

The Museum of Neon Art's logo is a silkscreen and neon sculpture of the Mona Lisa, created by museum founder Lili Lakich.

Courtesy of Museum of Neon Art

are a 12-foot 1923 electrical marquee from L.A.'s Melrose Theater.

In 1910, a Frenchman Georges Claude discovered that electrifying glass tubes of neon mixed with helium, krypton, argon, xenon, and other gases created a glowing color spectrum. It was a Packard showroom in Los Angeles that hung America's first neon sign in 1923 and it stopped traffic. Corporations across the

country began to hire "benders" to design and shape neon logos to flash over their headquarters.

By the 1950s, bars, movie houses, and strip joints sported blaring neon icons to beckon customers. With the introduction of cheaper and less complicated plastic signs, neon lost its appeal and came to be regarded as sleazy, garish, tacky. Some cities even banned outdoor neon, and many of the best displays, such as Mobil Oil's winged horse Pegasus, with its galloping legs and flapping wings, were torn down.

Thanks to the efforts of Lakich and her colleagues, who have been working in the medium since the mid-1960s, neon has been slowly regaining status and undergoing a renaissance of sorts. Shopping malls, restaurants, film sets, and even banks are utilizing neon, although the work is often more subdued and simpler than in the past, when the vibrant glow of neon warmed downtown nights in cities across the country.

Western Railway Museum

If the clang clang of trolley bells and the chugga chugga of brakes are music to your ears, then head for the tracks at the Rio Vista Junction, a former railroad station on the North Sacramento line that has become a unique showplace for a delightful collection of more than 85 old trains, trolleys, and pieces of historic railroadiana. In 1960, a group of historians and dedicated train buffs from California's Bay Area Railfan Association bought the junction and converted it into the 25-acre Western Railway Museum. Train devotees volunteer their time to restore old steam engines, repair track, and enjoy the thrill of preserving an era by driving old trolley cars.

The focus of the museum is to showcase and restore electric rail cars, trolleys, and interurban trains of the early 20th century, which are displayed on outdoor tracks and in carbarns. You can ride on some that chug around a 1 1/2-mile track outfitted with overhead electric trolley wires. Five vintage steam trains are an important part of the collection, including the Old Western Pacific Engine No. 94, built in 1909, which is occasionally fired up for a joyride.

Highway 12
Rio Vista, California 94571
(415) 653-3303
Open: Saturdays, Sundays, and holidays, 12:00 noon to 5:00 P.M.
Admission: $3 for adults, $2 for students and seniors, $1 for children ages three to 11, free for children under three
Wheelchair accessible

Visitors marvel at Western Pacific No. 94, the steam engine that pulled the first passenger train through the Feather River Canyon in 1909 and one of more than 100 pieces of antique railway operating equipment at the Western Railway Museum.

Dave Young, Western Railway Museum

The first commercially run streetcars appeared in 1888, and within 30 years, 70,000 were hauling passengers in and around America's burgeoning cities, until their popularity declined in the 1920s and 1930s with the proliferation of the automobile. The museum proudly exhibits a vintage collection of trolleys, including a 1920 Birney streetcar; designed by Charles O. Birney, it was the first to be mass-produced. Smaller than most, it was affectionately known as Dinky by passengers and motormen, and the museum's No. 62 Dinky is fully restored and operational.

The museum especially prizes a streamlined blue and gold No. 1003 Muni Magic Carpet trolley, known for its smooth ride. Five of these experimental cars were made for the 1939 San Francisco World's Fair and this is the only one left. Other rolling treasures include a pair of New York El cars from 1887 and the famous Iron Monster, San Francisco's streetcar from the 1920s through the 1950s.

Since the museum depends on donations and volunteer labor, restoration is a slow process, sometimes taking 10 years and costing up to $50,000. On a stroll around the grounds, you'll see cars in various stages of repair by restorers who are eager to discuss their work.

The museum's bookstore has an extensive railroad bibliography. Shady picnic areas with redwood tables and benches provide a leisurely respite among the rolling pastures of the Sacramento-San Joaquin delta.

The Tattoo Art Museum

30 Seventh Street
San Francisco, California 94103
(415) 864-9798
Open: Tuesday through Saturday,
12:00 noon to 6:00 P.M.
Admission: $1 suggested donation

The exotic art of tattooing dates back to figures in cave paintings and has been practiced by every culture in the world. Renowned tattoo artist Lyle Tuttle is determined to elevate this often misunderstood artform. He has created a fascinating Tattoo Art Museum to preserve the history, artistic styles, and mystique of the ancient art of body decoration, tattooing, and ritual scarification. Founded in 1974, it is located on San Francisco's colorful Seventh Street, one flight up and adjacent to Tuttle's tattoo parlor.

Tuttle, who studied with American tattooists and spent time in the Orient learning from the great Japanese masters, is known as Tattooer of the Stars. In the past 30 years, he has put his mark on more than 30,000 people, including Peter Fonda, Joan Baez, and J. Paul Getty, III. To Tuttle, beauty IS truly skin deep. A striking man, with long white jowl-length sideburns, his body is covered with 400 tattoos by artists from all over the world. In the early 1970s, he journeyed to Western Samoa, where generations of natives have worn tattoos as badges of honor. They were so impressed with Tuttle's tattoos that they made him a chieftan.

Tattoos have long been associated with sailors and circus sideshows, and for a time it was considered a barbaric practice and decried as un-Christian. According to Tuttle, the craft first fell into disregard in the eighth century. "That's when the Pope banned body painting, and tattoos became the province of the outlaw and the adventurer," he explains. But its popularity has fluctuated over the years. Captain James Cook reintroduced it to polite European society when he brought back Polynesian natives covered with designs, and it became a trend among wealthy Europeans and even royalty. King Edward VIII, Czar Nicholas II, and King George V were all proud possessors of tattoos.

It isn't necessary to be in the market for a tattoo to visit the museum. Tuttle considers it an educational resource, not a

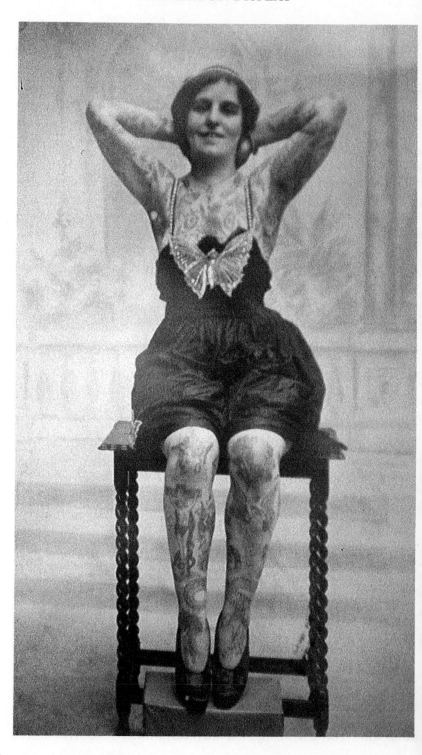

A turn-of-the-century tattoo
collector shows off her artwork.

Courtesy of The Tattoo Art
Museum

promotion of his own work. The small museum presents a range of tattoo forms, from primitive and ritualistic to the circus side-show variety. The tools of the trade have changed, and one exhibition traces the evolution from manual tattoo machines, used for thousands of years, through spring-powered devices to today's electrical and transistor-operated equipment. The personal histories of many famous tattoo artists, such as Doc Forbes or Ralph Kaufman, are carefully preserved in displays. Featured is an important collection once owned by British tattoo artist George Burchett, known as The King of the Tattooists because he left his mark on both King Alfonso of Spain and King Frederik of Denmark, among other royalty. It contains thousands of hand-drawn designs, which served as the tattooist's sales aid.

In the World War II exhibit, you'll find insignias, banners, flags, and other nostalgic patriotic symbols. In contrast to the mermaids or heart and eagle "armpatch" tattoos of the West, the museum also features the work of Oriental artists, whose classical designs of tigers, dragons, chrysanthemums, and ocean waves often ornament whole sections of the body. The great Japanese tattoo artist Horiyoshi creates elaborate full-body artwork inspired by elegant 19th century woodblock prints.

Tuttle established a Tattoo Hall of Fame in 1981, which immortalizes in bronze portraits the great artists as well as famous tattoo "collectors," as he calls them. His first inductee is Betty Broadbent, one of the last of the tattooed ladies in circus sideshows. After saving for two years, Betty went to New York City and had her entire body tattooed in 1927 by Charlie Wagner, a leading artist of the day. Ringling Brothers and Barnum and Bailey Circus signed her up, and she became a main attraction in the sideshow tent, demurely disrobing to reveal wondrous worlds of color and design for awestruck spectators. As the tattoo evangelist, Tuttle articulates his passion: "Tattooing is truly the magic art, found in every land from Alaska to Zanzibar. It's the most unique way to satisfy a personal desire for individuality."

Winchester Mystery House

525 South Winchester Boulevard
San Jose, California 95128
(408) 247-2000
Open: daily, 9:00 A.M. to
5:00 P.M.; closed Christmas
Admission: $8.95 for adults,
$7.45 for seniors, $4.95 for
children ages six to 12, free
for children five and under

To Mrs. Sarah Pardee Winchester, eccentric heiress of the Winchester Rifle Company fortune, an unemployed carpenter was unthinkable. She hired carpenters and craftsmen to transform a modest eight-room farmhouse in San Jose, California, into a 160-room, $5.5 million mansion, now called the Winchester Mystery House. Workers toiled 24 hours a day, 365 days a year, some remaining on the job for 20 years, and the house still isn't finished.

Designed by Mrs. Winchester, doors open to blank walls and staircases lead to nowhere—on purpose. You might well ask why, and the answer to this mystery is Mrs. Winchester's obsession with the occult. She fervently believed that the deaths caused by the famous Winchester rifle, "the gun that won the West," which had been invented by her father-in-law, would haunt her family. After the death of her husband and infant daughter, she sought the advice of a medium, who must have had a contractor in the family because she convinced Mrs. Winchester that as long as hammers kept pounding and workmen kept building, any evil spirits lurking about would be appeased.

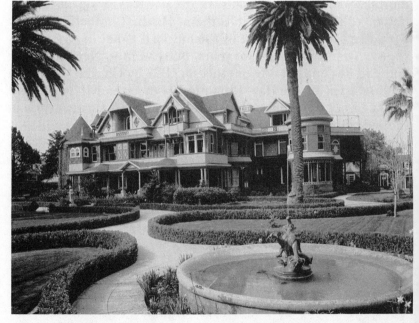

The elaborate features of Sarah Winchester's $5.5 million Victorian mansion provide a picturesque background for this restored fountain.

Courtesy of Winchester Mystery House

Any 160-room mansion would be worth a visit, but the Mystery House has even more to recommend it. Resplendently designed by Mrs. Winchester, who spared no expense—it has modern heating and plumbing systems, button-operated gas lights, three working elevators, and 47 fireplaces. Room after room shines with inlaid parquet floors, Tiffany art windows, and gold and silver chandeliers.

Each room of the grand mansion reflects Mrs. Winchester's mystical bent. The number "13" recurs throughout: there are 13 cement blocks in the Carriage Entrance Hall, 13 lights in the chandeliers, 13 bathrooms, 13 windows and doors in the Sewing Room, and 13 parts to her will, which she signed 13 times. Perhaps the doors that open to blank walls and staircases that lead nowhere actually did disorient the spirits as planned. She died in 1922 at the age of 83.

Beautiful Victorian gardens surround the complex. Mrs. Winchester employed eight gardeners, and imported trees, shrubs, and flowers from all over the world. The Victorian-era house includes many balconies, turrets, towers, arches, cornices, trellises, cupolas, and more than 10,000 windows.

Also on the premises are two museums—the Historic Firearms Museum has one of the largest Winchester rifle collections on the West Coast and the Antique Products Museum displays cutlery, flashlights, lawn mowers, fishing tackle, and farm tools manufactured by the Winchester Products company in the years following World War I.

BANANA CLUB MUSEUM

2524 El Molina
Altadina, California
(818) 798-2272

Yes, they have bananas—history, industry, and banana references throughout the world.

PACIFIC FILM ARCHIVE

2625 Durant Avenue
Berkeley, California 94920
(415) 642-1124, 642-1412

View rarely seen American and foreign films in this unique archives for film scholars.

LAWRENCE WELK MUSEUM

Lawrence Welk Resort Village
8975 Lawrence Welk Drive
Escondido, California 92026
(619) 749-3000

Located in the center of his mobile home retirement community, the Lawrence Welk Museum displays the world's largest champagne glass, a life-size bandstand, complete with music stands and instruments ready to pick up and play. Have your photograph taken on a video monitor as you stand next to a cardboard cutout of Mr. Welk.

THE FOOTHILL ELECTRONICS MUSEUM OF THE PERHAM FOUNDATION

Foothill College
12345 El Monte Road
Los Altos Hills, California 94022
(415) 960-4383

Here are a wide array of antique electronic gadgets, e.g., early spark-gap transmitters, Fleming Valves, and pre-World War II TV receivers. See the first commercial radio broadcasting station, once owned by tinkerer Charles Herrold, who started broadcasting music and advertisements in San Jose in 1909.

WATTS TOWERS OF SIMON RODIA and WATTS TOWERS ART CENTER

1727 East 107th Street
Los Angeles, California 90002
(213) 569-8181

Between 1921 and 1954, Mr. Rodia built eight mammoth towers, two of them more than 100 feet high, out of discarded materials—bottles,

seashells, crockery, dismantled pipe structures. One day, he announced he was finished, deeded them to a neighbor, and left town. Today it is a Los Angeles landmark.

WELLS FARGO HISTORY MUSEUM

444 South Flower Street
Los Angeles, California 90017
(213) 683-7166

Learn about the original Western courier; sit in a rocking carriage, and hear about an 1859 cross-country trip. See guns, treasure boxes, and a two-pound gold nugget.

THE EXPLORATORIUM

3601 Lyon Street
San Francisco, California 94123
(415) 563-7337

Founded in 1969 by physicist Dr. Frank Oppenheimer, this unique museum's purpose is to inspire awareness and discovery in science, art, and human perception. Located in the cavernous Palace of Fine Arts, more than 600 ingenious interactive exhibits encompass and connect such themes as the physics of light, vision and color perception, sound and hearing, motion and balance, and electricity.

THE SAN FRANCISCO FIRE DEPARTMENT MUSEUM

655 Presidio Avenue
San Francisco, California 94115
(415) 861-8000

On thematic display is the city's first fire engine, The Protection, built in 1810, and an assortment of uniforms, bells, helmets, leather

buckets, and speaking trumpets. Of special interest are photographs of yesterday's firefighters, beginning with San Francisco's first volunteers in 1849. A special exhibit commemorates the disastrous fire of 1906.

THE WORLD OF OIL

Chevron USA
555 Market Street
San Francisco, California 94105
(415) 894-4895

See exhibits on exploration, production, and refining, and view a multimedia show to learn the history and uses of petroleum.

CALIFORNIA OIL MUSEUM

1003 Main Street
Santa Paula, California 93060
(805) 525-6672

Located in the original building occupied by the Union Oil Company in 1888, the museum contains antique tools and oil equipment, as well as early records and artifacts of Union Oil.

THE ROY ROGERS MUSEUM

15650 Seneca Road
Victorville, California 92392
(619) 243-4547

Once past the 24-foot statue of Trigger up on his hind legs and inside the fort-shaped building, visitors see famous saddles and the stuffed carcasses of Trigger, Buttermilk, and Bullet the Dog. Whoa Nelly! There's lots of Roy and Dale's artifacts, including wedding photographs, hunting trophies, and Roy's favorite bowling ball—a clear plastic ball with a photograph of Trigger embedded in the middle.

COLORADO

Museum of the American Numismatic Association

818 North Cascade Avenue
Colorado Springs, Colorado 80903
(303) 632-2646
Open: Tuesday through Saturday,
8:30 A.M. to 4:00 P.M.
Admission: free
Wheelchair accessible

It's a coin collector's dream. Oversize replicas of pesos, guilders, yen, francs, and other international coins are mounted in the entrance rotunda of the Museum of the American Numismatic Association, located in Colorado Springs, Colorado, on the campus of Colorado College. Since the 1920s, members of the ANA have donated rare collections, which comprise the thematic displays on view in eight handsome galleries in this museum. Currency includes ancient and modern coins, paper money, and the symbolic monies of non-Western bartering cultures.

More than a good investment, many coins and related items are works of art and historic significance. At the museum, you'll review the history of coinage, which began with the Greeks, who were the first to imprint sculptural images on precious metal nuggets. This practice became the model for European and American minting. The sculptural relief on Greek coins was based on Greek art, allowing historians to see renderings that were described by Greek writers but were subsequently lost or destroyed.

The theme of the Modern Metallic Art Hall is coins as art. It displays coins and medals commemorating such events as space exploration and the Statue of Liberty's centennial. American history buffs will enjoy the Hall of Presidents, a comprehensive exhibit of the coins and paper money issued at the birth, death, and inaugural year of each president, accompanied by their signatures and engraved portraits. The Americana Galleries presents American money from Colonial times and the establishment of the Philadelphia Mint in 1792 through Civil War currencies up to the present. The Amos Press Theater shows films and slide presentations on numismatic topics.

If you have rare coins and would like them authenticated, the staffs of the ANA Library and ANA Certification Service will be available if arrangements are made in advance.

Yeeeehaaaa! Can you rope a calf, throw a steer, or ride a buckin' bronco or a Brahman bull? Those who have distinguished themselves in the uniquely original American sport of rodeo are honored at the ProRodeo Hall of Champions and Museum of the American Cowboy. This entertaining and educational monument in Colorado Springs, Colorado, located in the rugged countryside near the foothills of Pikes Peak, was created in 1979 to preserve the legacy of the cowboy and his competitions. If you want to touch a hundred-year-old saddle, stare a Brahman bull square in the eye, or meet a rodeo clown, the bull rider's best friend, this is the place. Within 25,000 square feet of well-designed exhibition space, the history of the American cowboy, the early West, and professional rodeo come alive.

The tour starts in Theater I, with an electronic multimedia presentation that takes visitors on a trek through the old West, and in Heritage Hall, attractive displays trace the development of ropes, saddles, chaps, boots, and other cowboy gear over the past hundred years.

Rodeo began as informal competitions on the Western prairies, where cowboys would challenge each other in roping and riding. Along with the entertaining Wild West shows, the

ProRodeo Hall of Champions and Museum of the American Cowboy

101 ProRodeo Drive
Colorado Springs, Colorado 80919
(303) 593-8847, 593-8840
Open: Memorial Day through
Labor Day, daily, 9:00 A.M. to
5:00 P.M.; remainder of year,
Tuesday through Saturday,
9:00 A.M. to 4:30 P.M.;
Sunday, 12:00 noon to 4:30 P.M.
Admission: $3 for adults, free for
children under 12
Wheelchair accessible

In the outdoor garden a real rodeo clown kids around and talks with visitors about the sport of rodeo.

Courtesy of ProRodeo Hall of Champions and Museum of the American Cowboy

241

Oscar, the Brahman bull, charms a
young visitor.

Courtesy of ProRodeo Hall of
Champions and Museum of the
American Cowboy

sport organized and grew at the turn of the century. Today,
there are 600-plus rodeos annually, where spectators can cheer
their favorite contestants, who compete for millions of dollars in
prize money.

For armchair cowboys, Theater II recreates a bone-rattling
Brahman bull ride from atop the bull and simulates "ridin'
down the road" with rodeo cowboys. The Hall of Champions
showcases trophies, buckles, and tools of rodeo heroes. Western
art graces the hallways and waiting areas, and each display is
highlighted by a bronze sculpture depicting a scene from that
event. An outdoor exhibit garden has a rodeo arena, complete
with a retired champion saddle bronc, Brahman bull, and Texas
longhorn steer. In summer, a bullfighter/rodeo clown discusses
the tricks of his trade with visitors.

Teddy Roosevelt wore nine-foot wooden skis and Gerald Ford favored six-foot Rossignols. You'll learn these and other facts about the popular winter sport at the Colorado Ski Museum. Located in a cozy little pine-paneled ski lodge on the shuttle route between Vail Village and Lionshead, the museum is packed with artifacts that trace the evolution of Colorado skiing from the 1880s to its current status as a million dollar tourist industry.

Detailed exhibits explain the history of skiing, which began 6,000 years ago. Imagine trying to maneuver on snowshoes made of reeds and animal skins, as the hunters in Central Asia did. When the Mongolian hoardes invaded Europe, they brought skis with them. Norwegian miners taught the skills of making skis to fellow miners in Colorado more than a century ago. With more than 100 inches of snowfall in winter, these long wooden boards, primitive by today's standards, gave new freedom to Coloradoans, who used them for transportation until, at the turn of the century, they discovered skiing could be fun.

The Hall of Fame Gallery honors those who have made major contributions to Colorado skiing, such as early ski pioneer Carl Howelsen and Graeme McGowan, one of the original hot doggers. Ascend a ramp to the Ski, Boot, and Pole exhibits,

Colorado Ski Museum

15 Vail Road
P.O. Box 1976
Vail, Colorado 81658
(303) 476-1876
Open: Tuesday through Sunday, 12:00 noon to 5:00 P.M.
Admission: free
Wheelchair accessible

This display tells the history of the U.S. Army's 10th Mountain Division, which trained in winter warfare and survival in Colorado during World War II.

Courtesy of Colorado Ski Museum

which present the story of ski equipment, arranged chronologically. You can compare the heavy wooden slabs and long single pole of yesterday to today's fiberglass skis and lightweight aluminum poles, designed for safety. Fashion on the slopes has become downright fashionable, thanks to new and lightweight fabrics, as you'll see in a retrospective exhibit on ski wear.

In 1912, Carl Howelsen of Norway organized the first Winter Carnival at Hot Sulphur Springs, and sport skiing in Colorado was launched, including the daredevil sport of ski jumping. As you'll see at the museum, the pioneer ski jumpers must have had snow on the brain, since the early jumping skis did not have reliable bindings and frequently fell off in midair. During World War II, the Army's 10th Mountain Division trained in winter warfare and survival in Colorado. After the war, many ski troopers returned and opened ski areas, and the Army offered its surplus skis to the public, boosting Colorado to the status of premiere ski resort. The self-guided tour concludes at the Museum Theater, where you can see the best of Colorado skiing and ski racing on film.

JACK DEMPSEY MUSEUM

402 Main Street
Manassa, Colorado 81141
(303) 843-5207

See Jack's boxing equipment and personal artifacts.

NATIONAL CARVERS MUSEUM

14960 Woodcarver Road
Monument, Colorado 80132
(303) 481-2656

View more than 4,000 woodcarvings created by American carvers, including an 87-foot chain carved from a Ponderosa pine tree. The Baseball Diamond features baseball bats carved with the faces of top players. Woodcarvers are on site to demonstrate their art and answer questions.

U.S.S. ARIZONA MEMORIAL

Pearl Harbor
Honolulu, Hawaii
(808) 422-0561

See a 20-minute film and exhibits document-ing the Japanese attack on Pearl Harbor December 7, 1941, including the sunken battleship U.S.S. *Arizona*.

IDAHO

V isitors are encouraged to wear comfortable shoes and dress according to the weather when taking a self-guided walking tour of the Old Idaho Penitentiary and grounds, located 2 1/2 miles east of Boise, Idaho. Built in 1870, this his-toric complex of imposing buildings, many constructed by con-victs, reflects the harsh correctional practices that date back to Idaho's days as a wild territory. You can traipse through the compound and inspect special areas, such as the Punishment Block, known as "Siberia," Death Row, and the Gallows.

Of the 13,000 prisoners who did time in the penitentiary, more than 500 escaped, some successfully. Displays include accounts of escapes and punishment methods, such as the ball and chain and the "Oregon boot," a metal brace that was locked to the foot, making it impossible for a convict to run. On view are old photographs of lawmen and famous inmates, such as 11-year-old James Whitaker, who was incarcerated in 1912 for kil-ling his mother. The public is also invited to inspect the War-den's Office, which has an elaborate eight-foot-high safe.

Life on the inside is further revealed in the Dining Hall, which is surrounded by a moat to provide natural light for a basement laundry, bakery, and plunge bath. Until 1967, prisoners were required to eat meals in silence while an armed

The Old Idaho Penitentiary

2445 Old Penitentiary Road
Boise, Idaho 83702
(208) 334-2844
Open: daily, 12:00 noon to
4:00 P.M.; closed state holidays
Admission: $3 for adults, $2 for
seniors and children under 13
Wheelchair accessible

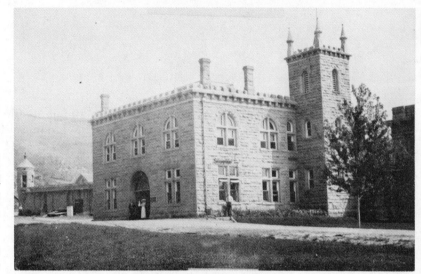

Built by convicts in 1894, The Old Idaho Penitentiary Administration Building now houses the museum and is the starting point for tours.

Courtesy of The Old Idaho Penitentiary

The North Wing of the 1899 cell house at The Old Idaho Penitentiary is largely unchanged today. When last used in the 1960s, it still had buckets for sanitation.

Courtesy of The Old Idaho Penitentiary

Convicts who escaped from The Old Idaho Penitentiary were tracked down by these bloodhounds.

Courtesy of The Old Idaho Penitentiary

guard observed them from an elevated balcony. Any complaints about the comforts of home life may be quieted after a look at the unlit, unheated cement cells in the Solitary Confinement building, not to mention the buckets used for sanitation. No wonder a 1973 riot finally shut the place down for good.

In its hundred-year history, the Women's Ward housed 215 women, and every attempt was made to keep them well behaved. A huge tree in the Back Yard was felled after women prisoners climbed it to do a striptease for the men across the wall. The ward had its share of rule breakers; infamous Lyda Southard, who was sent to prison in 1921 for murdering her fourth husband and had served 10 years, escaped temporarily with the help of her convict-lover.

When you're ready to bust out, the Old Prison Quarry Trail is a lovely walk. It passes the sandstone quarries where the prisoners loaded and hauled tons of stone to build the prison and its 17-foot-high walls.

MONTANA

TOWE FORD MUSEUM

1106 Main Street
Deer Lodge, Montana 59722
(406) 846-3111

Review the most complete collection of Ford cars, trucks, and station wagons on exhibit anywhere, including every Ford model made from 1903 through 1952.

NEVADA

The Liberace Museum

1775 East Tropicana
Las Vegas, Nevada 89119
(702) 798-5595
Open: daily 10:00 A.M. to 5:00 P.M.; Sundays, 1:00 P.M. to 5:00 P.M.
Admission: minimum tax-deductible donations $3.50 for adults, $3 for seniors, $2 for children
Wheelchair accessible

Find the glittering world of Mr. Showmanship inside the white Spanish-style stucco Liberace Museum in Las Vegas, Nevada, with its red-tiled roof and arched windows draped in velvet. Outside is the star's glowing signature in orange and yellow neon. Women have been known to swoon when they catch a glimpse of his smiling eyes in the life-size portrait near the piano-shaped visitors desk. According to museum director Dora Liberace, widow of brother George, more than 110,000 fans each year cross its marble floors, which reflect the sparkle of candelabras, crystal, and jewels, to view Liberace's opulent custom-designed cars, multimillion dollar wardrobe, antiques, and rare pianos.

"I started collecting pianos and other antiques before it became fashionable. It always seemed to me that when you have something beautiful, it's a shame not to share it," Liberace confessed. "I'm an incurable collector."

And collect he did. The knees grow a bit weak as one tries to take in his dazzling array of costumes. There's a copy of George V's coronation cape, covered with $60,000 worth of rare chinchilla; a costumed Liberace mannequin adorned in a piano-motif suit of solid silver and black glass bugle beads; not to mention a knockout black diamond mink coat and his Czar Nicholas uniform with 22-karat gold braiding.

One of the features of The Liberace Museum is a replica of his closet, with its million dollar wardrobe and his sparkling Baldwin grand piano.

Hank deLespinasse, The Liberace Museum

Liberace was equally proud of his vintage automobiles. Standouts on view are a Model A Ford Roadster with a rumble seat, a customized English taxi, a candelabra-crested Cadillac and a red, white, and blue Rolls Royce, which was featured in his Bicentennial show at the Las Vegas Hilton. Exhibited with it is the matching feather cape that he wore when he flew 35 feet in the air amidst blazing fireworks.

And then there are the pianos. He owned 22, and five of the world's rarest are at the museum, including one that Chopin played and a concert grand once owned by George Gershwin. Perhaps the most spectacular of all adorned his finger. It's a ring shaped like a piano, with 250 diamonds in an 18-karat gold setting, and has piano keys of white ivory and black jade.

Not bad for a precocious musically talented boy from West Allis, Wisconsin, named Wladziu Valentino Liberace, "Lee" to his friends. His trademark—a dazzling smile, flamboyant wardrobe and jewelry, candelabra, and glass-topped piano—attest to his place in the *Guinness Book of World Records* as the highest paid musician and pianist.

This piano-playing peacock was passionate about his miniature piano collection, worth an estimated $2 million. It contains more than 500 replicas, including one painstakingly crafted out of 10,000 toothpicks. Other outstanding pieces are a jeweled

piano given to him by Queen Elizabeth II, an antique porcelain piano with nude pictures hidden in a secret compartment (he used to hide them from his mother), and a miniature music box piano dating to Napoleon's court. "I believe I have every miniature piano ever made," Liberace twinkled.

The collection also ranges from more humble items—his mother's knitting basket and his first electrified candelabra—to rare artifacts—an inlaid crucifix presented to him by Pope Pius XII. Included are hundreds of newspaper clippings and inscribed photographs from practically everyone in the Western world. Among the unique items from his adoring fans is a miniature tableau of the maestro at the piano fashioned entirely of bread dough and glue, which took Mrs. Nola Becker of Norwalk, Ohio, six months to complete.

The museum is catty-corner to Liberace Plaza, a small shopping center that houses Liberace's Tivoli Gardens restaurant. It's also within earshot of the star's Las Vegas mansion, and tour guides will gladly provide directions. Before leaving, you'll probably want to stop by the well-stocked gift shop and pick up a paperweight, pillbox, candy dish, ringholder, or other Liberace mementos with the famous signature. Purchases are tax deductible and all proceeds go to the Liberace Foundation for the Performing and Creative Arts, a nonprofit organization that sponsors arts scholarships at educational institutions, including Johns Hopkins University and Oberlin College.

Harrah's Automobile Collection

Box 10
Reno, Nevada 89504
(702) 355-3500
Open: daily, 9:00 A.M. to 6:00 P.M.
Admission: $6.50 for adults, $5.50 for seniors, $3.50 for juniors ages six to 15, free for children under six
Wheelchair accessible

In the market for a sporty little used car? Chances are, you'll find just what you're looking for at Harrah's Automobile Collection on the outskirts of Reno, Nevada. Walk past row after row of more than 300 antique, classic, and rare cars, many previously owned by celebrities; you'll find Frank Sinatra's Ghia, Bill Cosby's Aston Martin, Wayne Newton's Bentley, and John F. Kennedy's Lincoln Continental. Vintage Fords, Packards, Buicks, and Cadillacs, as well as dozens of planes and boats, all beautifully restored, are housed in a 13-building complex that covers 12 acres. Too bad none of them are really for sale.

This mania for antique cars began in 1948, when Bill Harrah acquired a 1911 Maxwell and a 1911 Ford. The collec-

Just a few of the more than 300 cars in the sprawling Harrah's Automobile Collection.

Courtesy of Harrah's Automobile Collection

tion, which opened to the public in 1962 continues to search for rare finds here and abroad. A stroll through the cavernous showrooms documents the automobile's evolution from horse-less carriages to the latest formula-one racing cars. Throughout the sumptuous traffic jam, one comes across the unusual as well as the celebrated; of the six Bugatti Royales in existence, two are displayed. So are the 1949 Mercury James Dean drove in *Rebel Without a Cause*, Al Jolson's custom-built 1933 all-weather Phaeton/Fleetwood Cadillac, and John Wayne's 1953 Corvette.

Cars from the 1920s and 1930s had elaborate bronze or stainless-steel hood ornaments and radiator caps, which were designed by European and American artists. Known as "mascots," these delicate sculptures have become collector's items; of note are the 1923 Rolls Royce Flying Lady and the Bugatti Silver Elephant.

What's most impressive about the collection is the attention to detail. Observe the complex work in progress at Harrah's restoration facilities, where windows, upholstery, and orna-ments are replaced, engines rebuilt, and bodies smoothed and repainted in original colors. Many completed automobiles have "before" photos accompanying them.

1930 Cadillac 1933 Lincoln-Continental 1922 Isotta Fraschini

1923 Rolls-Royce 1928 Diana 1930 du Pont

The elaborate hood ornaments and radiator caps made of bronze or stainless steel, known as "mascots," from the 1920s and 1930s have become valuable collector's items.

Courtesy of Harrah's Automobile Collection

Liberty Belle Saloon and Slot Machine Collection

4250 South Virginia Street
Reno, Nevada 89502
(702) 825-1776
Open: daily, 11:00 A.M. to 11:00 P.M.
Admission: free
Wheelchair accessible

If you've lost your share of quarters at the slots, here's a chance to inspect those one-armed bandits without risk. The Liberty Belle Saloon and Slot Machine Museum in Reno, Nevada, has a dazzling collection of vintage gambling machines that once contributed their share to the billion dollar industry.

Nevada's most popular sport was invented in San Francisco by Charles Fey, a mechanic and part-time inventor, who struggled for years to come up with a successful gambling machine; he hit the jackpot in 1887 with a nickel slot design he called the Liberty Bell. Since it's not possible to patent gambling devices, Fey made his fortune as an operator. Before being exported to other states, his invention was played in every saloon on the Frisco waterfront.

Frank and Marshall Fey, grandsons of Charles and owners of the Liberty Belle Saloon, are avid collectors of Western

The Liberty Bell, Charley Fey's first nickel slot machine, is the prized artifact at the Liberty Belle Saloon and Slot Machine Museum.

Courtesy of Liberty Belle Saloon and Slot Machine Museum

Americana. In addition to the original Liberty Bell, which is enshrined in a glass case just inside the entrance, visitors will find rare 19th century Caille and Dewey gambling machines along with roulette wheels, nickelodeons, and early card and dice machines.

Slot machines have changed over the years, but the basic operating principles developed by Fey have not. The Fey brothers' collection includes eight of the original designs and modifications made by Charlie Fey and several by their father, Edmund. The museum room displays early slots, ornately decorated with Indian beads and creeping grapevines. Outstanding in the collection are the gleaming, polychromed Silver Dollar, the first slot machine to accept coins of that size, and a rare cocktail waitress figurine slot salvaged from the Golden Hotel fire of 1962.

In business since 1958, the saloon/restaurant/museum offers hearty fare amidst authentic Western memor-

Charles Fey, a mechanic and part-time inventor who struck it rich in 1887 with the nickel slot machine.

Courtesy of Liberty Belle Saloon and Slot Machine Museum

abilia—antique Tiffany lampshades, vintage cash registers, beer taps, and exit signs collected from bars throughout the West. On the roof, find the brothers' Western Wagon Collection, which includes a turn-of-the-century beer wagon, an 1860s horse cart, and a covered wagon from the Roaring Camp collection.

NEW MEXICO

At a secret research center, hidden in the mountains of Los Alamos, New Mexico, a contingent of 8,000 scientists and support personnel labored under the direction of J. Robert Oppenheimer to devise a weapon to end World War II. They called it Project Y, and on July 16, 1945, the mushroom cloud of the Trinity test ushered in the age of nuclear weapons. Within 24 days, two nuclear bombs destroyed Hiroshima and Nagasaki, killing more than 100,000 Japanese. Soon Japan surrendered, ending the war.

Today, the country's top nuclear physicists and scientists continue research and development at the Los Alamos National Laboratories. Nearby, the Bradbury Science Museum provides a window on the laboratory's achievements in alternative energy sources, biomedical research, and new weapons.

Atomic bomb components are displayed matter-of-factly in the museum's well lit display cases; you can walk around and touch a sleek cruise missile or the bulbous metal bomb casing identical to Fat Man, the nickname of the bomb that destroyed Nagasaki. Imaginative hands-on exhibits allow visitors to align a laser, pinch plasma, monitor radiation, and interact with

The Bradbury Science Museum at Los Alamos Laboratories

Mail Stop B286
Los Alamos, New Mexico 87545
(505) 677-4444
Open: Tuesday through Friday, 9:00 A.M. to 5:00 P.M.; Saturday, Sunday, and Monday, 1:00 P.M. to 5:00 P.M.
Admission: free

Visitors inspect Fat Man.

Courtesy of The Bradbury Science Museum at Los Alamos Laboratories

computer displays that describe the making of ICBM warheads, among other topics. You can manipulate bars of simulated plutonium in a laboratory glove box and perform the steps to create a bomb core. The process of uranium fissure is highly complex, and exhibits explain the basic steps involved in splitting uranium nucleus to create a massive explosion of energy.

The history of Project Y is revealed in photographs, artifacts, and declassified documents, such as a letter from Albert Einstein to President Roosevelt in 1938, reporting on the energy resources of uranium. At the Museum Theater, see rare footage of preeminent physicists of the 20th century, among them Edward Teller (inventor of the hydrogen bomb), Enrico Fermi, who built the first nuclear reactor, and Niels Bohr, a leading atomic theorist. Other films present the latest in lasers, computers, and engineering.

INTERNATIONAL SPACE HALL OF FAME

Highway 2001
Alamogordo, New Mexico 88310
(505) 437-2840

Situated on the edge of the White Sands Desert, this gleaming new museum honors the men and women who have contributed to space exploration. Displays highlight the quest for space. See multimedia programs and laser light shows at the Planetarium; the Omnimax Space Theater shows breathtaking space films.

NATIONAL ATOMIC MUSEUM

S. Wyoming Boulevard
Kirtland Air Force Base
Albuquerque, New Mexico 87115
(505) 844-8443

Located on Kirtland Air Force Base East, this is the official museum of the U.S. Department of Energy. After viewing a documentary film on the Manhattan Project, *Ten Seconds That Shook the World*, tour atomic bomb hardware and casings, including most major weapons designs in the nuclear arsenal and displays of nuclear power plants and alternative energy resources. More weapons and aircraft are shown outside, like the awesome Hound Dog nuclear missile and the B-52 bomber used in the last atomic bomb drop during atmospheric tests in the Pacific.

OREGON

The calliope plays, and colorful prancers, standers, and leapers circle round and round, up and down, thanks to Duane and Carol Perron, who are dedicated to preserving the art, tradition, and good times of the wooden carousel. To share their love of merry-go-rounds, they opened the Portland Carousel Museum in Portland, Oregon, and a number of beautifully restored carousels can be seen throughout the city.

An important display in the museum includes 10 horses, one from every major carver in the country between 1890 and 1930, and describes the different characteristics of the horses and how to identify them. Another area focuses on construction and restoration techniques, and you'll find pictures of early carousels and a glossary of carousel terms. A display case shows tokens, tickets, brass rings, and other memorabilia, including paint chips from the Perrons' restoration projects. You'll learn the origin of the carousel and its role in the Portland area; before steam and electricity, carousels were powered by ponies.

"There are only about 270 wooden carousels left operating in the world. Everytime one of them is torn down, we mourn it," says Duane, who left his job as vice-president at a bank to devote

The Portland Carousel Museum

P.O. Box 14942
121 S.W. First Street
Portland, Oregon 97214
(503) 241-2560
Open: daily, 11:00 A.M. to 4:00 P.M.
Admission: $1 for adults, free for children under six
Wheelchair accessible

A few of the intricately carved carousel horses on display at The Portland Carousel Museum.

Courtesy of The Portland Carousel Museum

full time to his hobby. The couple have purchased and restored eight carousels. "We learned restoration by trial and error," says Carol. "There was no one to tell us how to do it." They have attracted a loyal band of volunteers, who run the museum and enjoy repainting and restoring the durable steeds to their original glory, with flared nostrils, rearing hoofs, and manes flowing in the wind.

After touring the museum, take a nostalgic turn on the large carousel outside the museum, which has even hosted a wedding party. The minister stood, the guests sat on the horses, and when the ceremony was over, everyone took a ride.

MALHEUR NATIONAL WILDLIFE REFUGE MUSEUM

Oregon Highway 205
Oregon

Bird watchers flock to see nearly 200 mounted specimens and more than 250 species of birds that stop at Headquarters Pond, one of the major stops on the Pacific Flyway. Photographers praise the close-up viewing offered by the superb blind at the pond.

ROUND UP HALL OF FAME AND MUSEUM
P.O. Box 609
Pendleton, Oregon 97801
(800) 524-2984

Here's another museum that cheers bronco busting and cattle roping. See saddles used by famous riders, photographs, and memorabilia as well as War Paint, one of the meanest broncos that ever lived. Today, he is stuffed and looks quite tame.

If paleontology is your subject, you can touch the bones of a brontosaurus embedded in sandstone at the Dinosaur National Monument Quarry, miles from civilization on high-desert country at the Colorado-Utah border. More than 2,000 fossil bones have been uncovered and left in high relief in the quarry face, a tilted 10-foot-thick sandstone layer, which comprises one wall of this unique museum. In summer, National Park Service paleontologists continue working to expose bones, and visitors are invited to see how they are freed, cataloged, dated, and protected for study in the museum's laboratory.

You can study the face of the quarry from the upper-level observation deck or get up close and feel the texture of 140-million-year-old embedded fossils from the quarry floor. Like the rock around them, the bones are quite hard, but their color and texture are different from the grainy gray sandstone. The pores and cavities of the bones have been filled in with minerals

Dinosaur National Monument Quarry

P.O. Box 128
Jensen, Utah 84035
(801) 789-2115
Open: daily, 8:00 A.M. to 4:30 P.M.
Admission: $5 per car or $1 per person by bus or bicycle
Wheelchair accessible

The main exhibit is the quarry face itself. More than 2,000 dinosaur fossil bones have been uncovered and left in high relief in the tilted sandstone which forms one wall of the quarry building. During the summer months, National Park Service paleontologists continue to expose bones, mainly using small hand tools.

Courtesy of Dinosaur National Monument Quarry

259

Visitors to Dinosaur National
Monument Quarry can view the
quarry face from an observation
deck or get a close-up look at some
of the fossils from the walkway at
the foot of the tilted rock wall.

Courtesy of Dinosaur National
Monument Quarry

from the surrounding rock, and iron oxides give them their
brownish color. Bones have been treated with a waterproof
preservative.

From 1909 to 1924, paleontologist Earl Douglass, from the
Carnegie Museum in Pittsburgh, and his assistants excavated
over 350 tons of dinosaur bones from the site, which proved to
have the largest concentration of dinosaur fossils in the world.

In 1915, President Woodrow Wilson proclaimed it a national monument and eventually, at Douglass' suggestion, an on-site museum enclosing the excavation was created and opened to the public in 1958.

Besides dinosaurs, a few bones of turtles and crocodiles as well as freshwater clam shells have been discovered. However, the dominant fossils found came from sauropods, huge, long-necked, long-tailed vegetarians that were the largest creatures to have walked the land. The bones are the remains of several kinds—brontosaurus, stegosaurus, and camarasaurus, among them. To identify bones along the walkway, you can look up their catalog numbers in a notebook available to visitors. Staff at the Information Center will answer questions, and books, slides, and maps are for sale at the bookstore. Dinosaur National Monument lands extend along the Green and Yampa rivers, covering 200,000 acres of desert plateaus cut by deep and colorful canyons.

WASHINGTON

The Whale Museum

On a two-hour ferry ride to The Whale Museum through the San Juan Islands, visitors usually see whales frolicking alongside. The gentle giants of the sea, once prehistoric land mammals, reentered the ocean about 60 million years ago, and most forms have changed little in the past five million years. The nationally renowned museum, begun in 1979, focuses on the fascinating history, biology, and behavior of Cetacea, the scientific name for whales and dolphins.

The museum, located in Friday Harbor in the misty San Juan Islands of Upper Puget Sound, is close to the Vancouver border in Washington state and attracts more than 20,000 visitors a year. Some 80 orcas (killer whales) reside year-round in Washington's inland sea in three family groups called "pods," and this area is also home to minke and gray whales, transient orca pods visiting from the open ocean, dalls, and harbor porpoises.

P.O. Box 945
62 First Street North
Friday Harbor, Washington 98250
(206) 378-4710
Open: Memorial Day through September 30, daily, 10:00 A.M. to 5:00 P.M.; October 1 to late May, daily, 11:00 A.M. to 4:00 P.M.
Admission: $2 for adults, $1.50 for students and seniors, $.75 for children ages five to 12

A complete skeleton of an orca whale on display at The Whale Museum.

Rich Osborne, The Whale Museum

Whales are pretty gregarious, as anyone from the Moclips Cetology Society, the nonprofit research organization that created the museum, will tell you. Their studies have gone far beyond identification to acoustics and behavior. Using a computer and hundreds of hours of recordings, they have distinguished between pod dialects and have noted that the three pods in Puget Sound travel separately, go through elaborate greeting ceremonies, and can hear each other from a distance of six miles.

In the museum, a barnlike structure with rough-hewn paneling and delicate stained-glass windows, visitors are serenaded by whale calls. Exhibits range from entire skeletons to the enormous brain of a fin whale; whale evolution, migration, social behavior, and communication are comprehensively presented. Whale watchers can study a life-size sperm whale sculpted from seasoned red cedar and the head of a Baird's beaked whale.

Whale hunting is banned in Puget Sound, but it remains a living laboratory, and a hot-line map shows the latest sightings. Enthusiasts will also find a library and video room to watch continual tapes of several species. A children's room is equipped with drawing materials and a magnetic wall puzzle. In the gift shop, marine-related gifts range from jewelry and pottery to "Save the Whale" paraphernalia.

THE BING CROSBY HISTORICAL SOCIETY MUSEUM

Perkins Building, Room 443
11th and A Streets
Tacoma, Washington 98402
(206) 627-2947

Harry Lillis "Bing" Crosby, international film star and one of the great crooners of the radio age, was born in Tacoma. Since his death in 1977, he has been fondly remembered at the Bing Crosby Historical Society Museum (BCHS). On display are Crosby records, photographs, sheet music, videotapes, and personal items, such as a New York license plate ("Bing") and a copy of the young Crosby's favorite comic strip, "The Bingville Bugle." According to Ken Twiss, president of the BCHS, Crosby used to ask to have it read aloud so often that folks began calling him "Bing."

WYOMING

The National First Day Cover Museum

In stamp-collecting circles, the most valued stamp in any series is the First Day Cover—a first edition of a stamp on a specially prepared envelope certified at a specific post office on the first day of issue. Many First Day Covers, created by distinguished artists, are regarded as miniature works of art.

In 1979, Fleetwood, a division of Unicover Corporation, marketers of First Day Covers since 1929, created The National First Day Cover Museum in Cheyenne, Wyoming. Housed in a small brick, post office-like building, this well-designed museum presents a wide selection of rare and valuable First Day Covers. Stamps are tastefully displayed, framed, and encased in thematic groupings—Space Exploration, American History, Birds and Flowers of the 50 States; information on their background and the artists who designed them is noted. Many of the beautiful works of art from which the stamps were created grace the walls.

The world's first First Day Cover, the *Penny Black*, issued on May 6, 1840, is a prized item in the collection. Valued at more than $40,000, it is one of only six known to exist and features a

702 Randall Avenue
Cheyenne, Wyoming 82001
(307) 634-5911
Open: Monday through Friday,
9:00 A.M. to 12:00 noon,
12:30 P.M. to 5:00 P.M.
Admission: free
Wheelchair accessible

The *Penny Black* is the world's first First Day Cover. One of only six known to exist, this is a business letter bearing the world's first postage stamp, issued on May 6, 1840, and postmarked on that same day. The stamp, currently valued at more than $40,000 features the profile of a young Queen Victoria.

Courtesy of The National First Day Cover Museum

young Queen Victoria (she was nicknamed Penny) in profile; it is affixed to a business letter. America's first commemorative stamp, the 1893 *Columbians*, is on view as are First Day Covers once carried on historic flights, like the *Graf Zeppelin*'s first Europe-Pan American round-trip.

Philatelic enthusiasts will be delighted by the exhibits of First Day Covers from other countries, including delicately conceived editions from China and another series from England on the Royal Wedding, in honor of Charles and Diana's betrothal.

For atmosphere, there's a turn-of-the-century Wyoming post office and general store in one section of the museum. Visitors can browse through flour sacks and cracker barrels, old-time scales and grinders, complemented by a display of First Day Covers celebrating the old-fashioned charms of small-town America.

THE BUFFALO BILL HISTORICAL CENTER

720 Sheridan Avenue
Cody, Wyoming 82414
(307) 587-4771

This complex captures Western history with a Buffalo Bill Museum, a gallery of Western art, a Plains Indian Museum, and a Winchester Museum, displaying a collection of rifles and guns.

CANADA

ALBERTA

DONALDA AND DISTRICT MUSEUM

Railway Avenue and Main Street
Donalda, Alberta T0B 1H0
(403) 883-2345

Displayed are more than 600 antique oil lamps, including Aladdin, parlor, and kerosene styles, dating back to the 19th century.

BRITISH COLUMBIA

BRITISH COLUMBIA SPORTS HALL OF FAME AND MUSEUM

British Columbia Pavilion
Pacific National Exhibition Grounds
Vancouver, BC V5K 4W3
(604) 253-2311

In addition to an outstanding collection of Olympic and Pan American medals, this museum showcases superlative athletes representing 75 different sports, from lacrosse and cycling to badminton and curling, through photographs, artifacts, and news clippings. Among the hall of fame's illustrious inductees are skier Nancy Green, who won gold and silver medals for Canada at the 1968 winter olympics in Grenoble, Frank Avery, known as "Mr. Curling" in Vancouver, and rodeo champion Kenny McLean.

MANITOBA

AQUATIC HALL OF FAME AND MUSEUM OF CANADA, INC.

Pan Am Pool
25 Poseidon Bay
Winnipeg, Manitoba R3M 3E4
(204) 284-4035

Built to host the Pan American Games of 1967, the 13-acre Pan Am Natatorium complex has an Olympic-size swimming pool and the adjacent museum pays tribute to swimming, diving, water polo, and synchronized swimming. There's an extensive collection of sports stamps, model ships, and sculpture on aquatic themes.

267

NOVA SCOTIA

ALEXANDER GRAHAM BELL NATIONAL HISTORIC PARK

Route 205
Chebucto Street
Baddeck, Nova Scotia B0E 1B0
(902) 295-2069

Multi-talented inventor Alexander Graham Bell made contributions to aeronautics, marine engineering and medicine. He settled on Nova Scotia's Cape Breton later in his life and constructed a laboratory, where many famous experiments were conducted. Across the bay from his estate, Beinn Bhreagh, this museum displays many of the objects Bell invented during his 37 years at Cape Breton, including tetrahedron-shaped kites used during his explorations of flight principles and a full-scale replica of his 60-foot-long Bell Hydrofoil HD-4.

MARGAREE SALMON MUSEUM

Cabot Trail
Northeast Margaree, Nova Scotia B0E 2H0
(902) 248-2848

The Margaree River has always been tops in salmon fishing and at this museum visitors will see a profusion of old-time rods and tackle, fly-tying material, and confiscated poacher's equipment. A display traces the salmon's development from hatched egg upriver through salmon adulthood, when it returns to the Margaree to spawn and die.

The Daredevil Hall of Fame at the Niagara Falls Museum

I f life is just too dull and you're considering a little adventure, say a trip over Niagara Falls in a barrel, then make a trip to the Daredevil Hall of Fame at the Niagara Falls Museum in Niagara Falls, Ontario, for a look at the battered relics of those who've made the plunge.

Schoolteacher Annie Edson Taylor was the first to successfully navigate the Falls in a plain wooden barrel in 1901 and became known as Queen of the Mist. Englishman Bobby Leach used a specially designed metal cylinder in 1911 and had plenty of time to contemplate improvements while recuperating from his injuries. It was Jean Lussier who revolutionized the art of barrel plunging with an ingenious rubber ball approach, which is on view at the museum. On July 4, 1928, Lussier floated over the Falls in a sealed rubber sphere with enough oxygen cannisters for 40 hours. His good planning paid off and for years all daredevils consulted him before their attempts. Perhaps the most dramatic ride of all was the unplanned one taken in 1960 by seven-year-old Roger Woodward. Thrown overboard in a boating accident upriver, he rode the crest of the Falls with just a fragile life preserver and miraculously survived.

Among the many dangers of plummeting 176 feet at speeds of 90 miles per hour is landing on rock instead of water, the fate of some since the first known attempt in 1825. If you're lucky enough to land on water, then contemplate being sucked underwater by the vortex of the Falls and held there as happened to George Strathakis, who suffocated in his barrel in 1930. Nevertheless, some continue to take the plunge: Steve Trotter took a barrel made of truck tire inner tubes, padding, and fiberglass over the edge in the summer of 1985 and walked away only slightly shaken.

The rest of this four-story museum, which opened in 1827, is devoted to eclectic exhibitions: insects, butterflies, Indian relics, guns, military memorabilia, Egyptian and Oriental curios, and more than 5,000 seashells. An odd collection of wild, domesticated and freak animals recalls the sensational spirit of P.T. Barnum's famous American Museum, no longer in existence. Before leaving, visit the fifth floor Observation Tower for an inspiring view of the mighty Falls and its thundering rapids.

P.O. Box 960
5651 River Road
Niagara Falls, Ontario
L2E 6V8
(416) 356-2151
Open: June 1 through Labor Day, daily, 8:30 A.M. to 11:00 P.M.; spring and fall, 10:00 A.M. to 7:00 P.M.; winter, Saturday and Sunday, 10:00 A.M. to 5:30 P.M. Admission: $4 for adults, $3 for seniors and students, $1.75 for children ages seven to 12, free for children under seven

The Seagram Museum

57 Erb Street
Waterloo, Ontario,
N2L 6C2
(519) 885-1857
Open: Tuesday through Saturday,
12:00 noon to 8:00 P.M.;
Sundays and holidays, 12:00 noon
to 5:00 P.M.
Admission: free
Wheelchair accessible

Fermenting grapes to make wine dates back to 6000 B.C. and distilled alcohol was first produced by Islamic alchemists in the 11th century. The history and technology of creating great wines and spirits is presented at the Seagram Museum in Waterloo, Ontario. Using their enormous resources, the Seagram company, which owns wineries and distilleries around the world, has amassed an impressive collection of more than 2,000 drink-related objects.

The $5 million museum, which opened in 1982, is housed in a historic brick warehouse and a newly built connecting wing. Beneath a 55-foot-high skylight, steel "pavilions" present thematic displays of Irish and Scotch whiskey, North American whiskeys, rum, gin, and wines of all kinds. Warehouse 5, the original 1868 Joseph E. Seagram distillery building, holds 50-foot-high pine storage racks, filled with white oak distillery barrels. Among the other salvaged artifacts are a 45-foot-tall copper still and a beautifully restored 1919 Pierce Arrow flatbed delivery truck.

The museum tour includes a nine-projector, 15-minute slide show that tells the Seagram story and highlights displays you are about to see. Video stations throughout the museum offer three- to five-minute vignettes on such subjects as distillation, fermentation, and wine making. Step into a re-creation of a 19th century champagne cellar, stocked with a special hand-bottled line from turn-of-the-century France. Nearby, a 1945 spirit laboratory presents the equipment and techniques used in whiskey blending and quality control. Among the 5,000 bottles in the museum's collection are many rare wine and spirit vessels, including a Civil War-era Canadian Malt Whiskey bottle and a display tracing the evolution of wine bottles from the 17th century. The development of the cork stopper revolutionized wine making, and a cork exhibit informs how cork is made and used to seal wine bottles; vintage brass, silver, and copper corkscrews are also displayed.

The library and archives, located on the mezzanine level atop the pavilions, offer more than 4,000 current books on alcohol-related subjects as well as 400 rare tomes, including a book on wine by Louis Pasteur (circa 1873) and an Italian book on distilling from 1545. You can raise your glass in a toast to this unique repository at Spirits restaurant and/or take home some of Seagram's diverse products from the LCBO boutique.

A Canadian flavoring pot still (circa 1930) from The Seagram Museum.

Willi Nassau, The Seagram Museum

BATA SHOE MUSEUM FOUNDATION

59 Wynford Drive
Don Mills, Ontario M3C 1K3
(416) 446-2011

If you want to learn about the history of shoes, try this museum on for size. Exhibits present a collection of historical footwear from cultures all over the world as well as artifacts from the shoe industry.

CANADIAN FOOTBALL HALL OF FAME

58 Jackson Street
West Hamilton, Ontario L8P 1L4
(416) 528-7566

Canadian football combines elements of U.S. football and the English sport of rugby. Instead of a Super Bowl, each year Canada's best teams compete for the Grey Cup, named after Lord Grey, governor-general of Canada at the turn of the century. The hall displays life-size steel busts of enshrinees, audiovisual exhibits, and a 100-seat theater, where fans can watch football films.

INTERNATIONAL HOCKEY HALL OF FAME AND MUSEUM, INC.

Alfred and York Streets
Kingston, Ontario K7L 4V6
(613) 544-2355

It is generally agreed that ice hockey was invented on frozen Kingston Harbor by British soldiers in the mid-19th century. Every year, a re-creation of the first game, which took place in 1886 between Queen's College and the Royal Military College, is staged on Kingston Harbor, and the hall displays many artifacts of that historic rivalry. Exhibits also include Russian, Swedish, Czechoslovakian, and Japanese memorabilia, as well as antique hockey sticks and skates.

CANADIAN HOCKEY HALL OF FAME AND CANADIAN SPORTS HALL OF FAME

Exhibition Place
Toronto, Ontario M6K 3C3
(416) 595-1046

Canada's national sport, hockey, is highlighted along with the country's outstanding athletes in other fields, such as skiing, skating, and cycling. Such hockey greats as Bobby Hull and Gordie Howe are honored and exhibits include hockey sticks and uniforms once belonging to star players. The Hockey Hall of Fame is also the home of the coveted Stanley Cup, which is awarded to the number one professional hockey team each year.

METROPOLITAN TORONTO POLICE MUSEUM

590 Jarvis Street
Toronto, Ontario M4Y 2J5
(416) 967-2222

Located in a re-creation of a turn-of-the-century police station interior, this lively museum displays artifacts and evidence from Toronto's most notorious crimes. It's all here—murder, fraud, theft, kidnapping. View exhibits of bank hold-up notes, murder weapons, even a freezer where David Todd stored the body of his wife after killing her. His children found the body and turned him in.

REDPATH SUGAR MUSEUM

95 Queens Quay East
Toronto, Ontario M5E 1A3
(416) 366-3561

See the history of sugar located in a small room behind the Redpath sugar-manufacturing company. There are a variety of artifacts and displays as well as a short film.

TOUR OF THE UNIVERSE

301 Front Street West
CN Tower
Toronto, Ontario M5V 2T6
(416) 364-2019, 363-8687

This $12 million simulated space shuttle ride of the future is a breathtaking experience, complete with security checks, baggage claim, and a superrealistic view of space through the windscreen.

ONTARIO PUPPETRY ASSOCIATION MUSEUM

171 Avondale Avenue
Willowdale, Ontario M2N 2V4
(416) 222-9029

On view is one of the largest collections of international puppets in the world, from Balinese shadow puppets to marionettes, as well as hand, rod, and finger puppets.

SASKATCHEWAN

ROYAL CANADIAN MOUNTED POLICE MUSEUM

Depot Division
Box 6500
Deudney Avenue West
Regina, Saskatchewan S4P 3J7
(306) 780-5838

This museum celebrates the courage of the famous Canadian Mounties, who covered the vast territories of Western Canada on horseback, with displays of uniforms and equipment and tales of derring-do.

TURNER'S CURLING MUSEUM

417 Woodlawn Crescent
Weyburn, Saskatchewan S4H 0X5
(306) 842-3604

Curling is a fascinating sport in which teams of four slide a heavy "curling stone" across a stretch of ice towards a target circle. The speed and direction of the stone can be controlled by skillfully sweeping ice particles out of its path. The Turner collection includes curling stones, brooms, flags, posters, and more than 3,800 curling club pins from all over the world.

INDEX

INDEX

INDEX

INDEX

INDEX

INDEX